Imagining Identity in

JOE R. AND TERESA LOZANO LONG SERIES IN
LATIN AMERICAN AND LATINO ART AND CULTURE

Imagining Identity
in New Spain

Race, Lineage, and the Colonial Body
in Portraiture and Casta Paintings

MAGALI M. CARRERA

University of Texas Press, Austin

First edition, 2003

Requests for permission to reproduce material from this work
should be sent to Permissions, University of Texas Press,
Box 7819, Austin, TX 78713-7819.

(∞) The paper used in this book meets the minimum
requirements of ANSI/NISO Z39.48-1992 (R1997)
(Permanence of Paper).

Library of Congress Cataloging-in-Publication Data

Carrera, Magali Marie, 1950–
Imagining identity in New Spain : race, lineage, and the colonial
body in portraiture and casta paintings / Magali M. Carrera.
 p. cm. — (Joe R. and Teresa Lozano Long series in Latin
American and Latino art and culture)
Includes bibliographical references and index.
ISBN 978-0-292-74417-2
1. Casta paintings. 2. Racially mixed people in art.
3. Mexico—Social life and customs—18th century. I. Title.
II. Series.
ND1312.M44C37 2003
757'.098'09033—dc21
2002011033

With gratitude and love, I dedicate this book to
My mother and father, who told me about the ocean,
Alan, who always helps me see and hear the ocean,
and
Arin and Ana, who bring me joy as immense as the ocean.

Contents

LIST OF ILLUSTRATIONS

Acknowledgments

In 1992 I was lucky enough to be a participant in a National Endowment for the Humanities Summer Institute on Mexican colonial art. The organizers and leaders of the Institute, Mary Grizzard and Clara Bargellini, and the lecturers, Elena Estrada de Gerlero and Elisa Vargasluso, opened a world I had only known peripherally through my previous work on pre-Columbian Mexico. For me, colonial Mexico became a place of intense and unending intellectual fascination. I am thankful to the NEH and Institute organizers and lecturers for opening this door.

Once the door was opened, building a comprehensive knowledge of the history and culture of colonial Mexico required more years of study made possible through grants from the University of Massachusetts Dartmouth's Healey Research Fund, its College of Visual and Performing Arts Dean's Discretionary Professional Development Fund, and, again, the NEH.

Focusing on specific topics required extensive work at the Rockefeller Library of Brown University, the John Carter Brown Library, also at Brown University, and the Archivo General de la Nación, Mexico City. The librarian assistance at these institutions was friendly and impeccable. I also thank Linda Zieper, librarian, University of Massachusetts Dartmouth Library, who was always helpful in locating research material for me. Further, I am indebted for the extensive help I received from the professional staff of the Instituto Nacional de Antropología e Historia and of museums in Mexico, Madrid, and the United States.

In addition to written and visual sources, conversations and exchanges with scholars have been important in the development of this project. Dr. Charles Long has always insisted that I think past the data and the images, into broader realms of critical theory. Extended exchanges with Dr. Pearlee Freiberg, who invariably asked a sagacious question that made me return to our next meeting with a clearer idea of my topic, were critically important. I thank her for our friendship, numerous lunchtime discus-

sions, and continuing patience with my propensity for critical theory. I am also in the debt of Dr. Elizabeth Perry, who, in all the stages of manuscript writing, offered extremely helpful and insightful ideas, suggestions, and sources on the colonial period. Her astute comments on drafts of the text were invaluable.

I am indebted to two readers, Jeanette F. Peterson and Stacey Schlau, who pointed out the weakness of an initial draft of this manuscript and gave me the insights to improve it. I wish to express my sincere appreciation to the professional staff of the University of Texas Press. Theresa May, Assistant Director and Executive Editor, assisted me with the development of the manuscript. Leslie Tingle, Assistant Managing Editor, Allison Faust, Associate Editor, and Nancy Bryan, Catalog and Advertising Manager, carefully guided the production of the book. I thank Lynne Chapman, Manuscript Editor, and especially Jenevieve Maerker, who were thoughtful and extremely meticulous copyeditors.

Along with financial support, UMass Dartmouth has provided me with sterling colleagues. Critical to the completion of this project has been the steadfast assistance of Charlene Ryder, Secretary to the Department of Art History. She has always been there for me with her quick and accurate assistance with the minutiae of keeping me and my research materials, correspondence, and grants in order; most importantly, I am grateful for her subtle humor and unswerving friendship. My department colleagues, Drs. Memory Holloway, Thomas Puryear, and Michael D. Taylor, have given me their unflagging professional support and personal friendship. As department chairperson, Dr. Taylor also cleared the administrative path to allow me to finish this book. I also acknowledge the research support of Dr. John Laughton, Dean of the College of Visual and Performing Arts.

Enduring friendships have sustained me through this project. Janet Freedman has given me her unconditional friendship in my personal and academic life. Our years together theorizing the construction of knowledge, society, and life have been a fountain of spiritual, emotional, and intellectual strength and renewal. Andy Peppard, a rock-steady friend, has been there with the right set of words of encouragement and a totally disarming sense of humor. Faith Matelski has always been an unwavering friend despite my many missed coffee hours.

Finally, all words of gratitude are inadequate to express my appreciation for the love and assistance of Jorge and Jo Carrera, my father and mother.

Their assistance in the final phases of this project was critical. I wish to express gratitude to Alan Heureux, my partner in life, love, and laughing, who has provided me with the emotional and physical space to do my research and writing. I thank Ana and Arin, my children, who love me without question and despite my constant disappearance into my study, my sometimes bad temperament from frustrating hours of writing, and numerous catcher-as-catcher-can (also known as "catchers catch can") suppers.

Despite all the best words and efforts of these colleagues, readers, editors, friends, and family, I remain responsible for all the weaknesses, omissions, and errors of this book.

Introduction
Visual Practices in Late-Colonial Mexico

> . . . colonial discourse produces the colonized as a social reality which is at once an "other" and yet entirely knowable and visible. It resembles a form of narrative whereby the productivity and circulation of subjects and signs are bound in a reformed and recognizable totality. It employs a system of representation, a regime of truth, that is structurally similar to realism.
>
> Homi Bhabha, *The Location of Culture*

In the process of researching and writing this book, I found myself constantly returning to the 1769 painting *The Painter's Cupboard*, an image I had first encountered at the Pinacoteca Virreinal in Mexico City many years ago (figure I.1). This beautifully executed image by Antonio Pérez de Aguilar, who was active in New Spain between 1749–1769, is one of the few surviving still-life images of the colonial period. It is a painting that one could easily disregard or overlook. Its ostensible topic, artists' tools and props, seems inconsequential and mundane, especially when compared to other opulent and ornate religious and secular paintings of eighteenth-century New Spain. In the painting, keys dangle in the lock of the wooden cabinet's closed glass door, and the three shelves inside contain various objects that seem hastily placed. Crammed on the top shelf are a pen, loose paper, books, what appears to be a lute, a violin, and a basket that holds a doll, a clay jar, a palette, and brushes. The middle shelf contains a haphazard arrangement of two silver plates, circular wooden boxes, two loaves of bread, a small clay pitcher with a spoon, and a shallow bowl askew on top of a small wooden barrel. On the bottom shelf, the artist has left a straw basket, another pitcher (possibly of copper) topped with a small ceramic bowl, a patterned plate, three glasses, and two dark glass bottles, one with a short neck and one with a long neck.

Given the late-colonial artists' propensity for highly ordered imagery, a painting of disheveled objects resting on shelves seems an anomaly. One

Figure 1.1. Antonio Pérez de Aguilar. *The Painter's Cupboard*. Oil. 125 x 98 cm. Museo Nacional de Arte, Mexico City.

scholar has suggested that in this painting the artist has shifted from the contrived composition of baroque still life to the austere Enlightenment idea of "The portrayal of ordinary objects in the dignity of their everyday existence."[1] In its present location in the magnificently refurbished Museo Nacional de Arte in Mexico City, the painting's adjacent label states that the painting is a metaphor for human existence: objects on the top shelf refer to the life of the mind, that is, literature, art, and music; and items on the other shelves are concerned with daily physical subsistence. These stylistic and metaphorical references are, without a doubt, critical elements of the image. I am fascinated, however, not just with the totality of the cupboard but also with the specificity of its contents and their ordering. I am interested in unlocking the cupboard, opening the glass door, looking at each object, and wondering how it came to be made, who was meant to use it, and why it appears on one shelf and not another.

Curiously, while studying the numerous secular images of late-colonial people, I recognized that the objects on the cabinet's shelves are commonly found in the eighteenth-century secular paintings of New Spain. The paper, pen, books, and musical instruments of the top shelf are found exclusively in association with elite individuals (for example, see figures 3.29, 3.32, and 5.2). The doll might have been a prop used in another type of elite portrait known as a *monja coronada*, an image of a newly professed nun usually shown wearing her habit, an *escudo* or chest shield, and a flowered crown, and holding a flowered scepter and a doll-like image of the Christ child (for example, see figure 3.1). The objects on the second and third shelves—plates, ceramic vases, glass bottles, boxes, and bread—are regularly found in *casta* images, a genre of painting illustrating mixed-blooded plebeians (for example, see figures 3.23, 3.30, and 3.4).

Certain cultural associations are evident as well. Some objects are very clearly European in source: the musical instruments, the glasses, the patterned plate, the artist's tools, and the bread. Others are truly of the Americas: the weaving technique of the basket on the bottom shelf is indigenous in origin, and the basket itself may have been used for holding tortillas, a traditional food; the clay, copper, and silver of the plates and jars are indigenous materials as well. And then there are hybrid objects, such as indigenous clay molded into European shapes. The cabinet narrates a dynamic mix of European, indigenous, and hybrid objects. The objects in

the cabinet, paralleling the inhabitants of colonial New Spain, are of diverse, distinct, and mixed identities.

Importantly, the objects are visually framed by the cabinet door and related within the ordered space: the upper shelf contains objects associated with elite living conditions, while the second and third shelves hold items that, while possibly used by the elite, most likely refer to plebeian daily existence. What may seem a disorderly but uncomplicated still life is, in fact, quite ordered and intricate: the painting becomes a portrait of the social economy of bodies and spaces that constituted late-colonial culture. Put in another way, Pérez de Aguilar's painting constructs and refers to social identity, not by reference to the figurative image of a person, but by the conceptual linking of social markers and ordered spaces associated with kinds of people. In the following pages, I explore the visual practices and themes exemplified in *The Painter's Cupboard*. I investigate how certain artistic practices of eighteenth-century New Spain visually conceptualized specific social and political constructions of the people of urban New Spain.

In chapter 1, I begin this exploration by looking at the mechanisms by which people and spaces were aligned and ordered in late-colonial Mexico. Because I believe that it is insufficient to talk about material culture without some sense of the texture and context of its production, I examine the curious 1789 court case of Doña Margarita Castañeda. Doña Margarita was an *española*, or Spanish woman, whose name had been written in the wrong baptismal record book, the *libro de castas* (book of mixed-blooded people), instead of the appropriate book, the *libro de españoles* (book of Spaniards). In trying to ascertain if this woman was a true Spaniard, the court did not consider the physical person of Doña Margarita; rather, it was her social body that was assessed, classified, and inscribed within a hierarchy of social meanings and values. Doña Margarita's case introduces the comprehensive issues of the colonial body, its territories, and eighteenth-century techniques and practices of corporeal differentiation. I argue that this case must be considered in the context of the constructs of *calidad*, or status, and *raza*, or lineage, and not of twenty-first-century notions of "race." In addition, I consider the utilization of mimicry, hybridity, and ambiguity, theoretical constructs derived from post-colonial writings, as tools to better understand the conditions and construction of New Spanish colonial discourse.

Chapter 2 provides an overview of Doña Margarita's world through a summary and analysis of social and demographic data on eighteenth-century New Spain. Based on current scholarly research, it clarifies for the reader the social and historical setting of the visual practices of New Spain. Spain's Bourbon dynasty established a social perspective that would emphasize and promote ideals of order, orderliness, and productivity effected through law and management at a time when demographic conditions in metropolitan New Spain were erupting and devolving into more and more disorder.

The next three chapters take up a detailed consideration of the visual practices of eighteenth-century New Spain through analysis of the visual structuring of examples of eighteenth-century portraiture and three sets of casta paintings. In chapter 3, we see that through time, casta paintings incorporate more and more of the lived environment of metropolitan New Spain, and surveillance of people becomes more intense. Identifying these images as illustrations of "race" is a static, twenty-first-century reading of the imagery, and it may actually obscure more complex, subtle, and comprehensive readings of the panels, especially in light of the eighteenth-century superceding notions of hybridity as formulated in the concepts of raza and calidad. Secular painting, like religious art, was dynamic in style and content and reactive to social and political changes.

In chapter 4, I look at the question, Why would casta paintings emphatically and repeatedly illustrate a phenomenon—mixed blood—whose demographic identification was inconstant and diminishing and, ultimately, nonexistent? Analysis of the production of casta genre paintings as a visual practice must take into consideration the volatile and emerging conditions evidenced in demographic data and archival documents of eighteenth-century Mexico. By the mid-eighteenth century, the discrete categories of casta hierarchy were disappearing demographically, yet the paintings insist on illustrating a complete, and nonfunctioning, taxonomy of castas. Thus, there is a continuing production of casta paintings through the century, at the same time as the mixed-blooded people are disappearing in general from social apperception. I argue that the visual strategy of surveillance is not just about looking; rather, it constructs the very object of its observation: hybrid bodies, that is, people of mixed blood.

Finally, in chapter 5, I examine why casta painting production ends in

the early nineteenth century. I investigate the legal requirements of citizenship in the early nineteenth century, as well as the possible impact of the establishment of the neoclassic ideas and ideals of the Academy of San Carlos at the end of the eighteenth century, which emphasized nationalistic imagery.

Overall, I argue that portraiture, and especially casta genre paintings, may better be understood as a set of visual practices embedded in, and reflective of, broader regulatory narratives of the late eighteenth century. These secular art practices narrated an illusion of totality in order to obscure the specificity of the lives and lived conditions of eighteenth-century New Spain.[2]

Imagining Identity in New Spain

Identity by Appearance, Judgment, and Circumstances

Race as Lineage and Calidad

> Most esteemed Vicar General, I, Christobal Ramon Bivian, a
> Spaniard and resident of Mexico City, stand before you in this court
> of New Spain with a most grave problem. It seems that by some error,
> my wife's baptismal record has been caught in a most egregious
> falsehood: at baptism, her name was recorded in the book of castas
> [mixed-bloods], not the book of Spaniards as it should have been. I
> stand before you with a most urgent request to have this lie corrected
> by having her name erased from the book that identifies those with
> the defect of impure blood, and placed in the book for those of our
> calidad [quality, status].

IN THIS SCENE, I have imagined the polite but intense concern and disquiet of an elite Spaniard who had found that there was a shadow over the bloodline of Doña Margarita Castañeda, his wife. This fictitious narration is based on the archive record of Christobal Ramon Bivian's petition of 1789 in the ecclesiastic court of New Spain. Although court documents do not state why Don Bivian's request was brought forward, it is likely that if the location of Doña Margarita's baptismal record in the libro de castas were made public, it would tarnish Don Bivian's and his family's reputations. More importantly, however, the certification of Doña Margarita's bloodline as pure Spaniard would have been essential for her children's inheritance of the social and civil prerogatives of eighteenth-century Spaniard or *criollo* (American-born Spaniard) status.[1]

At initial glance, the Doña's case could be construed as a simple example of late-colonial racial discrimination in New Spain. That is, Don Bivian simply wanted to certify that the Doña and their offspring were free from any taint of Indian, Black African, or mixed blood. While avoiding any confusion with other groups or kinds of New Spanish people is the intent of Bivian's request, to use the general labels of "race" and "racism" is to put twenty-first-century constructs of race into play in eighteenth-

century contexts. In fact, as the following examination reveals, the Doña's case traces the broad territory of the differentiation and alignment of kinds or categories of people of New Spain in terms of the social estates and moral qualities they represented. By demonstrating that it is Doña Margarita's public, social body that must be brought into alignment, I introduce more comprehensive theoretical issues of the colonial body, its territories, and eighteenth-century techniques and practices for its differentiation.

I begin with the facts of Doña Margarita Castañeda's case. On 7 September 1789, Christobal Ramon Bivian, a resident of Mexico City, appeared before the ecclesiastical court and the vicar general of the Archbishopric of New Spain. His request was simple: There had been a flagrant error in the registration of his wife's baptism. For some unknown reason, Doña Margarita's name had been placed in the wrong baptismal record book. Specifically, her name was located in the libro de castas, or *libro de color quebrado* (book of mixed-bloods, or book of people of broken color), which recorded people of mixed Spanish, Indian, and/or Black African blood. In fact, according to Don Bivian, Doña Margarita was of pure blood, a Spaniard, and he stood before the vicar to request that his wife's name be removed from the libro de castas and placed in the libro de españoles.[2]

Such a request required investigation. Over the following weeks, a court notary collected sworn depositions from four witnesses about their knowledge of Doña Margarita and her background. In one declaration, dated 10 September 1789, Don Mariano Linarte, a priest from Tacuba, swore under oath that he had known Doña Margarita for fifteen years. Although he did not know her parents, he claimed he had knowledge that they were "españoles limpios de todo mala raza" (Spaniards clean of bad lineage, meaning without stain of Black African, Moorish, or Jewish blood). Further, according to what he had heard from two people, a brother of Margarita's father held the noble rank of Caballero Cruzado, a title that would have required an official certification of purity of Spanish blood, known as *limpieza de sangre*. Finally, Linarte stated that Doña Margarita was "tenida y reputada públicamente [*sic*] por tal Española" (considered and reputed publicly to be a Spaniard). Having communicated with her on several occasions, Linarte found her to be a woman of "circunstancias y de juicio manifestando su buen nacimento"

(circumstances and judgment manifesting her good birth). He concluded that he had never heard or known of anything to the contrary.[3]

In the next, very brief affidavit, a Maestro Juan Jose Pina y Auñon, a priest from the San Pablo parish, stated that he had known Doña Margarita for fourteen years and had always considered her to be a Spaniard; however, not having known her parents or her ancestors, he declined to say more.[4] A third priest, Mariano Aponte, stated that he had known Don Ramon Bivian for twenty years and Doña Margarita for four years. Repeating the first priest's words, Aponte stated that he knew her to be a Spaniard "limpia de toda mala raza, tenida y reputada por tal." He testified that her mother was a criolla, a Spanish woman born in New Spain, and her father was a *gachupín*, a derogatory term for a Spaniard born in Spain.[5] They were considered Spaniards, and "lo manifestaban en sus personas y circunstancias" (they demonstrated it in their persons and circumstances). Finally, Aponte concluded that he had not heard or known of any fact to the contrary.[6]

The next witness statement is that of Petra Pozos, a free Black woman of about seventy years of age, born and living in Mexico City, and the widow of Domingo Gorospe. Petra testified that she had known Doña Margarita de Agrestas since she was a little girl because, as a baby, Margarita had been entrusted to her care, and as an adult, Petra had accompanied the young Doña to her husband's house. She stated the Doña Margarita's father was a gachupín; that both parents were Spaniards, "tenidos y reputados como tales"; and that Petra had never heard or known of anything to the contrary. Petra Pozos was unable to sign her deposition because she could not write.[7]

Finally, on 16 September 1789, after a review of the testimony presented, the court adjudged that it had been proved sufficiently that Doña Margarita was "de calidad española, hija de padres españoles, conocidos notoriamente por tales" (of the status or quality of Spaniard, daughter of Spaniards, well known as such). It was then ordered that the priest of San Miguel parish remove the name of Doña Margarita Castañeda from the libro de castas, where it was mistakenly recorded, and inscribe her name into the libro de españoles.[8]

At first reading, the facts of the case point to a simple incident of mistaken identity or, perhaps, a scribe's error. Whatever the cause of the alleged recording error, however, the court had to adjudicate whether

Doña Margarita was a Spaniard, not of mixed blood, and thus whether she had the right to have her name placed in the libro de españoles. Closer analysis of the processing and resolution of the case highlights critical issues about the formulation and functioning of what has been designated as "race" in late-colonial Mexico. Such analysis also leads to a broader theoretical exploration of the functioning of eighteenth-century colonialism.

It is Don Bivian who brings this case. Although details about Don Christobal Ramon Bivian are not given, it is likely that he was—or was considered to be—a Spaniard because by eighteenth-century law, the titles "*don*" and "*doña*" could only be used by pureblooded Spaniards, criollos, and Indian nobles.[9] Certifying a wife's baptismal status would not have been critical to a Spanish male in order to maintain his public social status unless a problematic association were made public. By the late eighteenth century in New Spain, however, baptismal records were of critical importance for offspring because parents' and grandparents' baptismal documents were required to prove one's ancestry in order to be admitted to universities, professions, certain guilds, and noble orders; to avoid paying tribute (required from Indians and mulattos, those of mixed Spanish and Black African blood) or imprisonment for debt; and, of course, to prove a right as legal heir.[10] Don Bivian may have had concern for his children's futures.

Notably missing from the proceedings is a copy of or any reference to the specific contents of the Doña's baptismal certificate, which should have stated the names of her parents and their designations as Spaniards and/or criollos. Also, although central to the proceedings, Doña Margarita herself is noticeably absent. She is not mentioned as being present at the hearing, nor does she provide any sworn statements. This is not necessarily unusual given the limited legal status of elite women and the fact that such women were generally prohibited from appearing in most public places. But more to the point, the Doña did not need to be present because this case is not about the physical person of Doña Margarita; rather, it is about how this woman's public social body was assessed, classified, and inscribed within a hierarchy of social meanings and values.

Because there were no other written records—such as the Doña's parents' or grandparents' baptismal documents—presented to the court to justify her claim of pure blood, evidence in this case took the form of

sworn statements from individuals who knew the Doña. Witnesses confirmed repeatedly and consistently that proof of her status as a Spaniard was based on their continual personal readings of her social body through assessment of Doña Margarita's *person, judgment, and circumstances*. Their statements indicate that Spaniard identity was not fixed or defined by a specific or definitive set of physical characteristics. This is evident from the fact that not one of the four witnesses cited explicit physical traits such as skin color or hair texture to verify that Doña Margarita was a Spaniard. Instead, each witness certified to the court that he or she discerned Doña Margarita to be Spaniard because she presented herself and acted in ways that *demonstrated* or signified Spanish-ness. These may have included wearing certain types of clothing and jewelry restricted by law to Spaniard use. The witnesses were also aware of the urban spaces she inhabited: the house in which she lived would have been in an area of the city and of a kind associated with Spaniards. Most importantly, Doña Margarita would have been observed with other Spaniards in church and elite gathering places and accompanied by her husband or servant in city streets, public gardens, or the marketplace. The Doña would never have been seen in certain public spaces—such as Mexico's bars, public baths, dance halls, or even the legal courts—where mixed-blooded people were found regularly.

Finally, as Linarte pointed out, direct communication with the Doña indicated that she was of "good judgment," that is, she likely spoke in a decorous and modest manner expected of Spanish women, and her spoken Spanish was not flawed with Indian or plebeian accent or grammatical errors. Through such diagnostic inspection, the witnesses recalled and certified that Doña Margarita did not have any associations that would signify her as a person of mixed blood. Witnesses relied on their observations of her appearance or person and the places or circumstances she inhabited. Indeed, they were reading her social body through a diagnostic system that identified certain visual and aural characteristics associated with Spaniard identity and differentiated it from non-Spaniard identity.

These diagnostic evaluations of Doña Margarita's social body and the social spaces it occupied structured the sworn statements. In the resolution of the case, this subjective evidence is used to substantiate what, at first, appears to be an odd final judgment: the court certified Doña Margarita's

calidad as a Spaniard, not her race. The word "calidad" appears in numerous eighteenth-century documents, from works of fiction to legal documents such as royal decrees and edicts. In these documents, rather than being named as separate races, late-colonial people are more often identified as being of separate *razas*, or lineages, which are demarcated by specific calidades. Translatable into English as "quality" or "status," the identification of "calidad" is more precisely understood as the differentiating, defining, and ordering of the diverse people who inhabited New Spain by kind or type. Calidad represented one's social body as a whole, which included references to skin color but also often encompassed, more importantly, occupation, wealth, purity of blood, honor, integrity, and place of origin.[11] Thus, being of the calidad of mulatto was not solely associated with darker skin or other physical characteristics; it also aligned a person to certain diagnostics, such as debased social and moral traits. Likewise, the calidad of Spaniard was manifested not by light skin color alone but also by a certain lineage and concomitant social and moral attributes.

Critical in this case is the fact that, because her name was written in the wrong book, Doña Margarita's identity was not just erroneous but confused. The mistake was even potentially undermining to social alignment because it was feasible that she could be "passing," that is, be a person of mixed, impure blood—a casta—with a Spaniard's traits. The court's order to erase Doña Margarita's name from the libro de castas and write it in the libro de españoles not only corrected a recording error; in certifying Doña Margarita's social body as being of Spaniard calidad, the court both utilized and reaffirmed a diagnostic system that oversaw, affirmed, and maintained the social alignment and order of late-eighteenth-century New Spain.

CALIDAD: A DIAGNOSTIC DISCOURSE ON THE BODY

The processing and resolution of the Doña's case around the notion of calidad opens the door to a broader discussion of the derivation of calidad and its manifestation as part of a comprehensive late-colonial discourse of—and fascination with—the body.[12] The notion of calidad and its functioning in late-colonial Mexico has received uneven and inconclusive study from scholars of New Spain.[13] Scholarly research, however, in the

fields of art history, history, and literature has begun to reveal how fundamental the trope of the "body" was in the thinking of seventeenth- and eighteenth-century Spain and New Spain. For example, scholars have shown that various parts of the human body were assigned to different classes of people and professions.[14] Further, in his recent dissertation study of the visualization of viceregal power, Alejandro Cañeque, a historian of seventeenth-century New Spain, has argued convincingly that the metaphor of the body is critical for understanding the political discourse of much of the history of New Spain. In particular, this corporeal trope is important in tracing the evolution of the early modern concept of the nation-state, which, as an essential concept that unifies and gives cohesion to a political community, did not enter the political imagination of Spain before, if not 1900, at least 1800.[15] After a careful analysis of the rights, perquisites, and prerogatives of certain social estates of New Spain—such as the guilds, nobles, plebeians, et cetera—Cañeque writes,

> Early modern society was populated by "imaginary persons" . . . such as the estates or corporations of diverse rank. . . . *The "individual" as an "indivisible" person, as a unitary subject of rights, was nonexistent.* This way of conceiving the political community had one fundamental implication: *the multiplicity of estados (estates) and the absence of individuals made the existence of the Estado (state) as the only depository of the subjects' loyalties impossible.* (Italics mine)[16]

That is, in terms of the formation of the colonial political structure of New Spain, the "logic of the Spanish monarchy was not one of centralization and uniformity but of a loose association of all its territories [and bodies], a logic very different from that of the centralized sovereign nation-state."[17]

As a result, colonial power was dispersed into an array of relatively auto-nomous centers, whose unity was maintained, more symbolically than in an effective way, by reference to a single head. Using sixteenth- and seventeenth-century political treatises and other primary documents, Cañeque asserts that

> This dispersion corresponded to the dispersion and relative auto-nomy of the vital functions and organs of the human body, which . . . served as the model for social and political organization. This vision made impossible the existence of a completely centralized political

government— a society in which all power was concentrated in the sovereign would be as monstrous as a body which consisted only of a head. The function of the head of the body politic, that is, the king, was not, therefore, to destroy the autonomy of each of its members but to represent, on the one hand, the unity of the body politic and, on the other, to maintain harmony among all its members.[18]

Cañeque suggests that recurring visual public spectacles—processions and official events—asserted and affirmed the trope of the body as central to the political practices of New Spain. For example, in Mexico City, the 1666 funeral procession marking King Philip IV's death was organized to demonstrate that the community was a harmonious and hierarchized body. The procession began with the Black and mulatto confraternities, followed by the Indian and Spanish confraternities. After these groups came the Spanish elites who were members of colleges and seminaries, the religious orders, the clergy, and the ecclesiastical chapter. Then came the royal tribunals, followed by the royal insignias of the scepter, sword, and crown, and various important officials. Finally, the viceroy appeared with the senior judge at his right. This ordering of the procession showed that the plebeians' role was not to rule the community; in the language of the period, they were not its head but its feet. This is to say, "the physical space they occupied in the procession meant the position they occupied in the political community: they were literally performing their place in the body politic."[19]

In New Spain, Cañeque concludes, the Spanish monarchy, rather than attempting to impose a colonial-state idea of kingship like those found in the nineteenth century, relied on the view of the political community as a political body, a corporation. New Spain was not conceived of as a totally subordinate, satellite territory tethered to a political center; rather, it was considered a kingdom, based in the metaphor of the human body, constituted of disparate, independent yet intradependent members with a common head—the king/viceroy. Clearly evident in the seventeenth century, the trope of the body would slowly shift through the eighteenth century under Bourbon tutelage.

I believe that the concept of calidad, which appeared in numerous documents of eighteenth-century New Spain and was formulated and contextualized in the trope of the body, may have derived from two

different Spanish/European debates. The first was physiognomics, a phenomenon well outlined in *Embodying Enlightenment* by Rebecca Haidt, a scholar of eighteenth-century Spanish literature. Haidt has explained how "the body" functioned as one of the most basic tropes in eighteenth-century European cultures and how the outward appearance of the human body was perceived as "discursive, a telltale transcript of the identity it housed."[20] She argues that in late-seventeenth- and early-eighteenth-century Spain, numerous Enlightenment discussions by writers like the influential intellectual Benito Feijoo (1676–1764), who was also admired in contemporary New Spain, structured ideas around expanding scientific knowledge of the human body. In part, they focused on renovating the nomenclature of human anatomy. These discussions, however, became intertwined with physiognomics, a concept traced to Greek and Roman texts, a technique that diagnosed a person's interior disposition or character though a visual examination of the body's external appearances.[21] Using physiognomic rationale and relying on a diagnostic gaze, these writers observed the body as being legible through assessment of "external bodily characteristics as a system of signs representing the invisible inner character. . . ."[22] Physiognomics did not reference specific persons but analyzed exterior human features and extrapolated the content of inner moral and ethical character.[23] In Spain this discourse on the body was used to promote better identification and maintenance of the king's subjects. In eighteenth-century New Spain, as is clear in Doña Margarita's case, the concept of calidad shared this diagnostic strategy and may be seen as reflecting physiognomic constructs.

In the Spanish Enlightenment, according to Haidt, physiognomy was specifically used to distinguish the *hombre de bien*, a virtuous gentleman, from the ignoble *petimetre*, or fop.[24] In New Spain, while the characters of the hombre de bien and petimetre are found in late-colonial literature, physiognomy in its form as calidad was an adaptation to a demographic phenomenon not encountered in Europe: miscegenation.[25]

In addressing miscegenation, a second discourse informing calidad was one combining pejorative notions about Black Africans, or any so-called nonwhite people, with the concept of raza, that is, lineage. As summarized by Elizabeth Kuznesof in her study of ethnicity in criollo society, it was unusual to find race as a coherent construct being treated anywhere in

Iberia as an indication of quality or inferiority prior to the voyages of discovery. Of greater concern was the distinction between Christians and non-Christians, who were identified as the Jews and Moors.

> The common Spanish idea of blood as a vehicle initially of religious faith and later as a mark of social condition is probably related to medieval physiological theory according to which the mother's blood fed the child in the womb and then, transformed into milk, fed the baby outside the womb as well. A child's substance was provided by the mother's blood. . . . The origin of the idea of purity of "clean blood" actually dates from the emergence of the issue of religious purity in the fifteenth century.[26]

"Raza" connoted generational association with Jews and Moors and was used in Spain as a means to legitimatize the discrimination and persecution of non-Christians and their descendants. In Spain and New Spain, the certification of limpieza de sangre, purity of blood, was required to obtain certain social and civil prerogatives. Kuznesof concludes that what began as an issue of religious purity was transformed into one of raza, or lineage.[27] Ann Twinam adds in her study *Public Lives, Private Secrets* that in Spain, extensive "purity of blood ordinances provided guidelines by which Spaniards could identify each other through shared obsession with Catholic orthodoxy."[28]

Twentieth-century notions of race are most closely associated with nineteenth-century nation building and colonization in association with scientific exploration.[29] Studies of eighteenth-century New Spanish culture often erroneously implicate nineteenth- and twentieth-century notions of race. In fact, eighteenth-century uses of what appear to be "race" constructs must be viewed in light of earlier and contemporary European thought and the specific cultural conditions found in New Spain.

As we have seen, in Spain purity of blood was an essential notion in differentiating and discriminating different kinds of people. In other parts of Europe in the 1500s, "race" was essentially a literary word denoting a class of persons or things. In the late 1600s, Europeans began to categorize humans on physical grounds when François Bernier, a French scientist, proposed four "Especes ou Races d'homme" — Europeans (including Persians and North Africans), Black Africans, Chinese, and Lapps — based on facial character and skin color. Soon a hierarchy of these groups came

to be accepted, with the White European at the top. The Black African was usually relegated to the bottom of this hierarchy because of skin color and primitive cultures.[30] Discussions of race that are separate from the concept of lineage actually occur in the latter part of the eighteenth century. Immanuel Kant is thought to have first used the term "race" in the sense of biologically or physically distinct categories of human beings in 1764. His writings promoted the idea of an unchanging inner essence within human beings that became attached to the meaning of race.[31]

In Spain, a discussion of notions of "race" is found in the 1739 intellectual treatise *Color etiópico* (Ethiopian color) by Benito Feijoo. Feijoo attempted to probe the question of whether African pigmentation was caused purely by heredity, meaning a separate and distinct genealogy, or by the cumulative effects of environment.[32] He began his examination with a point-by-point refutation of older theories about African dark skin as a kind of malediction. Specifically, he contradicted certain explanations of blackness that were based on biblical references stating that the Black race stemmed from Cush, a son of Cain and grandson of Noah, and claiming that black skin was settled on Cush and his descendants through a curse uttered by Noah. A similar explication stated that blackness was God's curse on Cain for slaying Abel.[33]

Feijoo further argued against the psychological causes for African skin. It would seem that previous writers had argued that the mother of the first Ethiopian had been struck forcibly during pregnancy by some black object and, thus, negritude became fixed and extended to succeeding generations. A variation on this explanation was the theory that some women in the distant past were so stricken by the sight of their husbands' bodies covered with black paint that their successive progeny took on the black color. Yet another extant explanation seems to have focused on seventeenth-century physiological theories that claimed that the bile and vitriolic fluids that coursed through the veins of Ethiopians caused their skin pigmentation. In contrast, Feijoo ascertained that the climate or country inhabited by Africans influenced skin pigmentation. More specifically, he explained, the air and soil caused the dark skin of Black Africans.[34]

Clearly, the previous explanations of African pigmentation referred to and critiqued by Feijoo were tied to derogatory interpretations of black skin. Feijoo's references indicate that in Spain in the early part of the

eighteenth century, black skin was associated with the evil of Cain; with a pejorative assessment of the weakened content and ability of the African female mind; and/or with the problems of Black African physiology.

It would be later Enlightenment writers who further developed these pejorative explications of black skin and argued for separateness of races based on biology, not nature.[35] In Europe, by the end of the century, a discourse on black skin that had begun as a series of explanations for the pigmentation of African people shifted to denying these people, because of their skin pigmentation, participation in the progressive Enlightenment ideals of self-governance and nation building. This discourse summarily correlated the causes of African pigmentation with a loss of the capacity for compliance to natural law or accepted morals. These eighteenth-century discussions of black skin transformed the physiological explanations for the skin of Black Africans into a pejorative discourse on the debased social meaning and moral content of people with dark skin color.

We have seen, then, that in eighteenth-century Europe, discussions of black skin shifted through time, were multi-layered, and overlapped older references. While we know that Feijoo was read in New Spain in the eighteenth century, the transference to the colony of these discussions of skin pigmentation and its associations is difficult to trace precisely. Permutations of these discourses of physiognomics, raza (lineage), and derogatory notions of a black race did function in late-colonial Mexico. The Spanish association of raza with purity of blood and blood lineage was adapted to fit the specific circumstances of the conquest. In Mexico, the Spaniards found themselves in the minority among the Aztec-Mexica, who had achieved a certain degree of social complexity. They acknowledged the existence of social and political hierarchy among the indigenous people and recognized the *caciques*, Indian nobles, as having civil and social rights and privileges. In fact, following the logic of raza, Spaniards believed that Indian blood was not blemished by infidel blood and, thus, was essentially a pure blood. Concomitantly, unions between Spanish men and Indian women that produced mestizo offspring resulted in diluted but not polluted blood. Further, by the seventeenth century, it was thought that the union of a mestizo and a Spaniard resulted in *castizo* offspring and, ultimately, by the third generation, the offspring of a castizo and a Spaniard returned to Spanish calidad, meaning pure Spanish blood.[36]

This would not be the case for the mixing of Spanish or Indian blood with that of Black Africans. Africans were brought to the Americas as laborers and servants. This African population increased and began to interact with the Indian and Spanish populations. As individuals of African descent reached *pardo* (free Black) status, they began to participate in the general economy of New Spain as artisans, market people, et cetera. The Spanish crown saw a need to control African presence in the Americas. Various laws were passed disqualifying Black Africans from military service, guilds, and certain quarters of Mexico City. One sumptuary law stated that Black Africans and mulattos could not wear gold, silk, lace, or pearls.[37] More importantly, throughout the eighteenth century and into the nineteenth century, the Crown forbade Indian and Spanish nobles from marrying Black Africans and mixed-blooded persons.[38]

The reason for this disqualification and control of black-skinned people was quite simple. Criollos and Spaniards of New Spain were confronted with a problem not faced as extensively by their European counterparts: miscegenation, that is, the possibility that the purity of Spanish blood—and to a certain extent, Indian blood—would be permanently corrupted by admixtures with African blood. In 1774, Pedro Alonso O'Crouley, a wealthy Spanish merchant from Cádiz, summarized this concern in his book *Idea compendiosa del reyno de Nueva España* (A description of the kingdom of New Spain); his writing is also indicative of thinking on raza at the beginning of the last quarter of the eighteenth century.[39] He wrote that the offspring resulting from a Spaniard and a "Negro" was a mulatto, and this "*mulato* can never leave his condition of mixed blood, . . . [because] it is the *Spanish element that is lost and absorbed* into the condition of a Negro . . ." (italics mine).[40] Further, it would seem that not only did this inferior African blood overwhelm the Spanish element but its stain was permanent. O'Crouley elaborates:

> It only remains to say a last word on the mixture with the Negro, in whatever degree it may be. To those contaminated with the Negro strain we may give, over all, the name *mulatos*, without specifying the degree or the distance direct or indirect from the Negro root or stock, since, as we have clearly seen, it colors with such efficacy . . . [that] even the *most effective chemistry cannot purify.* (Italics mine)[41]

This is to say that Black African blood, unlike Indian blood, would permanently imprint and adulterate not only the chemistry but the social meanings of pure Spanish (or Indian) blood. In New Spain, therefore, the various discourses on the causes of African pigmentation and its associated negative social meaning were entangled and overlapped with imported Spanish discourses on pollution of non-Christian blood, particularly as the mixed-blooded population propagated and increased in urban New Spain. Late Enlightenment ideas associated with citizenship and nation building were not as evident in New Spain as they were in late-eighteenth-century Europe.

Importantly, O'Crouley also pointed out a significant corollary problem; he noted that "Many pass as Spaniards who in their own hearts know that they are *mulatos.* . . ."[42] It was then possible that there were people who were accepted as Spaniards but were really mulattos or of other mixed blood. Miscegenation and the practice of "passing as a Spaniard" were serious threats to the maintenance and alignment of the social order and required constant management and surveillance. Thus, physiognomics was the perfect diagnostic system to deal with the threat of passing, and as a result, diagnosis of one's calidad came into play as a visual and aural means of assessment of physical traits as indicators of moral character.

Returning to Doña Margarita's case, the context of Don Bivian's consternation and disquiet is evident. When Aponte, the priest, identified Margarita as "limpia de mala raza," he certified that she did not have the stain of infidel blood. However, when the court judged her to be of the "calidad de espanol," Doña Margarita was also being evaluated as to mixture with Black African and/or Indian blood. Because her name was written in the wrong book, Doña Margarita's social body was thrown into a complex discourse that derived from extended Spanish encounters with infidels and early Enlightenment ideas about the people of Africa that had been implanted in the unique context of miscegenation in New Spain.[43]

In the eighteenth century, calidad was the construct through which this complex web of discourses on physical associations and assessment manifested itself like a palimpsest. As a discourse of raza, or lineage, and not of "race," calidad sometimes displayed its historical derivations and, at other times, its physiognomic associations. Use of the construct of calidad

became part of eighteenth-century legal, social, and—as I shall discuss in the next chapters—visual practices that assessed and negotiated the protean physical, social, and moral qualities of a proliferating mixed-blooded people.

CALIDAD'S DEVICES:
MIMICRY, AMBIGUITY, AND HYBRIDITY

In fact, the Doña's case traces a broad territory of the differentiation and alignment of kinds of people of New Spain in terms of the social and moral estates they represented. Calidad leads us to certain theoretical perspectives with which to analyze this case further. Historical reconstructions of intellectual structures are always hypothetical and cannot be seen as definitive; rather, they are a means to come to a closer understanding of specified phenomena. It is clear that calidad in the culture of eighteenth-century New Spain has not been well understood and, as a construct, may offer some helpful guides to rethinking the obfuscating labels of "race" and "racism" that permeate the scholarly literature on colonial New Spain. As part of a broader discourse on the body, calidad was utilized in the specific practices of eighteenth-century colonialism in New Spain.

The study of colonialism has been conceived as an academic inquiry into the history of the domination of the cultures of Africa, Asia, and the Americas by European political entities. In the last thirty years, scholars have sought to uncover colonialism's general operating mechanisms. The theoretical works of Michel Foucault (1972, 1979) and Edward Said (1978, 1993) shifted scholarly thinking away from colonialism as a static, period-based fixture in the chronology of Western history toward a concept of colonialism as a dynamic mechanism used by the West for constructing its history. Described as a redefining of normative oppositions and boundaries, colonialism uses a constantly transformative mode to elude any fixed or static operation; and, most importantly, it shifts to fit the particular situation. The idea of colonial discourse may be summarized "as a complex of signs and practices that organize social existence and social reproduction within colonial relationships."[44]

Subsequent critics and followers of the writings of Said and Foucault corrected, refined, and expanded their insights. In the introduction to his book *After Colonialism*, Gyan Prakash comprehensively summarizes mid-

1990s revisionist views on colonialism. While for the most part referring to nineteenth-century colonial circumstances, his broad concepts are provocative in relation to eighteenth-century New Spain. Prakash writes:

> Modern colonialism, it is now widely recognized, instituted enduring hierarchies of subjects and knowledges—the colonizer and the colonized, the Occidental and the Oriental, the civilized and the primitive, the scientific and the superstitious, the developed and the underdeveloped. The scholarship in different disciplines has made us all too aware that such dichotomies reduced complex differences and interactions to the binary (self/other) logic of colonial power. But if the colonial rulers enacted their authority by constituting the "native" as their inverse image, then surely *the "native" exercised a pressure on the identification of the colonizer.* . . . Compelled to mix with, work upon, and express their authority in repressed knowledges and subjects, the colonial categories were never instituted without dislocation and transformation. . . . [The] artful lie of colonialism emerges as its alienated and artless truth: The paradoxes reveal a fundamental instability and division in the functioning of colonial power. (Italics mine)[15]

Concordant with this thinking, Alejandro's Cañeque's research, discussed above, indicates that colonialism in New Spain was not an inflexible or static metropole/margin relationship. Colonialism in New Spain, then, was not just a matter of historically identified colonizers and colonized, Spaniards and castas. Instead, of greater importance is the fact that the epistemological identity of Spaniards, whether *peninsulares*—European-born Spaniards—or criollos, was interlocked with the created, imagined identity of non-Spaniards (Indians, Black Africans, or castas) and their traits and characteristics. The Spaniard's positive self-definition as pureblooded, et cetera, was constructed in tandem with perceived negative traits of the Indians, Black Africans, or castas, that is, those of impure/mixed blood. Thus, the identities of both Spaniard and casta were constructed within this positive/negative complex of signs and practices and were inseparable, entangled, and unstable identities. In concrete terms for our study, the libro de españoles and the libro de castas, so critical to Doña Margarita's case, locate the existence of such a system of positive and negative values and meanings: stated simply, one book could not exist without the other.

The writing, erasure, and rewriting of Margarita's name in these books indicate the presence of certain dynamic mechanisms of colonialism suggested in the work of Homi Bhabha in *The Location of Culture*. In his exploration of the impact of nineteenth- and twentieth-century colonialism, Bhabha distinguishes mimicry, ambivalence, and hybridity as broad, critical internal devices and markers of all colonial discourses. In colonial terms, the notion of mimicry asserts that "when colonial discourse encourages the colonized subject to 'mimic' . . . the colonizer's cultural habits, assumptions, institutions and values," the result can only be an imitation. This imperfect duplicate is menacing because "mimicry is never very far from mockery, since it can appear to parody whatever it mimics. Mimicry therefore locates a fissure in the certainty of colonial dominance, an uncertainty in its control of the behavior of the colonized."[46] Further, Bhabha states that, as a potent strategy of colonial power and knowledge,

> colonial mimicry is the desire for a reformed, recognizable Other, *as a subject of a difference that is almost the same, but not quite. . . .* Mimicry is . . . a complex strategy of reform, regulation and discipline which 'appropriates' the Other as its visualized power.[47]

Bhabha concludes that mimicry is at once resemblance and menace. In other words, within colonial contexts, there is an intense desire and drive to make the colonized appear, act, and be like the colonizer. But if the colonized, or in our case, castas, are exactly like the colonizer, that is, Spaniards, how can the ordering hierarchy be maintained?

It cannot. Therefore, colonial ambivalence comes into play. Mimicry, a flaw in the logic of colonialism, leads to ambivalence, which marks the inherent conflictive economy of colonial discourse in general, and the unstable relationship between the colonizer and the colonized specifically. For Bhabha, the term "ambivalence," following the notion of "ambi-valent" (two-powered), describes the shifting relationship between mimicry and mockery, and ambivalence is undermining of colonial dominance.[48] Most importantly in Bhabha's theory, however, ambivalence disrupts the clear-cut authority of colonial discourse because it disturbs the simple, binary relationship between colonizer and colonized. The ambivalence of colonialism causes unsettling consternation for the colonizer and forces into action complex modes of maintenance of the colonized's subjected position.[49]

For Bhabha, the notion of hybridity extends the concept of ambivalence and stresses the interdependence and mutual construction of the colonizer/colonized binary. He posits that all cultural statements are fabricated in a hybrid space, and thus, cultural identity always emerges in this contradictory and ambivalent space.[50] It is in this space where the interlocking of colonized/colonizer, Spaniard/casta identities occurs; or, as Bhabha states, "It is not the colonialist Self or the colonized Other, but the disturbing distance in-between that constitutes the figure of colonial otherness. . . ."[51] While Bhabha uses hybridity as a counterposition to what he considers the simplistic ideas of late-twentieth-century multiculturalism and cultural diversity, in the context of the present colonial study, his formulation of hybridity supports my contention that in New Spain, colonial identity never comes singularly from a Spaniard's or a casta's viewpoint, but must necessarily be a heterogeneous, conflicted amalgam.

In this study, I argue that manifestations of New Spanish colonialism in literature and visual culture are found in this in-between locale of hybridity. Bhabha additionally posits that "colonial discourse produces the colonized as a social reality which is at once an 'other' and, yet, entirely knowable and visible. . . . [This discourse] employs a system of representation, a regime of truth, that is structurally similar to realism."[52] Here Bhabha concludes that even though the colonized—in our case, castas—is an imagined entity, its physical and moral characteristics can be essentialized and made to seem real in literary and visual practices. As seen above, and throughout his theoretical writings, Bhabha constantly makes reference to the visual aspects of colonial discourse by citing its use of "ocular metaphors" and the "structured gaze of power" whose objective is authority—appropriation of the Other, as control over seeing confers power to the viewer. He forcefully argues that colonial discourse is most consistently deployed through surveillance and the gaze of the colonizer towards colonial bodies.[53] This discussion expands upon Michel Foucault's notion of the panopticon, a surveillance technique of eighteenth-century prisons, which results in a "faceless gaze" that transforms "the whole social body into a field of perception."[54] Bhabha emphasizes that omnipresent surveillance is a colonial practice that makes all visible while keeping the observer invisible.[55]

In colonial visual discourse, the gaze is a visual totality, that single, central vantage point from which surveillance or looking occurs. The

colonial gaze and its mechanism of surveillance are strategies for differentiation and dominance, that is, strategies to overcome ambiguity and locate hybridity. In the teetering equation that is colonialism, the Other must constantly be under surveillance, watched for any shifts in behaviors, appearances, and movements.

Bhabha's concepts are much debated, but nevertheless, they offer potential analytical tools to better understand the nature of colonialism in eighteenth-century New Spain. In particular, they can help us better understand calidad, not only as a construct that evolved from European ideas of blood and raza (lineage), but as an inherently ambiguous term that confirms the existence and workings of mimicry and hybridity within the expanding and shifting population of eighteenth-century Mexico City. Without a doubt, throughout the text of the case I have cited, Doña Margarita's social body is described from a field of perception and surveillance, the gaze. Issues of ambiguity, mimicry, and hybridity mark Doña Margarita's case. The insistent reference to calidad indicates an attempt to resolve the mimicry resulting from proliferating hybridity and miscegenation in New Spain. Whatever the cause of the alleged recording error, the processing and resolution of this case reveals the contingency of late-colonial identity. By fundamentally addressing the question "Is Doña Margarita a real Spaniard, or is she a casta mimicking a Spaniard?" the petition brings to light a critical question of Mexico's late-colonial period: How is that space between Spaniard and casta narrated? This is particularly clear when we consider that all the testimony hinges on the issue of mimicry: the court notary essentially asked each witness, "How closely does Doña Margarita correspond to the semblance of a Spaniard?" The witnesses, utilizing colonialism's best disciplining mechanism— surveillance (aural and visual)—certified to their visual and auditory observation of her "appearance, character, and circumstances" and assured the court that Doña Margarita was a true Spaniard and not mimicking one.

Thus, Doña Margarita's identity, by appearance, judgment, and circumstances, was inextricably linked to that of castas because she was only defined as a Spaniard when she was shown *not* to have characteristics associated with mixed-blooded people. In an effort to shore up this ambiguity in her Spanish identity and the instability of New Spain's lineage categories, Don Bivian's solicitation to correct a simple error requested colonial authority to distinguish truth from lie, real from fake. It

produced witnesses who were aware of the problems of mimicry and hybridity, and it asked the court to exercise its power to evaluate and categorize and thus overcome ambiguity. Understanding eighteenth-century colonialism to be a form of unending redefining and renegotiation of oppositions and boundaries, Don Bivian's petition locates a most problematic space: that hybrid, in-between space where the interlocking of colonizer/colonized—and in this case, Spaniard/not-Spaniard—social identity occurred. Again, the libro de españoles could only exist in reciprocal relationship to the libro de castas.

I close with the final, and remarkable, episode of Doña Margarita's case. Likely unknown to Don Bivian and the Doña, the court became curious as to why the priest, Mariano Aponte, named Doña Maria Antonetta, Margarita's father's wife, as Margarita's mother, while Petra Pozos named a certain Doña Mariana Ligueredo as the Doña's mother. Immediately prior to the court's 16 September 1789 resolution to the case, the notary scribbled a quick note stating that he has been directed verbally by the court to look into this discrepancy. The results of his investigation appear in the penultimate, and obscurely written, document of the court record, under the title "Certification puesto por separado" (A separate certification). As it turns out, Doña Margarita's birth parents were Don Miguel de Agestas and Doña Mariana Ligueredo, a Spanish woman married to an unnamed *alcalde* (official), who was enigmatically noted as "absent." It seems that, as the resulting offspring, Margarita was given over to Petra Pozos's care and brought to her father's house to be raised.[56] Instances of private pregnancies—those that were hidden from public view, and the offspring of which were removed from the mother's immediate care to avoid dishonor to her or her family's reputation—were not uncommon among New Spanish elites.[57] Along with these surprising facts, the document states that in order not to stain (*deslucir*) the honor of Doña Margarita or Doña Mariana Ligueredo, their names had not been mentioned previously by verbal order of the vicar-general.[58] This information did not affect the conclusion to Don Bivian's request.

 In eighteenth-century New Spain, Doña Margarita's natal status (referring to the marital status of her mother and father) would have been that of an *adulterina*, the offspring of adulterers, a status that would have affected her inheritance rights.[59] The circumstances of her birth may explain why her actual birth certificate was never brought in as evidence.

Given her birth mother's identity as a Spaniard, however, Doña Margarita's natal status did not detract from her blood purity or raza (lineage), although it could have stained her honor if it had been made public.[60] This final disclosure reveals the multileveled, complex, and often convoluted situations of lives and identities in late-colonial Mexico.[61] Transferring the Doña's name from one book to the other, then, did not assure any historical or even personal truth; it only certified the perceived social hierarchy of late-eighteenth-century Mexico.

The multilayered construct of calidad and the associated mechanisms of mimicry, ambiguity, and hybridity appeared across various material manifestations of late-colonial culture, in particular the visual practices. For this study, the visual priorities of colonialism in the form of the gaze and surveillance, which we have traced through the analysis of Doña Margarita's case, are critical perspectives because the visual practices under consideration here are not just matters of descriptive, narrative representation of the Other or its corollary, raza. Rather, the visualization and surveillance of non-Spaniards indicate that those who perceived themselves to be Spaniards needed to look, see, gaze at, and observe Black Africans, Indians, and castas as part of a comprehensive attempt to know, manage, and dominate them. At the same time, as seen in the epilogue to Doña Margarita's case, identity was (and is) never about truth.

Doña Margarita's story and the visual practices I shall analyze are embedded in the complex social and historical situation of metropolitan New Spain. The next chapter will review the demographic and social conditions of eighteenth-century Mexico City.

The Faces and Bodies of Eighteenth-Century Metropolitan Mexico

An Overview of Social Context

DOÑA SEBASTIANA INÉS JOSEFA DE SAN AGUSTÍN, a noble Indian woman, and Doña María de la Luz Padilla y Cervantes, an elite Spanish woman, were contemporaries in eighteenth-century New Spain. While the details of the lives of these women are not known, we do know what each looked like. In figure 2.1, we see the portrait of Doña Sebastiana, painted in 1757 by an unknown artist, and in figure 2.2, the

Figure 2.1. Unknown. *Retrato de Doña Sebastiana Inés Josefa de San Agustín.* 1757. Oil. 58.2 x 47.7 cm. Museo Franz Mayer, Mexico City.

Figure 2.2.
Miguel Cabrera.
*Doña María
de la Luz Padilla
y Cervantes.*
c. 1775–1760. Oil.
109.4 x 84 cm.
Brooklyn
Museum of Art,
Brooklyn, N.Y.

image of Doña María, painted by Miguel Cabrera, a prolific artist, well
known for his religious and portrait painting between 1755 and 1760. Both
artists employ a conventional visual vocabulary of portraiture to represent
the privileged status of these young women.[1] Neither is shown in full
length: Doña Sebastiana is presented in half-view, while Doña María is in
two-thirds view. Both are compressed into shallow interior spaces, with a
reddish fabric draped left to right behind the figure and across the canvas,
forcing the figure to move to the frontal plane. Each young woman faces
the viewer with the right side of the body turned away slightly; the head is
turned in a three-quarter view with eyes looking slightly off to the right and
at the viewer.

Doña Sebastiana's elegant circular face frames her round, brown eyes and full lips. Her dark hair is pulled back into a zigzag-shaped, beaded hair decoration. The soft brown color of her skin glows with rose highlights. In contrast, Doña María's ovoid face is long and narrow with drooping eyes, a slender nose, and thin, pursed lips. Her gray-white powdered hair is pulled back into a ribbon that matches her dress, and resting on her head is a small white cap with an elaborate gold ornament attached to it. The soft, light beige pink color of her skin emphasizes her long neck and the upper chest. The black *chiquedoras,* or beauty marks, on her face are fashionable references to her prestige.[2]

While each woman holds small sprigs of flowers and a fan, their clothing is distinct. Doña María's European-style embroidered brocade dress has a green-and-yellow floral pattern on a white background. The tightly fitted bodice has three-quarter sleeves, which are completed by a double ruffle that ends at the wrists. The bodice is heavily embroidered across the upper chest area and decorated with yellow lace. Her skirt is very full, filling the lower section of the painting. Doña María's jewelry consists of rings inset with precious stones, a multistrand pearl bracelet on each wrist, and matching silver-and-gold earrings and necklace.

Doña Sebastiana wears a loose-fitting *huipil,* a traditional Indian garment made of oblong panels of woven cloth, often with geometric designs, sewn to form a rectangular shape with slits for the arms and head. Ribbon appears around the edges of the garment and likely covers its seams. The huipil has been elaborated with nontraditional decoration of lace and beadwork, possibly pearls, and jewels have been attached to the center of the bodice and the shoulder area, referencing the wearer's cacique, or noble Indian, status. Like Doña María, Doña Sebastina wears jeweled rings, pearl bracelets on each wrist, and a necklace-and-earring set.

Each image is inscribed with the sitter's name. A medallion to the left of Doña Sebastiana states, in Spanish, "Portrait of Sebastiana Inés Josefa de San Agustín legitimate daughter of Don Mathias Alexo Martínez and of Doña Thomasa de Dios y Mendiola. 16 years of age in the year 1757." Inscribed to the left of Doña Maria is "Doña María de la Luz Padilla y Cervantes," followed by the Latin words "Miguel Cabrera painted it."

Although they represent different sectors of elite colonial society, there is remarkable uniformity in the presentation of these two women. As in the

case of Doña Margarita Castañeda, the calidad of each elite woman is indexed to specific ideas about elite identity, which include the visual references of genteel bearing, the refined appearance of her clothing, and placement in a narrow, protected space.

Mauricia Josefa de Apelo, a contemporary of the three Doñas', was technically of the same Spanish bloodline as the Doñas Margarita and María. This woman, however, experienced her Spanish identity in a very different way than the Doñas did. This difference is evident in records showing that Mauricia Josefa was called to the Inquisition court in two separate proceedings: first between 1768 and 1773 and again between 1784 and 1785. In the Inquisition records, Mauricia is identified as the thirty-five-year-old unmarried daughter of Martín de Apelo, a Spaniard, and Phelesia Galizia, a castiza (meaning the offspring of a Spaniard and a mestiza). Mauricia was an inhabitant of Mexico City, born and raised in the Barrio de la Puente e Manianires, and was the servant of Francisco Azullar de Maianary, an artisan who made small statues of saints from iron and held the office of maker of handrails. Denunciations from her confessors claimed that Mauricia did not believe in certain articles of faith. After extended hearings and written depositions, the court determined that Mauricia had "disruptive spiritual diseases or illnesses" and ordered her to undergo certain curative penances.[3]

The primary issue of the case was the review of Mauricia's spiritual condition; however, asides in the tribunal records indicate that this woman was well acquainted with the system that defined Spaniard and non-Spaniard and their corollary, calidades. From one denunciation, we learn that Mauricia had stated to a confessor that a woman had explained to her that glory in the afterlife was only for priests, nuns, and Spaniards. *Chinos* (a term generally referring to people with Indian and Black African blood), Indians, Black Africans, and, in her words, all those of "color quebrado" (broken color), meaning castas, were not saved, no matter how virtuous. Mauricia further recounted that she was told that

> there are seven heavens and in all there is glory, but with this difference: that in the highest heaven, and most glorious, are the priests and nuns; in the next level are the Spaniards; in the third, others of inferior calidad whose glory is according to their color and calidad. Of course, the Indians and the Black Africans are in the last

heaven, and here there is not that much glory because the [heavenly] award does not conform to one's merit, but conforms to one's calidad.[4]

Her confessor attempted to correct the error of this creative redaction of the Church's dogma of heavenly reward, but the fact that Mauricia volunteered this detailed explanation—and seemed to accept it—indicates that she understood at some level the abstract entitlement implications of calidad. She also understood the concrete impact of inferior calidad. She complained to her confessor that certain supposedly Spanish ladies, who were also in the hospital where she took her curative penance, were allowed to use their parish priest, while Mauricia, not being recognized as a Spaniard, had to use the hospital chaplain.[5]

Because of her castiza/Spaniard descent, which gave her three-quarter Spanish blood, Mauricia should have been classified as a Spaniard. Apparently, Mauricia was neither accepted as a Spaniard in her daily existence nor recognized as such by the Inquisition court. Despite her confirmed parentage, Mauricia was designated inconsistently throughout the court documents: sometimes she was labeled a castiza; at other times, she was said to be a mestiza (of one Indian and one Spanish parent). Further, in an unusual digression, the court notary responded to Mauricia's own claim to be a Spaniard with the comment "it's doubtful."[6] This confusion about her blood category probably indicates that Mauricia's physical markers (skin color, hair texture) were not readily indexed. More likely, as an illiterate servant who lived in a non-elite area of Mexico City, her calidad was assessed and classified by her "judgment, appearance, and circumstance" and associated character—in other words, physiognomically. As in Doña Margarita Castañeda's case, issues of ambiguity and mimicry mark the court proceedings. Also similarly, intellectual, economic, and social markers located Mauricia's social designation—that of mestiza—and her associated calidad more readily than did her specific physical characteristics or her own self-identification. Mauricia Josefa de Apelo's case provides a glimpse into the lived experience of non-Spanish lives.

Just as elite individuals were pictured in portraits, people considered to be of mixed blood, like Mauricia, were visualized in the eighteenth-century secular art of New Spain in a painting genre known as *cuadros de castas*, or

casta paintings. These visually engaging paintings portray men, women, and their offspring classified in hierarchical order according to their proportion of Spanish blood. While a detailed and comprehensive analysis of this genre of painting will be undertaken in the next chapter, a brief discussion of two of these paintings will lead us into an overview of the historical and demographic contexts of Mauricia's and the Doñas' lives.

Miguel Cabrera, the artist of Doña María's portrait, executed one known set of paintings showing groupings of mixed-blooded people of New Spain.[7] While technically distinguished, Cabrera's sixteen-panel casta series follows a format established early in the eighteenth century. The fact

Figure 2.3.
Miguel Cabrera.
1. De Español,
y d India; Mestisa.
1763. Oil.
135.5 x 103.5 cm.
Private collection,
Mexico.

that Cabrera painted both elite portraits and images of non-elite castas allows us to analyze how an artist applied the prescriptions of each format in order to present his subjects' respective calidades.

Painted during the 1760s, close to the time of his portrait of Doña María, the first panel of the Cabrera series, entitled *1. De Español, y d India; Mestisa* (1. From a Spanish man and an Indian woman, a mestiza girl), shows a Spaniard and an Indian woman with their offspring, a mestiza (figure 2.3). Exercising his elite male prerogative to be seen in public spaces, a Spanish man, marked by his European-style clothing (complete with tri-corner hat and white wig), is placed in a unique and curious profile stance, with his head turned toward the Indian woman— whose calidad associates her with public spaces—and away from the viewer. His right hand holds the upper arm of the child, while his left, held up at chest level, opens toward the child's mother.

The non-elite status of the woman is made clear through the details of the picture. Instead of a confined interior space, she is located in an open market, in front of a stall where bolts of fabrics woven with traditional indigenous designs are stacked neatly on shelves. Her status as a vendor or buyer is not clear. The orange color of her costume, which is a mixture of traditional European and Indian clothing, highlights the sepia tones of the Indian woman's soft, light brown skin. Her dress is not the traditional huipil but a skirt with a fitted bodice. The lacy brocade skirt seen behind the apron, as well as the pearl necklace and earrings, are nontraditional. The folded cloth headpiece, the *rebozo*, or shawl, and the apron made of woven fabric are associated with traditional Indian clothing. She does not wear elaborate jewels like those of Doña Sebastiana and Doña María.

Finally, the little girl, who has the skin coloring of her mother, wears a European-style dress with an overskirt made of what looks like a woven fabric similar to those displayed on the shelf. The presence of the child serves as a sign of the miscegenation of Indian and Spanish lineage. Cabrera's portrayal of the child is rather neutral and contrasts with the negative commentary on the results of the mixing of Indian, Black African, and Spanish blood that is evident in the subsequent canvases of his series. For example, in figure 2.4, entitled *11. De Lobo, y de India; Albarasado* (11. From a lobo man and an Indian woman, an albarasado [white-spotted] boy), the artist depicts a *lobo* (literally "wolf," a name most often assigned to the offspring of a Black African and an Indian). Along with the lobo are

Figure 2.4.
Miguel Cabrera.
*11. De Lobo,
y de India;
Albarasado.*
1763. Oil.
135.5 x 103.5 cm.
Museo de
América,
Madrid.

an Indian woman and their resulting offspring, an *albarasado* boy. The lobo appears in ragged and torn clothing; he is probably an itinerant cobbler, as he is holding a basket of shoes and tools. He looks intently at the Indian woman, who is dressed in a huipil made of a simple striped material and a folded cloth headpiece. A burlaplike cloth used to carry a box is wrapped around her shoulders, and she holds a tray of fruit, probably indicating that she is a street vendor. The young boy, also in torn clothing, holds a basket of *zapotes*, a type of fruit, suggesting that perhaps he assists his mother. The family's diminished status is certified by their

impoverished circumstances as vendors walking the streets of Mexico City in tattered clothing. The portraits of Doña Sebastiana and Doña María along with Cabrera's two casta paintings visually parallel the perceived lived conditions of Doña Margarita's and Mauricia Josefa's lives as portrayed in the written documents.

While much of the eighteenth-century painting of New Spain takes up religious themes, in general the secular painting may be seen to display and reference a vast array of kinds of colonial bodies. These include political bodies, as seen in *Juan Vicente de Güemes Pacheco de Padilla, conde de Revillagigedo*, a portrait of the viceroy of New Spain from 1789 to 1794 (figure 2.5); elite social bodies, as seen in *Don Juan Xavier Gutiérrez Altamirano Velasco* (figure 2.6) and the image of Doña María; and

Figure 2.5. Attributed to Felipe Fabres. *Juan Vicente de Güemes Pacheco de Padilla, conde de Revillagigedo*. Late eighteenth century. Oil. 92 x 69 cm. Museo Nacional de Historia, Instituto Nacional de Antropología e Historia (INAH), Mexico.

Figure 2.6. Miguel Cabrera. *Don Juan Xavier Gutiérrez Altamirano Velasco*. c. 1752. Oil. 207.3 x 136 cm. Brooklyn Museum of Art, Brooklyn, N.Y.

caciques, or noble Indians, as seen in the image of Doña Sebastiana. Casta paintings, which appear only in eighteenth-century New Spain, emphasize non-elite social bodies like that of Mauricia.

Generally, scholars have treated such portraiture and casta paintings as distinct and unrelated genres of the secular art of colonial New Spain. In contrast, I believe that portraiture and casta paintings are closely related visual practices. Both are embedded in the broader discourse of the colonial body—specifically, of the kinds, categories, or calidades of social bodies that constituted the disparate political and social territory of late-colonial New Spain. The images must be seen as structured by a common set of ideas and beliefs about elite and non-elite status as contextualized in the lived experience of the people of late-colonial urban Mexico City. Put in another way, paralleling the reciprocal structure of the libro de españoles and the libro de castas, these elite portraits and casta paintings conceptually cross-reference each other and are inextricably bound to the specific colonial circumstance and discourses of late-eighteenth-century New Spain. In the following section, I present a brief overview of the historical and social setting of eighteenth-century Mexico. As we shall see, Spain's Bourbon dynasty established a perspective that would emphasize and promote ideals of order, orderliness, and productivity effected through law and management at a time when dramatic demographic growth in metropolitan eighteenth-century New Spain was causing greater social disorder.

PRESCRIBING AND DESCRIBING BOURBON ORDER

Spain's political and economic influence had expanded and risen to great heights during the first two centuries of the colonial period. By the late seventeenth century, however, Spain's fortunes as a European power were severely diminished. The ineffective rule of Charles II, the last Hapsburg king, who reigned from 1665–1700, had left Spain and its empire in an economic morass and political disarray exacerbated by military weakness. At his death, the Spanish throne passed to Philip of Anjou, a grandson of Louis XIV of France. Philip V (1700–1746) became the first Bourbon king of Spain.[8]

Numerous scholarly books and articles have been written about Bourbon Spain and its impact on New Spain.[9] There is general agreement

that, for the Bourbons, focused management became paramount in their reconstruction of the crumbling Hapsburg Empire. The first three Bourbon monarchs stabilized the Spanish economy and strengthened the military.

During the reign of Charles III (1759–1788), there was a move to restructure the viceroyalties. As a consequence, in 1765, José de Gálvez was sent to New Spain as inspector general. Gálvez undertook a five-year tour of the colony and compiled observations and data upon which he based strategic economic and political reforms. Shipping and commerce regulations were loosened, and the Bourbon government stimulated the economy by lowering some taxes, revising certain custom duties, and expanding the mining of silver.[10] Bourbon economic reform was extremely effective: at the beginning of the eighteenth century, New Spain provided the crown with about 2 million pesos a year; in the second half of the eighteenth century, New Spain became the most prosperous of Spanish kingdoms, annually providing 23.2 million pesos in the 1790s.[11]

Besides bringing economic stability and expansion, Gálvez also sought to restructure what he saw as a mismanaged and corrupt government in New Spain. To this end, Gálvez was successful in having an intendant system put in place in the late 1780s. In this system, New Spain was divided into twelve provinces, and some two hundred administrators were replaced with twelve intendant leaders and their assistants, whose broad responsibilities included improvement and maintenance of the judicial and economic administrations of their districts or intendancies.

The major benefits of these reforms were directed back to Spain. In New Spain, the economic wealth that resulted from Bourbon reform mostly benefited the peninsulares (European-born Spaniards, often derogatorily called gachupines) who came into the colony to take administrative positions, often replacing American-born Spaniards, or criollos. It is estimated that the number of highly paid intendant officials quadrupled. As a result, criollo resentment of gachupín privileges grew throughout the century.[12]

Over the course of the century, the Council of the Indies, the administrative body that governed Spanish America, and the Cámara, its subcouncil formed in the early seventeenth century, also promoted more and more restrictive social policies. Through her study of 244 *cédula de gracias al sacar* documents (petitions by which individuals with clouded

natal status requested official legitimacy in order to claim honor and the rights and privileges of Spanish identity), Ann Twinam elucidates how Council and Cámara appointees became more proactive through the century, with intensification between 1776 and 1793. During this time, the Cámara required more and more extensive investigation of all individuals who applied for legitimation. Twinam suggests that the Cámara saw itself as a social gatekeeper as it narrowed the standards for acceptance of applications.[13]

The Cámara's activity corresponded to an intensified desire to enumerate, aggregate, and denominate the places, things, and people of the intendancies. From its inception in the sixteenth century, colonial society in New Spain was conceived in terms of division and separation. The Indians of New Spain, particularly the Aztec-Mexica, were recognized for their many and varied social, administrative, engineering, architectural, and artistic achievements; however, the Indians' difference in religion placed them in the category of "pagan" and forced strict separation from Spaniards. By the middle of the sixteenth century, New Spain was seen as consisting of the *república de españoles*, under the direct control of the Spanish Crown, and the *república de indios*, governed at a distance through caciques, native nobles, who retained some local authority.[14] Black Africans, arriving in New Spain as slaves and laborers to the Spanish, were considered to be part of the Spanish república.

The repúblicas' conceptual and political separation was given physical form as the capital city was built. The gridded urban plan of Mexico City followed the features of the Aztec-Mexica island city of Tenochtitlán, upon which it was built. Initially, for protection from the Indians, the Spaniards lived in a rectangular area in the center of the city called the *traza*, where the houses were made of fine dressed-stone, streets were orderly, and many municipal services were available. The Indians were isolated from Spaniards to avoid exploitation by Spaniards and to make their conversion to Christianity more effective. Surrounding the traza, the Indians' section of the city had ramshackle housing, haphazardly arranged streets, and limited municipal services.[15]

The colonizers attempted to maintain the separation of the Spanish and the non-Spanish urban sections throughout the colonial period. Given the physical distinctions between these two sectors of the early colonial population, it would seem that separation should have been relatively easy

to maintain. Such spatial division, however, was undermined by the function and placement of the Plaza Mayor, the civic center, near the traza. This city square was surrounded by buildings that housed the major Spanish political and religious institutions: the cathedral, the viceregal palace, and later, the Ayuntamiento, or city council. Each of these building had very specific religious or civil functions for Spaniards and Indians.

It was the operation of the fourth feature of the Plaza Mayor, the marketplace, or *parián*, that most blurred the physical and conceptual boundaries of the repúblicas. In his 1777 description of the city, Juan Viera, a city resident, called this marketplace a "teatro de maravillas" (theater of wonders).[16] Walking through the parián, one would have seen numerous stalls displaying the abundant flora and fauna of the Americas; in addition, locally manufactured commodities were available, along with those from China and Spain. The diversity of the people who came to this market matched the diversity of the goods sold. People of the city and its environs mixed in a disorderly fashion to buy, sell, and exchange both essential and nonessential items. People like Mauricia and the subjects of our casta paintings would have been common sights. Given the pressure on elite women to stay in nonpublic, enclosed spheres, however, Doña Margarita, Doña María, and Doña Sebastiana would not have been regular visitors to the marketplace, although they may have visited with chaperones, perhaps to select fabric or other goods.

Following the conceptual separation of the city, the parián was conceived as a place where the people of the two repúblicas would encounter each other in economic exchange, then return to their respective domains. In fact, rather than separation, daily intermingling of people was a quintessential part of colonial life, and it resulted in structural and visual fusions, amalgams, and composites—that is, hybridity. This is seen in Miguel Cabrera's paintings: for example, in *1. De Español, y d India; mestisa* (figure 2.3), it is obvious in the presence of the mestiza child and also in the costume of the young Indian woman with its mixture of European and indigenous styles and materials. And, most importantly, it would have been evident in the physical features of the castas who visited the parián. Everywhere, the elegant, oval-shaped eyes of the Indians would have been mixed with the light skin of a Spaniard, or narrow Spanish features would have been highlighted by rich, dark skin. By the eighteenth century, the reality of the physical medley and social mixing of

"*generaciones*," as one visitor to eighteenth-century New Spain called the mixed-blooded plebeians, was to be seen everywhere.

This reality shifted dramatically through the eighteenth century, as the slowly expanding presence of a hybrid population became more widely acknowledged, both socially and economically. In the very early history of New Spain, children of one Spanish and one Indian parent were generally considered Spaniards and were granted the legal status of Spaniards. As colonial society became established, social and economic privileges became more difficult to secure. By 1530, Spaniards began to distinguish themselves from Indian-Spaniard offspring by creating the "mestizo" designation often associated with illegitimacy.[17] In addition, between 1521 and 1594, some 36,500 Black Africans were brought to New Spain, with 8,000 living in Mexico City.[18] Because most of the slaves were males and did not have easy access to Spanish females, mulattos (the offspring of Spaniards and Black Africans) appeared in the demographic records more slowly than mestizos.[19]

Obviously, mestizos and mulattos and their proliferating mixtures did not fit into either república. Beginning in the mid-seventeenth century and throughout the eighteenth century, these mixed people were recognized as a separate entity referred to as the *sociedad de castas* (society of castas) or the *sistema de castas* (system of castas).[20] Francisco de Ajofrín, a friar who traveled through New Spain in the mid-eighteenth century, comments that "castas de gentes, ha resultado en diversas generaciones, que mexcladas todas, ha corrompido las costumbres en la gente popular" (mixed-blooded people have resulted in diverse generations [lineages] that, mixing all, have corrupted the customs of the plebeians).[21] He goes on to enumerate some of these descendants and their attributes. Other contemporary writers also listed casta generations or lineages, which they imagined resembled genealogical charts, naming fourteen to twenty distinct offspring of Spaniard, Indian, and Black African unions, emphasizing the diminishing of Spanish blood and the polluting quality of mixed blood.[22] Although there were different versions, in general the taxonomy of the sociedad de castas was as follows:

1. *Español* and *india* beget *mestizo*
2. *Mestizo* and *española* beget *castizo*
3. *Castizo* and *española* beget *español*

4. *Española* and *negro* beget *mulato*

5. *Española* and *mulato* beget *morisco*

6. *Morisca* and *español* beget *albino*

7. *Español* and *albina* beget *torna-atrás*

8. *Indio* and *torna-atrás* woman beget *lobo*

9. *Lobo* and *india* beget *zambaigo*

10. *Zambaigo* and *india* beget *cambujo*

11. *Cambujo* and *mulata* beget *albarasado*

12. *Albarasado* and *mulata* beget *barcino*

13. *Barcino* and *mulata* beget *coyote*

14. *Coyote* woman and *indio* beget *chamiso*

15. *Chamisa* and *mestizo* beget *coyote mestizo*

16. *Coyote mestizo* and *mulata* beget *ahí te estás* [23]

The premise of this genealogy was that a person's blood lineage could be traced and his or her identity labeled. More importantly, it may be seen as an attempt to come to grips with hybridity and the resulting ambiguity of an individual's identity. In fact, studies of archival documents have shown that the categories of the sociedad were remarkably inconsistent, particularly after the morisco level. For example, looking at other sources, offspring designation number 10, a cambujo, could also be the offspring of nine different combinations.[24] Only Spaniard, castizo, mestizo, morisco, Black African, and Indian designations appear consistently in legal documents.

This hierarchy was reinforced with specific associations, which may well be seen as the demarcations of calidad. Seen as inherent qualities and attributes of casta personages were illegitimacy, impure blood, debasement, criminality, poverty, plebeian status, and manual labor. These were contrasted with elite, Spanish characteristics: legitimacy, purity of blood, honor, law-abidingness, wealth, and nobility.[25] Thus, a person who was a laborer was automatically associated with casta identity, even if his or her skin color was light. As we have seen in the cases of Doña Margarita and Mauricia, these attributes were the critical markers of calidad and were understood references in their respective proceedings. The promulgation of the sociedad de castas and its concomitant explication of calidad are further evidence of the continued hope and desire of the Spanish elite that

colonial society should and could be orderly, and that the traits of castas could be emphatically distinguished through physiognomics.

It would seem that casta and elite should have been clear-cut categories in the eighteenth century. As we shall see, demographic data and scholarly studies indicate that the opposite was the case. Casta identity was elusive and ambiguous, and Spanish identity could be mimicked; thus, neither category was definitive or conclusive.

SHIFTING POPULATIONS

The total number of inhabitants in Mexico City during the eighteenth century is not known absolutely because census counts and estimates diverge widely. It is thought that the more mobile parts of the population (e.g., street vendors) and Indians were not counted.[26] The estimation of the population of Mexico City from 1689 to 1811 is as follows:

TABLE 2.1.
POPULATION OF MEXICO CITY 1689–1813

YEAR	BASED ON	POPULATION
1689	Estimate	57,000
1753	Estimate	70,000
1790	Census	112,926
1811	Census	168,811

Based on Dennis Nodin Valdés, "The Decline of the *Sociedad de Castas* in Mexico City" (Ph.D. diss., University of Michigan, 1978), 55, table 2.1.

The increase in city population after 1749 due to a poor harvest and severe epidemics in rural areas caused Indians to move to Spanish sections of the city. Increased criminal activity forced a 1753 census of the traza, the Spanish area of the city.[27] The significant increase in the population in 1790 is attributed to increased birthrate and immigration from the countryside.

A 1790 census mandated by Viceroy Revillagigedo shows the population broken down by race to indicate both Mexico City and the Intendancy of Mexico.

Spaniards and mestizos were most likely to be found in the city—with more than 50 percent of the city population identified as Spanish or other European, compared to 13 percent in the province—while the Indian

TABLE 2.2

1790 POPULATION OF MEXICO CITY AND THE INTENDANCY OF MEXICO

MEXICO CITY			INTENDANCY OF MEXICO		
Group	Number	% of Total	Group	Number	% of Total
European	2,335	2.2	European	1,330	0.1
Spaniard	50,371	48.1	Spaniard	134,965	12.9
Mestizo	19,357	18.5	Mestizo	112,113	10.7
Mulatto	7,094	6.8	Mulatto	52,629	5.0
Indian	25,603	24.4	Indian	742,186	71.1

Based on Valdés, "Decline of the *Sociedad*," 58, table 2.2.

population was denser in the outskirts than in the city.[28] While these demographic statistics are limited in scope, they do point out the very distinct presence in urban eighteenth-century Mexico City of what appears to have been a larger Spanish, mestizo, and mulatto population than in the surrounding countryside.

Analysis of marriage patterns during the eighteenth century adds another layer of complexity to the data on population changes. In his dissertation study, Dennis Valdés reviewed marriage records from the Sagraria parish, a heavily Spanish district located next to the cathedral. The documents indicated the Spanish, casta, or Indian designation of the bride and groom. These records, while not comprehensive for the city, do highlight an important shift in marriage patterns in the core metropolitan area from the late seventeenth century to the late eighteenth century: mulatto, mestizo, and castizo individuals began to marry more consistently with Spanish individuals.

A summary of Valdés's extensive data provides an informative overview of this emerging pattern.

TABLE 2.3.

MARRIAGE RATES AT THE SAGRARIA

YEAR	SPANIARD-SPANIARD
1665–1670	96.0%
1752–1754	75.0%
1781–1783	72.7%

Valdés, "Decline of the *Sociedad*," 41, table 1.10. Marriages of Spaniards.

In the late seventeenth century, Spaniards married other Spaniards 96 percent of the time; remarkably, this percentage fell to 75 percent in 1750s and decreased slightly in the 1780s to 73 percent.

It would seem that by the middle of the century, 25 percent of the Spanish population in this sample married partners who were recognized as mulattos, mestizos, or castizos. If we turn the figures around to see what this shift meant for castas, an even more unexpected picture emerges and is summarized below.

TABLE 2.4.
MARRIAGE RATES AT THE SAGRARIA

YEAR	MESTIZO-SPANIARD	CASTIZO-SPANIARD	MULATTO-SPANIARD
1665–1670	15.0%	7.4%	5.7%
1723–1725	25.4%	36.0%	21.9%
1781–1783	33.5%	51.9%	44.0%

Based on Valdés, "Decline of the *Sociedad*," 37, table 1.6. Marriages of Mestizos; 39, table 1.8. Marriages of Castizos; 37, table 1.5. Marriages of Mulattos.

Of the marriages recorded at the Sagraria, the percentage of casta marriages with Spanish partners increased dramatically from the latter part of the seventeenth century to the latter part of the eighteenth century. By the 1780s, one-third of all mestizo unions, one-half of all castizo unions, and close to one-half of all mulatto unions were to Spaniards. Looking at these marriage patterns, Valdés determines that "the actual rates of intermarriage [of Spaniards] were sufficient to ensure that the biological purity of the [Spanish] group could not be long maintained" and that the "pure" Spanish population would have been depleted in a few generations.[29]

In addition, the offspring of castizo-Spaniard and morisco-Spaniard unions generally were more and more accepted as Spaniards. As a result, Valdés concludes that

> Marriage was an opportune moment for many individuals to pass into the Spanish category, particularly if one of the partners had long been accepted as a Spaniard. If both dressed, spoke and behaved in accordance with patterns, which could be accepted as white [i.e., Spanish], the physical features were less important.[30]

Dress, speech, and behavior were exactly those references and criteria we heard reiterated by the witnesses in Mauricia Josefa's and Doña Margarita's cases.

In sum, it is possible to suggest that in Mexico City during the eighteenth century: (1) the Spanish population expanded through offspring of intermarriage, not by immigration of peninsulares from Spain; and (2) these Spanish offspring likely had mixed blood, as they theoretically transformed from morisco through castizo stages into the Spanish category. Thus, "Spaniard" was associated with "purity" of blood; but in fact, by the last quarter of the century, this Spanish designation was probably the most inconclusive of the identified categories.

Population demography and marriage patterns in Mexico City offer a glimpse into how castas, as a distinct third sector of colonial society, may have been formed biologically and recognized socially; the economic status of castas was another element of their identification as a separate social group. The court records make no mention of Doña Margarita's association with any kind of labor; detailed information, however, is given about Mauricia's employer and her status as a servant. In earlier centuries, Spaniards and castas were viewed as having specific economic associations: the Spaniards were landholders and merchants; Indians, unskilled workers; and Black Africans, slaves and servants. Through the eighteenth century, the offspring of mixed unions breached the clear categories of work. Peninsulares and criollos were shopkeepers and merchants, although over half of all criollos were artisans.[31] Castas were more likely to work in production or service areas. Mestizos generally worked as artisans and were more likely to be laborers and servants than were criollos or castizos. Free mulattos functioned as artisans and servants.[32] Patricia Seed suggests that by the middle of the eighteenth century, the strict Spaniard-versus-casta socioeconomic division was no longer as straightforward as it had been earlier in the century.[33]

From this demographic picture of eighteenth-century Mexico City, it is clear that the social circumstances of the latter part of the century were dramatically different from those of the early part of the century. Population increases were quite substantial in the eighteenth century, with roughly a 22 percent increase in the first half of the century and a 62 percent increase in the second half. Increased intermarriage among groups was also evident and resulted in the blurring of the meaning of "casta" as well as of "Spaniard." Also, in the labor sector, any clarity of separation or standardized order of economic status was continually undermined by people transgressing their previously designated economic niches.

In addition, in numerous archival documents, it is evident that as early as the seventeenth century, Mexico City's inhabitants were referred to either as *gente decente* (respectable people) or as *gente vulgar* (common people), who were also called *plebes* (plebeians), castas, *gente popular*, or *populachos*, all terms that had abasing connotations. The term "plebes" did not just mean that those designated as such were commoners, nonnobles in the traditional European sense; these designations indicated mixed-blood identity as well.[34] By the mid-eighteenth century, the nomenclature of casta taxonomy and the broader definitions of "plebeian" and "gente vulgar" began to overlap and interweave with the colonial physiognomic discourse of calidad. Likewise, the category of "Spaniard," particularly "criollo," became less and less definitive. After all, there were Spaniards who had Indian blood and plebeians who were Spaniards. Douglas Cope best summarizes the emerging demographic labyrinth when he writes:

> Beneath Mexico City's façade of power and authority—symbolized by the grandeur of the city's palaces and churches and by the geometrical regularity of its broad avenues—lay the messy vitality of the urban poor. Plebeian society was a reality: in the streets, marketplaces, and taverns, in servants' quarters, ramshackle apartments, and adobe hovels, the poor of all races worked, played, begged, gossiped, argued, fought, drank, gambled, made love—survived. They shared a lifestyle and, to some extent, a consciousness, notably, in their disdain toward the rules and regulations promulgated by the authorities.[35]

PASSING IN THEIR HEARTS

Without a doubt, the expansion of a population of mixed-blooded people, whether they were called castas, gente vulgar, or plebes, points to the fact that hybridity was part of late-eighteenth-century daily life. Elite women like Doña Maria and Doña Sebastiana were the human façades paralleling Mexico City's architectural façades of power and authority. But every day, and in every way, their lives were circumscribed and defined in relationship to the ambiguous and mutable identity of people like Mauricia Josepha or the mestizo child or lobo itinerant cobbler seen in Cabrera's paintings. It was this protean quality and fluidity of casta existence that resulted in peninsular and criollo consternation and dismay over their

inability to keep colonial people in separate and distinct spheres; it also caused considerable apprehension about the potential of castas to pass as Spaniards. Pedro O'Crouley's 1763 words "Many pass as Spaniards who in their own hearts know that they are *mulatos*" encapsulate this deep anxiety about not only mulattos but all castas.[36]

It was demographically very possible for Doña Margarita de Castañada to be a casta with Spanish traits, and for Mauricia Josefa to be a Spaniard with casta traits. This possibility fractured the pristine, ideal images that the criollos and Spaniards like O'Crouley wanted to see mirrored in their surrounding cityscape. Casta unions and the resulting births were responsible for these population metamorphoses; passing occurred among all casta groups and at an accelerating rate in the late-colonial period.[37] There was little worry about passing among the lower casta groups. As one would expect, the issue of passing from a casta group into the Spaniard designation was of more critical concern to the elite, particularly because even people with clearly non-Spanish judgment, appearance, and circumstance, like Mauricia, were attempting to be accepted as Spaniards.

Colonial exclusiveness began to disintegrate once mestizos, mulattos, and other people of mixed blood slipped into the morisco, castizo, and Spaniard categories. For castas, passing into the Spaniard category provided access to a broader range of economic venues, restricted city spaces, and certain types of clothing. The result of this passing was that a plebeian body could and did mimic a Spaniard's body. Thus, the images of Doña María and Doña Sebastiana and the mixed-blooded people of Cabrera's paintings may be viewed as an attempt to visualize the perceived distinctions among eighteenth-century bodies. In fact, the images seem to contradict the increasingly cacophonous social reality of the late 1750s and 1760s, the decades in which they were produced. But these images, and casta paintings in particular, may not be about the social reality as much as they are about a social engineering that was being carefully put into place by Bourbon reformers as they attempted to construct, control, and maintain colonial bodies and the spaces they occupied. It is casta images as visual practices reflecting these vicissitudes of metropolitan cultural circumstances that will be the focus of the next three chapters.

CHAPTER THREE

Envisioning the Colonial Body

MEXICO CITY WAS ALIVE with anticipation in December 1680 as Tomás Antonio Manrique de la Cerda y Aragón arrived to become the thirtieth viceroy of New Spain. Extensive civil and religious ceremonies and celebrations had been prepared to mark his accession and greet his entrance into the noble city. When the new viceroy toured Mexico City, he had his first glimpse of a place unlike any city he had visited before. The buildings and city spaces, such as the great cathedral, the viceregal palace, the municipal buildings, and the parián (marketplace), while distinctive, were somewhat comparable to such buildings in Spain, and were perhaps even expected. However, the sounds, smells, people, and activities—that is, the lived vitality—that filled these spaces were likely neither expected nor comparable to those of the viceroy's native land. He saw people with Spanish and non-Spanish facial features, clothing, and customs that were sometimes easily distinguished and sometimes strangely mixed.

In this city tour, the new viceroy would have encountered another sight that may have consolidated the city's impression of sameness with a difference. A twenty-by-fifteen-foot triumphal arch had been built in his honor in the Plaza Santo Domingo, near the Plaza Mayor. Designed by Don Carlos de Sigüenza y Góngora, a highly respected criollo scholar and intellectual, the structure was not a permanent monument but a temporary scaffolding of wood and stone, which supported large, painted panels. Such temporary triumphal arches, which usually displayed allegorical images from Roman history and myth, were a custom in New Spain for the inauguration of new viceroys.[1] However, Viceroy de la Cerda y Aragón would not have read or seen on these painted panels the standard illustrations of authority and leadership associated with Roman gods and emperors. Instead, he would have examined its dedication, which read, in part:

CADA UNO DE LOS ASUNTOS
ESTE ARCO
ILUSTRE POR LOS RETRATOS DE EMPERADORES DE LA
ANTIGUA NACIÓN
LA CIUDAD DE MÉXICO
(CON LOS VOTOS DE TODOS Y CON ALEGRÍA COMÚN)
CON LARGUEZA Y PARA SU ESPLENDOR
SEGÚN EL TIEMPO Y FUERZAS
PUSO
EL DÍA TREINTA DE DICIEMBRE
DEL AÑO 353 DE LA FUNDACIÓN DE MÉXICO[2]

> [Each of the topics this arch illustrates through portraits of emperors
> of the ancient nation, the city of Mexico (with the approval of all and
> common accordance), with generosity and for your splendor
> according to their times and power, completed the thirtieth day of
> December of the 353rd year since the foundation of Mexico.]

The viceroy also would have observed its uncommon imagery: the panels
illustrated twelve Aztec-Mexica kings and allegorically associated each
with specific qualities of leadership. For example, Izcoatl, the fourth Aztec-
Mexica king, was associated with prudence, and the seventh leader,
Tizoctzin, with peace.[3] Sigüenza y Góngora, claiming to maintain the
original function of the Roman triumphal arches, as "erected . . . in your
name to mark the high office you are to enter," had designed his arch using
the theme of the "ardent spirit of the Mexican [meaning Aztec-Mexica]
emperors from Acamapich to Cuauhtémoc. . . ."[4]

Use of such "pagan" imagery was forbidden in New Spain, but in his
written exegesis on the arch, Sigüenza y Góngora explained his intention
in using this "Mexican" iconography.

> I manifested the finest virtues of the Mexican emperors, so that my
> intent would succeed without risking that the symbols would break
> the law: "Praise, which to the best princes (continuing Pliny's
> moderation) and through them, as through a mirror, to show to
> posterity the light that emanates from them, has much utility, and
> nothing of arrogance."[5]

As the new viceroy looked at/in Sigüenza y Góngora's metaphorical
mirror,[6] it is unlikely that he understood who these historical personages

were; but he probably did understand their intended allegorical functions as commentaries on meritorious qualities of leadership.

Perhaps not immediately clear to the viceroy, however, was that more than just a novel idea or a display of Sigüenza y Góngora's classical and historical knowledge, the arch's iconography may have indicated a sharpening criollo disaffection toward Spaniards resulting from the perceived lack of economic and political clout and access available to criollos like Sigüenza y Góngora. On the eve of the eighteenth century, which would witness dramatic demographic changes in Mexico City—a place that was like, but was not, Spain—criollos began to see themselves as similar to, but different from, peninsulares. Sigüenza y Góngora's arch may be seen as a visual statement that sought distinct ways to express New Spanish identity based on New World, not Old World, imagery.[7]

Documentary evidence of the reaction to Sigüenza y Góngora's arch is limited. We do know that the arch did not immediately spawn a proliferation of sculptural or painted images using Aztec-Mexica iconography. In fact, it would not be until the end of the eighteenth century that criollos would actually call themselves *americanos* or *mexicanos*; and it was only after the successful establishment of the Royal Academy of Art at the end of the eighteenth century that "Mexican"—that is, Aztec-Mexica— iconography would be used to allegorize the emerging independent nation of Mexico.

By the time of the construction of Sigüenza y Góngora's arch, nevertheless, innovation in the visual practices of New Spain had already begun to occur. Small-scale paintings and embroideries known as *escudos de monjas* (shields of nuns) were worn by certain nuns in colonial Mexico. One example can be seen on the young woman in figure 3.1. Elizabeth Perry has argued that escudos were a direct reaction to the religious reforms dictated by the Spanish bishops of New Spain, which included the imposition of strict dress codes and other regulations on the convents that housed the daughters of the criollo elite. These escudos were adapted from earlier Spanish shield formats and embedded in the religious practices of New Spain.[8] Like Sigüenza y Góngora's innovations, escudos de monjas also referenced a distinct cultural identity for the criollo elite: by the eighteenth century, the escudos became badges of criollo patriotism and carried a symbolic meaning for the criollos in their resistance to Spanish authority.[9]

Figure 3.1.
Unknown. *Retrato de sor María Ignacia Candelaria de Santísima Trinidad.* Eighteenth century. Oil. 203 x 125.5 cm. Museo Nacional de Virreinato, INAH, Tepotzotlán, Mexico.

The escudos were incorporated into a genre of painting that came into fashion in eighteenth-century Mexico: the *monja coronada*, or crowned nun (figure 3.1). Dating to as early as 1727 and unique to colonial Mexico, the monja coronada was a portrait of a woman on the day of her religious profession. As seen in our example, the young nun was shown against a

simple background dressed in her religious habit, carrying a statue of the Christ child and a floral scepter, and wearing an elaborate flowered crown. These life-size portraits hung in the public reception rooms of the home of the nun's parents. The images have both religious and secular references. As a religious devotional image, the monja coronada marked a momentous day in the criollo family's history. As a secular portrait, the image testified to the blood purity and calidad of the family's lineage, since limpieza de sangre certification was required for the novice.[10] In broader cultural terms,

> The *monja coronada* portrait genre appeared in the creole home precisely as the meaning of the religious profession pictured was being bitterly contested. This contestation existed within the context of larger political conflicts stemming from creole desire for political equity and self-determination in their relationship with Spain.[11]

Clearly, an incipient and subtle visual culture focused on criollo identity was functioning by the beginning of the second quarter of the eighteenth century.[12] In light of Perry's research, one may speculate that Sigüenza y Góngora's 1680 notion of differentiating and reflecting criollo identity in a metaphorical mirror was realized, at least in part, with the escudos de monjas and monja coronada paintings.

Concurrent with the initial production of monja coronada paintings, another genre of paintings was inaugurated in the 1720s. Images in series of twelve to sixteen panels illustrating the mixed-blooded people, as well as the flora and fauna, of New Spain appeared. Cuadros de castas or casta paintings, as they are called in the twentieth century, proliferated throughout the eighteenth century, and their production concluded at the beginning of the nineteenth century. The original genre designation of these paintings is not known. The word "casta" is rarely found on any of the three hundred panels catalogued by María Concepción García Sáiz. An inscription initiating one 1770s series reads, "Calidades que de la mezcla de Español, Negros, Yndios . . ." (Calidades derived from the mixing of Spaniards, Black Africans, and Indians . . .).[13] Numerous edicts, laws, and ordinances of the 1750s through 1790s also refer to the general population of New Spain less often as castas and more often as people marked by calidad and class. It is likely that these paintings were rarely, if ever, labeled as casta paintings in the eighteenth century.

The lack of documentation of casta images may indicate that, in the artistic production of eighteenth-century New Spain, this genre was not deemed as important as others were. This means that it is critical that scholars should not attempt to make casta paintings into "seminal" images in the history of colonial art. They were not. What may be seminal is the mundane theme that artists were able to insinuate in these images. The casta genre was not under the same orthodoxy prescriptions and Inquisition oversight as were the religious and portraiture genres; as a result, artists may have been more able to innovate and experiment with the iconography of the casta images.[14] I have developed a focused interest in these paintings not because they were unique but because they display an implicit ordinariness and, being perceived as ordinary, almost inadvertently reveal through time the increasing discourse on the colonial body found in late-colonial sources. Finally, it is important to consider that the production of these paintings has not previously been examined, in conjunction with the monja coronada paintings, as a further manifestation of an evolving and distinct late-colonial visual culture.

The origin, patronage, and production of this secular genre are not well understood. Ilona Katzew has suggested that paintings and engravings from northern Europe were a source of inspiration for the cuadros de castas.[15] There exists limited documentation showing that Viceroy Fernando de Alencastre Noroña y Silva, Duke of Linares (1711–1716), gave the king of Spain a series of paintings showing the mixtures of people of New Spain in the early part of the eighteenth century. In addition, at least four other sets of paintings are known to have been taken or sent to Spain. One of these sets of paintings was commissioned by Archbishop Francisco Antonio de Lorenzana y Butrón to take on his return to Toledo.[16] Curiously, this archbishop was also one of the harshest proponents of the radical convent reforms described above and avidly sought to deter the use of jewelry and personal ornamentation, possibly including escudos de monjas.[17]

Although their exact extent of patronage is not well understood, it is clear that peninsulares were interested in the production of casta paintings. On the other hand, criollos may have had very different sentiments about the images. In 1746, Andrés Arce y Miranda, a criollo intellectual, wrote that such images showed a vision of "useful minds but not noble ones, what harms us, not what benefits us, what dishonors us, not what ennobles

us."[18] It would seem that in at least one example, a criollo was openly disdainful of the paintings.

The written inscriptions on the images indicate that literate, and therefore elite, individuals were the perceived viewers. The perception or reading of the images would have been very different for the New Spanish viewer than for the Spanish viewer. The viewer in Spain may have seen the images as evidence of the exotic people, flora, and fauna of New Spain. While the New Spanish viewer may have had a sense of familiarity with the contents of these paintings, the presentation may not have been seen as an appropriate portrayal, as is evident in Arce y Miranda's words. Who the exact intended viewers of these images were, however, is difficult to ascertain.

Secular art of colonial Mexico has only recently become important in collections and scholarly research in the United States. As explained by Marcus Burke, the notable lack of secular art—which includes landscapes, cityscapes, allegory, and genre—in museum collections is due to three factors. Firstly, secular allegorical painted images were often ephemeral objects, like Sigüenza y Góngora's triumphal arch. Secondly, secular art was allied to decorative art such as screens (*biombos*) and furniture and was thus retained in private homes. Finally, and most importantly, the dissolution of religious institutions at the time of independence meant that thousands of religious paintings were put into circulation and available to collectors, while secular art, made for private patrons, often remained in private collections.[19] This means that while a somewhat comprehensive understanding of the production and consumption of colonial religious art is evolving, the same is not as true for secular art. Perhaps because of the subject matter and, in some cases, the poor artistic and technical quality of the paintings, sets of casta panels have been broken apart, left in disrepair, and probably destroyed.

Casta paintings have only been the focus of detailed scholarly interest for the past decade. This is due in part to the fact that the study of Latin American colonial art in general has only become of great interest to scholars in the past thirty years. In addition, because of the paintings' wide dispersal in public and private collections in the Americas and Europe, and their negligible documentation, scholarly investigation of casta paintings has been limited. Major studies have only been published in the last fifteen years, and they include: María Concepción García Sáiz's 1989

catalog of casta paintings, which provided the first comprehensive survey of the genre;[20] Abby Sue Fisher's 1992 dissertation, which looked at the clothing types found in the images;[21] and the 1996 Americas Society exhibition catalogue edited by Ilona Katzew.[22] Katzew's article in this catalogue provides an overview of current scholarship on these colonial Mexican paintings and expands on her earlier ideas. More recently, Katzew completed her dissertation study of casta paintings.[23] These researchers, along with other scholars who have written articles on the casta panels, have placed analytical emphasis on formal and stylistic analysis as well as historical context.[24] In general, interpretations of the paintings have consistently paralleled the social science discussion of the sociedad de castas and "race."

In 1989, María Concepción García Saíz authored a seminal catalog of fifty-nine sets of casta paintings (about three hundred images) from international public and private collections.[25] In her groundbreaking work, García Saíz was able to divide these sets of paintings into fifty-five series that outline the stylistic evolution of the genre. She documents that in 1711, a member of the Arellano family, who were well-regarded artists, painted a portrait of a mulatto man and a separate image of a mulatto woman. Although they were separate images, García Sáiz suggests that the paintings were conceived as a pair and clearly complementary. Subsequently, artists undertook a more precise delineation of casta genealogy that indicated a mixed-blood taxonomic chain, that is, the sistema de castas. Artists began to illustrate twelve to sixteen casta triads formatted on consecutive canvases or on a single panel.[26] After the middle of the eighteenth century, García Sáiz states, the artists emphasized more complex urban or rural background settings for the figures. García Sáiz concludes that these painting served the curiosity of colonial aristocrats and upper-class Europeans whose lives were unrelated to those of the people in the paintings.[27]

Abby Sue Fisher's study looks at dress as a nonverbal indicator of status and, consequently, as a method of understanding the meaning of the casta genre. She suggests that the occupation, dress, and social status of the pictured mixed-blooded people changed proportionately to their position in the depicted racial hierarchy. The paintings emphasize the advantages of lighter skin color, and "as a product of the Enlightenment and the desire to classify and document, . . . the classificatory format and didactic labeling

are like an educational blueprint of racial types."[28] Thus, for Fisher, dress formats served as a corroboration of the cultural ideals and status embedded in the casta taxonomy.

Ilona Katzew argues that the casta paintings promoted a regulated and controlled image of the colony, which served to counter the anxiety fostered by the perceived threat of the castas to an orderly society. Katzew maintains that early examples of casta paintings might have been reminders to the Spanish Crown that, despite contrary reports, Mexico was still a rigidly structured society, and the control of this society by Spaniards was validated by the fact that Spaniards were placed at the beginning of every series. The family trope created a sense of unity within hierarchy and served to "naturalize" the overall social hierarchy depicted in the paintings.[29] As strategies of self-representation, Katzew continues, casta paintings emphasize the overall stratification of society through the metaphor of race; highlight the wealth and abundance of Mexico; and involve "the deliberate mediation of reality . . . through scenes selected for representation." Katzew concludes that the idea of racial hierarchy in service to imperial order is clearly at the heart of these images.[30]

The general stylistic evolution and historical contexts argued by García Sáiz, Fisher, Katzew, and other writers are, without a doubt, important to the understanding of these paintings. These scholars provide valuable insights into, and interpretations of, casta paintings. In these previous studies, however, less consideration has been given to the fact that not only were the meanings of casta paintings diverse, but they also changed through time to reflect shifting social circumstances. Concluding that these images are illustrations of the sistema de castas may be too literal and static a reading of the imagery, and may actually obscure more complex, subtle, and comprehensive readings of the panels. The research of Marcus Burke and Elizabeth Perry has opened scholarly analysis to the idea that through time, colonial religious art was dynamic in style and content and reactive to social and political changes. The same may be expected of secular art.

The production of the casta painting genre must be considered in the confluence of complex and contentious late-colonial circumstances, particularly the shifts in metropolitan populations, the evolving marriage patterns, and the eighteenth-century notion of hybridity as formulated in raza and calidad. Specifically, a distinct and separate criollo identity was crystallizing, and at the same time, Bourbon mercantilist interest in

institutional centralization was initially forcing secular and religious reforms and would later focus on social reforms, as outlined in chapter 2. From these considerations, three critical problems of the visual practice of casta painting production come to light. First, although stylistic variation over time is well outlined by García Sáiz, Fisher, and Katzew, the visual structuring of these paintings has not been as thoroughly or systematically examined. For example, while it is well accepted that around midcentury there is a dramatic compositional shift toward more expanded and detailed settings for the figures, little consideration has been given to how this expansion of the viewing field occurred or how it may relate to the notion of physiognomic diagnostics. As we saw in the analysis of Doña Margarita's case, observation of the body as a system of signs was associated with the physiognomical determination of calidad. Thus, the repetitive and serial formatting of the panels may be examined as a visual strategy of surveillance in the overall structuring of the imagery.

Second, by the mid-eighteenth century, the discrete categories of the casta hierarchy were disappearing demographically. For example, by the 1770s, people of the classification "negro" were not even identified in legal records,[31] yet Black Africans continued to appear in casta paintings into the late 1790s. Also, while only the nomenclature of Spaniard, mestizo, castizo, and mulatto appeared regularly in public records and documents, the paintings insist on illustrating a complete, and nonfunctioning, taxonomy of castas. For example, the casta category of *albarasado* (white-spotted), the seventh generation of a Spaniard–Black African union, was never part of common usage, yet it was repeatedly painted late into the century. Thus, there was a continuing production of casta paintings through the century at the same time as the casta categories were disappearing in general from social apperception. The visual strategy of surveillance is not just about looking; it is about constructing the very object of its observation, hybrid bodies. In light of this discrepancy, a further consideration is: Why would these paintings emphatically and repeatedly illustrate a phenomenon whose presence in reality was inconstant and diminishing and, ultimately, nonexistent? Analysis of the production of casta genre paintings as a visual practice must take into consideration the volatile and emerging conditions evidenced in demographic data and archival documents of eighteenth-century Mexico.

Finally, little attention has been given to why casta painting production

ends in the early nineteenth century. The cessation could simply be ascribed to the fact that casta nomenclature was legally forbidden in 1822. Less attention, however, has been given to the possible impact of the establishment of the neoclassic ideas and ideals of the Academy of San Carlos at the end of the eighteenth century, which would ultimately utilize the body of the idealized, metaphorical Indian and mestizo to inscribe incipient national identity. The relationship between the colonial imagery of casta paintings and this growing interest in the nationalistic imagery of academic paintings also needs further consideration.

This chapter will discuss the initial problem mentioned above, of the visual strategies of casta paintings. The second problem—of demographic shifts, bureaucratic reactions to these changes, and their relationship to colonial visual practices—and the third problem associated with the cessation in the production of casta paintings will be discussed in chapters 4 and 5, respectively. Overall, I argue that casta genre paintings may better be understood as a set of visual practices embedded in broader regulatory narratives that simultaneously observed and constructed the late-colonial body. They were a visual practice that made the colonial body—both elite and nonelite—knowable and visible.

To trace the shifts in visual structuring that occur through time, in the following section I will undertake very detailed descriptions of panels from three sets of casta paintings representing the first, middle, and final thirds of the century. This visual examination highlights the shifting content and surveillance techniques of these paintings.

García Saíz dates the earliest known casta series to about 1725, and she attributes it to Juan Rodrígues Juárez (1675–1728/32); the series consists of ten known panels.[32] The images echo New Spanish portrait conventions emphasizing half-figures placed in shallow spaces. Although the panels in the set are not numbered, the title inscribed on each panel repeats the general nomenclature of the sistema de castas described in chapter 2. Further, the paintings of castas are formatted to show three distinct generaciones or lineages. These are Spaniard-Indian, Spaniard–Black African, and Indian–Black African.

In the first panel, the figures of an Indian woman and a Spanish man are shown with their mestizo offspring (figure 3.2). Shown in profile, the Spaniard wears a curly white wig and a red waistcoat accented by a lacy cravat and the cuffs of a white shirt, and he carries what appears to be a tri-

corner hat under his left arm. His eyes look downward, and his right hand rests gently on the head of his mestiza baby daughter, who is carried by a young boy, likely the man's mestizo son. The Indian woman, dressed in the traditional Indian costume of a huipil with folded-cloth headpiece, turns her head to look over to the Spanish father, and her right hand, formed in a C shape, gestures to the children. Besides the use of European versus Indian clothing, Spanish/Indian distinctions are marked by the contrast between the rich brown color of the Indian woman's skin and the pinkish white of the man's skin. The baby girl displays the lighter tones of her father, while the young boy's coloring is closer to that of his mother. The words *De Español, y de India produce Mestiso* (From a Spanish man and an Indian woman, a mestizo boy is produced) are inscribed on the blue background between the two adult figures.

In the next panel, titled *De Español, y Mestisa produce Castiso* (From a Spanish man and a mestiza woman, a castizo boy is produced), a mestiza

Figure 3.2. Attributed to Juan Rodríguez Juárez. *De Español, y de India produce Mestiso.* c. 1725. Oil. 80.7 x 105.4 cm. Private collection, Breamore House, England.

Figure 3.3. Attributed to Juan Rodríguez Juárez. *De Español, y Mestisa produce Castiso.* c. 1725. Oil. 80.7 x 104.5 cm. Private collection, Breamore House, England.

woman wearing a more fitted bodice, with a skirt, a shawl across her forearms, and pearl earrings and necklace, carries her baby daughter (figure 3.3). Dressed like her mother, the child reaches out to her Spanish father, who touches her tiny hand. He wears a fitted red waistcoat with embroidered sleeves, and a lace-edged neckerchief is tied at his neck. He does not wear a white wig like that of the Spaniard in the first panel; instead, his dark hair is tied back with a blue ribbon. The half-figures of this couple are placed in a narrow space with the outlines of a blank wall clearly visible. While the light and dark skin colors of the couple are not described in sharp contrast, the mestiza woman's skin has tones of medium brown, while the Spaniard's is a caramel white color; the offspring has the coloring of her father.

Following casta taxonomy, the next panel is titled *De Castiso, y Española produce Español* (From a castizo man and a Spanish woman, a Spanish boy is produced) (figure 3.4). The Spanish woman has the same

lighter skin tones as the Spanish male of the first panel. Wearing a costume similar to that of the mestiza woman in the previous panel, with the addition of an embroidered head cover and a bracelet of pearls, the Spanish woman rests her left hand on her Spanish son's head, and her right hand pats his back. The boy, dressed in a miniature waistcoat, seems distressed. His mouth is open, while one hand rubs his (crying?) eyes and the other grasps the cloak of his castizo father. The father, darker in skin color than the son or mother, has lit a cigarette, which hangs from his lips. He is wearing a brown cloak with a neck scarf and a wide-brimmed hat. Unlike the previous fathers, he makes no effort to touch his child; in fact, he seems to be turning away. The figures are displayed in front of a partial wall.

De Español, y Negra produce Mulato (From a Spanish man and a Black African woman, a mulatto boy is produced) is the title of the next panel (figure 3.5). In contrast to the previous figures, this couple and their

Figure 3.4. Attributed to Juan Rodríguez Juárez. *De Castiso, y Española produce Español.* c. 1725. Oil. 80.7 x 104.5 cm. Private collection, Breamore House, England.

Figure 3.5. Attributed to Juan Rodríguez Juárez. *De Español, y Negra produce Mulato*. c. 1725. Oil. 80.7 x 105.4 cm. Private collection, Breamore House, England.

offspring are placed in what is likely a kitchen, with food and dishes visible, a place naturally associated with Black African servants. The light-skinned man wears a dark waistcoat with a blue vest; the lace of his neckerchief and cuff indicates the shirt underneath. He wears a brimmed hat and a dark red cloak over his shoulders, and his eyes are focused downward as he pays attention only to rolling a cigarette, rather than to the child or its mother. The Black African woman has her body turned away from the Spaniard; however, as she prepares food, she turns her head to look at her son's father with a grimace on her face. She wears a European-style dress with a necklace of red beads and a headscarf. The young mulatto boy, shown in profile wearing ragged clothing, is eating. The dark skin of the mother is a rich coffee brown, while that of her son is dark brown with gray tones.

In the fifth panel, *De Español, y Mulata produce Morisca* (From a Spanish man and a mulatto woman, a morisca girl is produced), we see the

Figure 3.6. Attributed to Juan Rodríguez Juárez. *De Español, y Mulata produce Morisca.*
c. 1725. Oil. 80.7 x 105.4 cm. Private collection, Breamore House, England.

couple in profile, seemingly striding side by side with their morisca
daughter between them (figure 3.6). The Spaniard is wrapped in a heavy
blue cloak and wears a broad-rimmed beige hat with a red ribbon and bow.
The mulatto woman also wears a heavy blue cape; it has a frontal flap,
which hangs open to reveal a red lining. Pearl earrings and a pearl necklace
accent the woman's rich, dark brown skin, and a woven or embroidered
cloth bonnet covers her head. The morisca daughter is light skinned like
her father and wears a smaller version of her mother's cape, along with
earrings and a necklace.

The next panel, entitled *De Español, y Morisca produce Albino* (From a
Spanish man and a morisca woman, an albino boy is produced), shows the
young couple probably on a city street, as indicated by the architectural
element seen in the background to the right (figure 3.7). The morisca
woman wears a white huipil with red and blue accents, a garment usually
reserved for Indian women, which is pulled up so that she can breast-feed

Figure 3.7. Attributed to Juan Rodríguez Juárez. *De Español, y Morisca produce Albino.* c. 1725. Oil. 80.7 x 105.4 cm. Private collection, Breamore House, England.

Figure 3.8. Attributed to Juan Rodríguez Juárez. *De Mulato, y Mestisa produce Mulato es Tornaatrás.* c. 1725. Oil. 80.7 x 105.4 cm. Private collection, Breamore House, England.

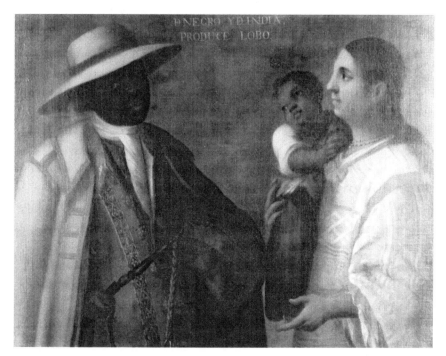

Figure 3.9. Attributed to Juan Rodríguez Juárez. *De Negro y de India, produce Lobo*. c. 1725. Oil. 80.7 x 105.4 cm. Private collection, Breamore House, England.

Figure 3.10. Attributed to Juan Rodríguez Juárez. *De Indio y Loba produce Grifo que es Tente en el aire*. c. 1725. Oil. 80.7 x 105.4 cm. Private collection, Breamore House, England.

her very blond albino baby. The Spanish father is dressed in a rich burgundy-colored fitted waistcoat. His body and right hand sweep forward as if directing the young mother, as his head turns back to peer at his child.

The building placed in the background of the next panel indicates that the group, identified with the words *De Mulato, y Mestisa produce Mulato es Tornaatrás* (From a mulatto man and a mestiza woman, a mulatto, that is, a torna-atrás boy, is produced), is also in a public space (figure 3.8). The mestiza woman wears a white cape with an open front, similar to that of the mulatto woman in panel 5. Her facial features are highlighted by her caramel skin color. Next to her, a dark-skinned mulatto man stands looking out at the viewer as he takes a pinch of snuff from a small case. A white cravat and lace cuffs accentuate his dark overcoat with its bright red cuffs. His brown cloak covers most of the coat. The child, a girl of medium dark skin color, wears an outfit similar to her mother's and stares straight ahead as she proceeds down the street.

The eighth panel, entitled *De Negro y de India, produce Lobo* (From a Black African man and an Indian woman, a lobo boy is produced), shows a medium brown–skinned Indian woman in profile view wearing a simple white huipil decorated with red ribbons (figure 3.9). She holds a swaddled baby of dark brown skin color, and motions to the father. The father wears a blue jacket with red decorations and a neckerchief. An off-white overcloak rests on his shoulders, and his dark brown face is shaded by the wide brim of his hat.

In the panel entitled *De Indio y Loba produce Grifo que es Tente en el aire* (From an Indian man and a loba woman, a grifo, which is a tente en el aire boy, is produced), a woman with her back turned towards the viewer wears a full cape similar to those worn by the women in previous panels (figure 3.10). The grifo (a name referring to curly hair[33]) child rests on his mother's left shoulder. The dark brown–skinned woman gestures toward the Indian man with her hand. He wears a red *tilma*, a cloak made of a single piece of cotton cloth tied at the shoulder and reserved for Indian males. His long, curled locks of hair, also customary for male Indians, dangle at the side of his brown-skinned face.

The next panel is titled *De Lobo, y de India produce Lobo, que es Tornaatrás* (From a lobo man and an Indian woman, a lobo, which is a torna-atrás boy, is produced) (figure 3.11). The group, posed similarly to the people in panel 5, seems to be striding down a street, although no

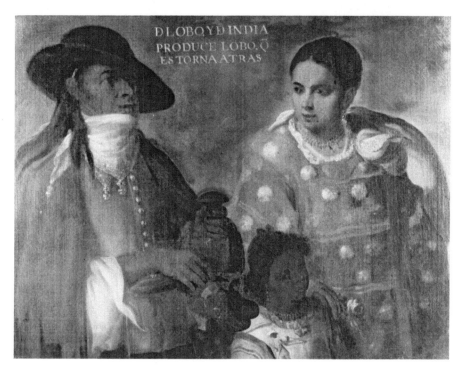

Figure 3.11. Attributed to Juan Rodríguez Juárez. *De Lobo, y de India produce Lobo, que es Tornaatrás.* c. 1725. Oil. 80.7 x 105.4 cm. Private collection, Breamore House, England.

indication of background is given. The Indian woman wears an orangish red huipil, with what may be her folded headpiece resting on her shoulder. She looks toward the lobo man and rests her hand on the child's shoulder. The dark brown–skinned child wears a white huipil accented with blue ribbon. The lobo man, wearing a white shirt and neckerchief and a blue cloak or jacket, which rests on his shoulders, carries a pair of high-heeled shoes and what is perhaps a cobbler's tool, indicating his profession.

The eleventh panel is called *De Mestizo, y de India produce Coyote* (From a mestizo man and Indian woman, a coyote boy is produced) (figure 3.12). The Indian woman, dressed in a huipil and the familiar cloth headpiece, has her back to the viewer. The coyote child puts his tiny arms around his mother's neck as he is carried on her back. The mestizo man stands frontally, with his head downward and slightly turned toward the woman and child. A dark blue cloak is thrown across his chest, and he holds his dark-colored hat.

Figure 3.12. Attributed to Juan Rodríguez Juárez. *De Mestizo, y de India produce Coyote*. c. 1725. Oil. 80.7 x 105.4 cm. Private collection, Breamore House, England.

Figure 3.13. Attributed to Juan Rodríguez Juárez. *Indios Mexicanos*. c. 1725. Oil. 80.7 x 105.4 cm. Private collection, Breamore House, England.

Figure 3.14. Attributed to Juan Rodríguez Juárez. *Indios Otomites, que ban a la feria.* c. 1725. Oil. 80.7 x 105.4 cm. Private collection, Breamore House, England.

Figure 3.15. Attributed to Juan Rodríguez Juárez. *Indios bárbaros.* c. 1725. Oil. 80.7 x 105.4 cm. Private collection, Breamore House, England.

The next three panels show three different types of Indians. The twelfth panel is titled *Indios Mexicanos* (Mexican Indians [referring to the descendants of the Aztec-Mexica]) (figure 3.13). The woman, who wears a huipil, seems to gesture to the Indian male, who wears a simple, short-sleeved tunic and carries a basket of fruit using a *tumpline*, a sling to support the basket. Their female child, wearing a huipil and headdress, looks in the direction of her mother's gesturing hand. The next group of Indians, identified with the words *Indios Otomites, que ban a la feria* (Otomí Indians, going to the market), has costumes similar to those of the Mexican Indians (figure 3.14). The woman holds a bowl of eggs, and the man carries a rooster; their son eats a rolled tortilla. Concluding this series is a panel entitled *Indios bárbaros* (Barbarian Indians [referring to Indians from the northern frontier]), which displays an Indian group scantily dressed in feathers and simple cloth swags (figure 3.15). The male carries a bow and quiver, and his son plays with a bow and arrow while the mother looks over the boy's head.

The panels of the Juan Rodriguez Juárez casta series show the three categories of inhabitants of New Spain—Spaniards, Indians, and Black Africans—and their potential mixed-blooded offspring. The legends utilize the basic sociedad de casta nomenclature discussed in chapter 2. The artist, however, emphasizes the grouping of castas into three lineages, or razas: (1) Spaniard-Indian, (2) Spaniard–Black African, (3) Black African–Indian. Thus, the first three panels of this series show the progeny of Spaniard-Indian mixing:

Español—India

↓

Español—Mestiza

↓

Castizo—Española

↓

Español

Continuing, the second grouping of three panels displays the offspring of Spaniard–Black African unions:

Español—Negra

Español—Mulatta

Español—Morisca

Albino

From an eighteenth-century perspective, these *generaciones* terminate at the point where the Spanish blood would have been most prevalent and accepted, in theory, as indistinguishable from that of "pure" peninuslares and criollos.

Skipping on to the eighth, ninth, and tenth panels, the third line of descent, we find the mixing of Black African and Indian blood:

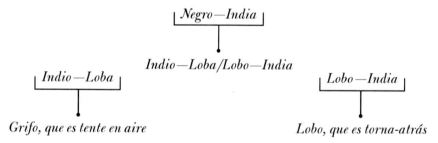

Negro—India

Indio—Loba/Lobo—India

Indio—Loba

Lobo—India

Grifo, que es tente en aire

Lobo, que es torna-atrás

Skipping another panel, the final three panels show so-called pure Indians, which, as we have seen, were not considered a casta/mixed category but a pure-blood—untainted by Moorish or Jewish blood—classification.

The seventh and eleventh panels, inserted after the second and third lineages, illustrate the mixing of mestizo blood with non-Spanish blood:

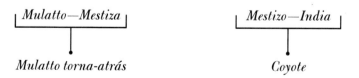

Mulatto—Mestiza

Mestizo—India

Mulatto torna-atrás

Coyote

This early patterning of panels ordered into three lineages followed by "pure" Indians—with the interpolation of various other possible casta

mixtures—was repeated in casta paintings throughout the eighteenth century. The paintings use straightforward conventions of clothing to show differences and hierarchy between and among the castas. Fitted European clothing styles are used for most of the male figures in the paintings, with the finer and more elaborate types reserved for Spaniards. Indian males are shown wearing loose-fitting tunics or, in the case of the indio bárbaro, a loincloth. Likewise, skin color is also used to differentiate the groups. Rich, dark brown skin color is assigned to Black Africans and mulattos; medium brown is used for Indians and Indian-mulatto offspring; and pale, cream-colored skin is reserved for Spaniards and castizo and albino offspring. The family unit is the focal point; economic references, such as occupation, and specific references to spatial location are of little or no interest. The overall directness and simplicity of these early casta representations and the lack of concern with contextual details combine to promote the images as illustrations loosely following casta taxonomy with emphasis on lineage grouping rather than just a rigid hierarchy.

Similar casta series continue to appear throughout the next two decades. Around the middle of the century, there is a very significant break in the format of the paintings: figures are relocated from blank, generalized backgrounds to specific interior spaces or public city spaces.[34] Thus, subsequent series begins to display the castas as located in urban or rural settings.[35] In addition, detailed information about the economic/vocational status of individuals is given greater attention. The move to more comprehensive programs of representation is augmented by the addition of numbering to the panels and notations about the specific local fruits and vegetables shown in the scenes.

Marcus Burke's research on religious art may offer a potential explanation for this shift. At the end of the seventeenth century, the massive effort of church building and large-scale decoration resulted in a reorganization of the arts that forced painters to become subcontractors to joiners and carpenters; the artists were reduced to producing devotional images that fit into the huge *retablos*, or large, elaborate altarpieces. Large ateliers reacted to this lower ranking by offering "completely painted environments," meaning "enormous single composition and multiwork decorative cycles" that filled the spaces of churches such as the altars, side-chapels, and sacristies.[36] Artists, Burke argues, began to organize their

imagery into comprehensive iconographic programs in cycle or serial fashion.

> Perhaps it was the necessity to compete with the sea of rich carving and gold leaf in the new church interiors after 1730 that led the Mexican painters to develop on their own, a somewhat naïve classicism well in advance of the development of neoclassicism in Europe.[37]

While the baroque style predominated in the large paintings, this "naïve classicism" emphasized a clear, simple composition and idealized figures, and is most often found in small devotional paintings and easel-sized images for the altars.[38] Burke's identification of a previously overlooked "naïve classicism" initiating in the early eighteenth century is an important observation, and it is a phenomenon that, I would argue, is also found in contemporary casta genre paintings.

With its emphasis on a comprehensive iconographic program set in serial format and utilizing the figural simplification of "naïve classicism," the 1763 casta set executed by Miguel Cabrera (1695–1768) is an excellent example of the midcentury innovations in the casta genre. Cabrera's considerable artistic talent, which combined an astute eye with a love of color, floral-patterned fabric, and contrasting textures, found its perfect outlet in his casta paintings. His palette tends toward light browns, with high contrasts of white and black and bright accents of rich oranges, yellows, greens, and blues. The artist's compositions are consistent in the use of consecutive organization of space: the foreground is used for depicting fruits and vegetables of New Spain; middle ground space is occupied by a casta triad; and background space is used to situate the family unit in a public or private locale. In public locations, Cabrera employs a wall in the background to keep the viewer's eyes on the figural group.

Despite the fact that two panels are missing, it is clear that Cabrera's sixteen-panel set follows a basic lineage structure similar to that of the Rodrígues Juárez set. Cabrera begins with an exploration of the Indian-Spaniard lineage. The first Cabrera panel is entitled *1. De Espanol, y d India; Mestisa* (1. From a Spanish man and an Indian woman, a mestiza girl) (figure 2.3). As discussed in chapter 2, in this panel, great attention is

given to the details of clothing and background. Using the burlaplike covering of the side of the stall as a neutral form, Cabrera is able to highlight the Indian woman's face and beautiful, layered costume. The placement of the three-quarter figures in front of a textile stall informs the viewer that the location is the public space of the market. The child holds a half-eaten piece of pineapple, and on display in the foreground are a whole and a sliced pineapple marked with the word "*piña*."

In the second panel, *2. De Español, y Mestisa; Castiza* (2. From a Spanish man and a mestiza woman, a castiza girl), the Spanish man's body and face are turned toward the viewer; his burnt orange embroidered

Figure 3.16. Miguel Cabrera. *2. De Español, y Mestisa; Castiza.* 1763. Oil. 135.5 x 103.5 cm. Museo de América, Madrid.

waistcoat is complemented by a cravat and white lace cuffs (figure 3.16). The light-skinned Spaniard wears a powdered wig and carries his tricorner hat under his left arm. The medium brown–skinned mestiza woman wears an off-white fitted dress with crisscross embroidery across the bodice and a blue, floral-patterned skirt. She carries her young, petite castiza daughter, who wears a dress resembling her mother's, but with the burnt orange coloring of her father's coat. The group is located in a public place, perhaps a market, marked by a vending stall with its door swung open to reveal shoes neatly stacked on shelves. In the foreground, stacks of unfinished shoes and fruit can be viewed.

The third painting of the series is missing. Most likely, following the format of earlier series, this first Spaniard-Indian genealogy would have concluded with a third panel showing a castiza woman and a Spanish man and their Spanish offspring.

With panel 4, Cabrera begins his description of the second line of descent: the mixing of Black African and Spanish blood. In *4. De Español, y Negra; Mulata* (4. From a Spanish man and a Black African woman, a mulatto girl), the Spanish male is shown wearing a simple, unadorned grayish brown waistcoat (figure 3.17). It is accented with a neckerchief; simple, white sleeve cuffs; and a reddish orange vest. His head, covered by a very broad-rimmed beige hat, is tilted downward, looking at the child and avoiding the glower of the child's mother. The Spaniard's arms are wrapped around the mulatto girl, who is hunched and seems to be seated on a low wall or table between the couple. She wears a white blouse with an orange shawl tucked into the waist of her lace-trimmed blue skirt. The child, holding a piece of fruit, has beautiful brown-toned skin. The child's mother stands in front of the young girl and gestures with her right hand while she scowls at the father. The woman's dark brown skin presents a sharp contrast to that of the Spaniard and the child, and to the lighter tones of other parts of the painting. This contrast is emphasized even more by the dense black headscarf and short cape worn by the woman. The edges of a gray-and-orange-striped rebozo are revealed below the cape, and her very full skirt is decorated with the artist's signature floral pattern of orange, blue, and green flowers and vines on a white background. The woman holds a small basket of fruits and vegetables in her left hand. The couple stands outdoors, with a tree and the corner of a building in the background.

De Español y Negra; Mulata.

Figure 3.17.
Miguel Cabrera.
*4. De Español,
y Negra; Mulata.*
1763. Oil.
135.5 x 103.5 cm.
Private collection,
Mexico.

Continuing this lineage, the next panel, 5. *De Español, y Mulata;
Morisca* (5. From a Spanish man and a mulatto woman, a morisca girl),
displays a brown-skinned mulatto woman whose tightly curled hair, tied
back in a red ribbon, encircles her face (figure 3.18). She wears a short,
dove gray cloth cloak, which is opened at the neckline, revealing a blue-
and-white-striped bodice or blouse. Gorgeous yellow flowers swirl and
bloom across the white background of her skirt. She looks intently over at
the Spanish man, whose scarf-covered head supports a wide-brimmed hat
with gold trim. He is shown wearing a black-trimmed brown cape that is
thrown over his shoulder. He gently holds his morisca daughter, who
stands on a table. The light-skinned little girl wears a white blouse, a green

skirt bordered with flowered embroidery or ribbon, and tiny white-and-blue shoes. She smiles and looks up at her father as she tugs at the edge of his jacket. A male child, in typical sibling taunting, uses a peashooter to shoot a small, round projectile at his sister. The boy, who has the same coloring as his sister, wears a short orange jacket with matching pants and a white shirt. In the foreground, two avocados rest on the table; one is cut open to reveal its pit. In the background, the blurry outlines of a landscape are seen through an arched window niche and may indicate that the figures are in an interior space.

Panel 6 is also missing, but following the format of the Spaniard–Black African lineage, it probably would have shown a morisco-and-Spanish couple and their albino offspring.

Figure 3.18.
Miguel Cabrera.
5. De Español, y
Mulata; Morisca.
1763. Oil.
135.5 x 103.5 cm.
Private collection,
Mexico.

De Efpañol y Albina Torna atras.

Figure 3.19.
Miguel Cabrera.
*7. De Español, y
Albina, Torna atrás.*
1763. Oil.
135.5 x 103.5 cm.
Private collection,
Mexico.

In *7. De Español, y Albina; Torna atrás* (7. From a Spanish man and an
albina woman, a torna-atrás girl), we see an extremely pale woman who
wears a dress consisting of a fitted white bodice with three-quarter sleeves
ending in lace cuffs, and a full skirt (figure 3.19). The front of the bodice is
decorated with lace and a series of orange, layered, fanlike bows that repeat
the color of the flower print on the skirt. The woman's white hair is pulled
back into a headband and net, setting off her limpid blue eyes, her pursed
pink lips, and a necklace and earring made of large pearls. The woman is
seated, looking away, perhaps at the colorful tropical parrot perched in the
window, with her right hand around the shoulder of the daughter who
stands next to her; her left hand cups the child's chin. The torna-atrás
child, who wears a fitted dress similar in design to her mother's, also seems

Figure 3.20.
Miguel Cabrera.
8. De Español,
y Torna atrás;
Tente en el ayre.
1763. Oil.
135.5 x 103.5 cm.
Private collection,
Mexico.

De Español, y Torna atras, Tente en el ayre.

to be gazing at the bird and offering it a tiny bowl of seed(?). The Spanish
father stands behind the mother and daughter. He is wrapped in a cloak,
with only his white collar showing, and wears a large, wide-brimmed black
hat. The triad is located in an interior space denoted by the chairs behind
the little girl and the table covered in seedpods in the foreground.

The rich colors of the eighth panel, which concludes this
Spaniard–Black African genealogy, are delightful to the eye (figure 3.20).
Entitled *8. De Español, y Torna atrás; Tente en el ayre* (8. From a Spanish
man and a torna-atrás woman, a tente en el aire boy), the picture shows a
seated Spanish man wearing a bright reddish orange cloak with a silvery
gray border at the neck and bottom edges; the right side of the cloak is
thrown across the left shoulder. Below the cloak, a yellowish brown jacket

De Negro y di dia China cambuja.

Figure 3.21.
Miguel Cabrera.
9. De Negro, y de
India; China
cambuja. 1763.
Oil. 135.5 x 103.5 cm.
Museo de América,
Madrid.

and matching pants, also with silvery gray decoration, are visible. His head
is covered with a white kerchief and topped with a brimmed beige hat. A
sword rests behind his left knee; he holds its hilt with his right hand. The
torna-atrás woman is dazzling in an all-white fitted dress accented with an
orange-striped rebozo, or shawl. Her hair is pulled back into a bow, and
she wears a pearl necklace with matching earrings. Her head is gently
placed next to that of her young tente en el aire son, whom she holds
lovingly with both arms. The boy is elegantly dressed in a white waistcoat
with blue embroidery around the edges and on the pockets, with matching
pants and vest. He wears tiny beige shoes with black tips and reddish

orange knee stockings. In the foreground, a second child wears a blue *Problems in the change of casta paintings* jacket and holds a metal platter with sliced papaya on it.

Beginning with panel 9, Cabrera describes the Black African–Indian lineage. Three important changes occur in the next seven panels: (1) the palette starts to shift to monochromatic browns; (2) the incidental and limited reference to fruit or vegetables seen in preceding panels becomes more elaborate; and (3) references to the means of economic subsistence, vague at best in the previous panels, are made more explicit.

In *9. De Negro, y de India; China cambuja* (9. From a Black African man and an Indian woman, a china cambuja girl), the couple look at each other tenderly (figure 3.21). The woman wears a white huipil, which has a woven diamond design in it, with a necklace and earrings. Her brown rebozo with a flower pattern is draped around her head and over her shoulders, and it sets off her medium brown skin. She gently touches her dark brown–skinned china cambuja daughter, who wears a European-style costume consisting of a white blouse and a skirt with a blue flower pattern. The child's seated father, who wears an orange waistcoat with brown button-decorated cuffs, a white shirt, a light brown cape, and a brimmed hat, holds her. The corner of a building on the right side of the paintings indicates that the couple is in a public space. The foreground is filled with an array of labeled fruits and vegetables.

The next panel is titled *10. De Chino cambujo, y d India; Loba* (10. From a chino cambujo man and an Indian woman, a loba girl) (figure 3.22). The Indian woman wears a handsome huipil with a geometric pattern woven into it and flowered ribbon decorating the neck edge and seams. A white cloth, probably the folded headpiece seen in other panels, is draped on her shoulder. Her necklace of black and orange beads highlights her medium brown skin. She holds her dark brown–skinned daughter, who wears a full-sleeved blouse and a flower-patterned skirt. The child holds a toy and plays with her father's black tri-corner hat. The chino cambujo is dressed in a blue waistcoat and a light orange vest with a white lace shirt. His hair is long and flows down his shoulders. The triad seems to be in the open air; in the foreground, the corner of a table is covered with ceramic ware.

Panel 11 of Cabrera's casta series, *11. De Lobo, y de India; Albarasado* (11. From a lobo man and an Indian woman, an albarasado boy), was described in chapter 2 (figure 2.4). Considered in relationship to the

preceding panels, the lobo man's tattered cloak, with emphasis on the stitching that holds it precariously together, and the woman's simple, striped huipil are stark contrasts to the neat, fine waistcoats and cloaks seen in the previous paintings. In addition, their status as vendors is made explicit, introducing the economic theme of the next three images. Finally, this canvas and all subsequent panels use monochromatic browns and lack the striking color contrast of the previous panels.

 12. De Albarasado, y Mestisa; Barsino (12. From an albarasado man and a mestiza woman, a barcino [no literal translation] boy) shows more

Figure 3.22. Miguel Cabrera. *10. De Chino cambujo, y d India; Loba.* 1763. Oil. 135.5 x 103.5 cm. Museo de América, Madrid.

complex interaction among the figures than previously seen (figure 3.23). In what appears to be a dark interior space, a mestiza woman wearing a simple white blouse, blue skirt, and striped rebozo is combing through the hair of her seated and grimacing daughter, perhaps picking nits out (the poor were often considered to be lice infested). The albarasado father wears a bedraggled-looking jacket with a shirt. His red pants are slipping down, revealing undergarments. His head, topped with a black hat, is tilted away, almost as though he is trying to avoid the stare of the mestiza woman. A young boy, also in tattered clothing, holds a candle and what appears to

Figure 3.23.
Miguel Cabrera.
12. De Albarasado, y Mestisa; Barsino. 1763.
Oil. 135.5 x 103.5 cm. Museo de América, Madrid.

De Indio, y Barsina: Zambayga.

Figure 3.24. Miguel Cabrera. *13. De Indio, y Barsina; Zambayga*. 1763. Oil. 135.5 x 103.5 cm. Museo de América, Madrid.

be a small bowl of beads, items he may have been hawking on the street. In this painting, unlike in previous panels, Cabrera uses the strong compositional direction of the boy's arm, the father's pointed finger, and the mother's right elbow to bring the viewer's attention to the girl's open right hand, which holds a coin. This attention to money may be Cabrera's comment on the results of the street vending common to this segment of the population.

The next panel, entitled *13. De Indio, y Barsina; Zambayga* (13. From an Indian man and a barcina woman, a zambayga [no literal translation] girl), takes the viewer back to the city streets, as marked by the building corners (figure 3.24). The Indian man, wearing a very ripped tunic, a blue-striped neckerchief, and what looks like a leather apron, holds a plate of

tamales. His daughter wears a tattered dress and is taking a tamale. The mother, also in frayed and torn clothing, serves a tamale to her son, who wears the curled side locks associated with Indians and squats in the corner of the canvas, holding a bowl. All figures have the same dark brown skin tone. In the foreground rests a large ceramic urn with a tumpline attached to its handles. This may indicate that the Indian is a water carrier, an essential job in the capital city.

The fourteenth panel, *14. De Castiso, y Mestisa; Chamiso* (14. From a castizo man and a mestiza woman, a chamiso [possible reference to a half-burned tree[39]] boy), is somewhat out of order because neither castizo nor

Figure 3.25.
Miguel Cabrera.
14. De Castiso, y Mestisa; Chamiso.
1763. Oil.
135.5 x 103.5 cm.
Museo de América, Madrid.

Figure 3.26.
Miguel Cabrera.
16. Indios gentiles.
1763. Oil.
135.5 x 103.5 cm.
Museo de
América, Madrid.

mestiza is part of the Spaniard–Black African lineage (figure 3.25). Here,
the artist takes the viewer to the interior of a cigarette maker's workshop.
Again, the family is shown wearing extremely unkempt and torn clothing.
The castizo father sits rolling cigarettes on a tray. The mestiza woman,
elbows resting on a table covered with packages of cigarettes, holds her
head between her hands while she looks down at the activity of the
workshop. Their chamiso son plays with a tray. In the foreground,
coconuts are visible. The fifteenth panel, which is missing, probably would
have shown the coyote offspring and its parentage, which was a popular
triad in all casta series.

Cabrera concludes his casta series with a panel entitled *16. Indios gentiles* (16. Gentile [meaning pagan] Indians) (figure 3.26). The man and woman are pictured in the wilderness, scantily clothed and carrying the basket and bow and arrows that mark their hunting/gathering existence. Gourds and an armadillo are shown on a rock outcrop in the foreground of the painting.

In sum, the order of the Cabrera series is similar to that of the Rodrígues Juárez set in that it illustrates the three lineage units of casta hierarchy. Skin color and clothing remain markers of blood mixing; however, following the 1750s shift in iconography discussed above, Cabrera visually elucidates more concrete and tangible characteristics and qualities of the upper and lower castas through contrasting iconographic details. Specifically, in panels 12–14, he illustrates the characteristics of the lower castas by depicting them with unkempt, soiled, torn clothing, in contrast to the fine, colorful clothing of the upper-class groups in panels 1–11. Means of economic subsistence are less clear for the upper casta levels, but mestizo and castizo calidad are associated with market exchange of goods—textiles and shoes. The subsequent castas are described explicitly as street vendors, water carriers, and cigarette makers. Finally, Cabrera attempts to give specific places to these mixed-blooded people: they are shown in interior spaces and in the markets and streets of the city. Only the indios gentiles of the final panel are shown completely outside the city.

The details of Cabrera's work, reflecting a midcentury stylistic shift, may be seen as an expansion of the viewing field to emphasize how these people might appear and function in metropolitan spaces. His imagery exemplifies how the visual practice of casta paintings changed from the illustration of castas through indeterminate, portraitlike, compartmentalized, and fragmented observations like those found in the Rodrígues Juárez paintings, to a surveillance of castas through a tangible, serialized, more comprehensive presentation of the casta lineages. In fact, Cabrera's paintings proclaim the presence of the observing, penetrating, and discriminating surveillance, a kind of diagnostic gaze, one that provides an anonymous and accurate observation of casta appearances and circumstances and naturally distinguishes truth from fiction, Spaniard from casta.

Through the eighteenth century, this gaze deployed a progressively more intense and comprehensive scrutiny and surveillance. This

progression is illustrated by a third casta series dated 1774 and signed by
Andrés de Islas (active 1750–1770s), a well-known portrait painter and
possible student and/or follower of Cabrera.[40] As in the previous two
series, the Islas paintings illustrate, not casta taxonomy, but the Spaniard-
Indian, Spaniard–Black African, and Black African–Indian lineages.

In the first panel, entitled *N. 1. De Español, e India; nace Mestizo* (No. 1.
From a Spanish man and an Indian woman, a mestizo boy is born), we see
three full-length figures who are walking in the countryside (figure 3.27).
The Indian woman wears a dress with a fitted white bodice and a full skirt

Figure 3.27.
Andrés de Islas.
*N. 1. De Español,
e India; nace
Mestizo.* 1774. Oil.
75 x 54 cm.
Museo de
América, Madrid.

made of traditional fabric, which seems to have geometric patterns woven into it. Over her dress, she wears a gauzelike, almost transparent garment that has the general shape of a huipil, is embroidered with flowers, and has a ribbon edging. The woman is adorned with a multistrand pearl necklace and matching earrings. Her right arm is raised as she holds her folded cloth headpiece to her head with her hand. Striding alongside her is a Spanish man who is attired in a white waistcoat, matching vest and pants, and a black tri-corner hat. Their mestizo son, wearing a miniature version of his father's outfit, grabs his mother's arm with one hand and rubs his eye with the other, perhaps sobbing.

Indicating that the surveying eye can penetrate any colonial space, Islas dramatically shifts the setting for the next two groups in the Spaniard-Indian lineage to the private domain. The panels entitled *N. 2. De Español, y Mestisa; nace Castiso* (No. 2. From a Spanish man and a mestiza woman, a castizo boy is born) and *N. 3. De Castizo, y Española; nace Español* (No. 3. From a castizo man and a Spanish woman, a Spanish boy is born) show the second and third generations of this Spaniard-Indian genealogy (figures 3.28 and 3.29). In the second panel, a mestiza woman sits quietly nursing her castizo baby, while the Spanish father touches the woman's back and the child's head. The adult figures are garbed in European-style clothing, and the baby is swaddled in a long dressing gown and a blanket. Looking through the large arched window on the left side of the panel, we see a garden scene. While Cabrera situates the corresponding triad in a public space in front of a shoe-vending stand, Islas emphasizes a more elite status by placing this group in a private domestic space, denoted by the European-style chair on the left and the paintings and mirror with reflected candles on the back wall.

The reference to elite domestic space is continued in the next panel, where a very light-skinned Spanish woman and a castizo man sit in their parlor. Using some of the conventions of elite portraiture, Islas shows the woman wearing an elegant off-white dress with pearl earrings, necklace, and bracelet, and holding a fan. Grayish white powdered hair emphasizes her pale beige skin, and behind her is a swag of orange cloth. Wearing a blue waistcoat, white shirt, and red pants with black stockings and shoes, the Spanish boy sits on his mother's lap and grabs the bow of his father's violin. The wigged castizo father, attired in a blue waistcoat with matching pants, a red vest, white stockings, and black shoes, guides the bow for his

De Español, y Meſtiſa, nace Caſtiſo.

Figure 3.28.
Andrés de Islas. *N. 2.*
De Español, y
Mestisa; nace Castiso.
1774. Oil. 75 x 54 cm.
Museo de América,
Madrid.

young son. Compared to the previous and most of the subsequent panels, Islas provides very little background detail for this couple; no doubt, their elaborate clothing and leisurely, cultured activity were sufficient manifestation of their elite Spanish/criollo calidad.

 In stark contrast to the domestic tranquility of the previous paintings, Islas introduces the Black African–Spaniard lineage with the depiction of a violent encounter between a Black African woman and Spanish man. *N. 4. De Español, y Negra; nace Mulata* (No. 4. From a Spanish man and a Black African woman, a mulatto girl is born) shows a Black African woman who has grabbed the hair of a Spanish man and is about to strike him with some

Figure 3.29.
Andrés de Islas.
N. 3. De Castizo, y Española; nace Español. 1774. Oil.
75 x 54 cm.
Museo de
América, Madrid.

sort of kitchen implement (figure 3.30). The Spaniard appears shocked as he attempts to free his hair from the woman's grip and protect himself from the oncoming blow. Their mulatto daughter pushes at her mother's leg. Within the system of honor in colonial Mexico, hair grabbing was used during arrests of criminals and was considered to be a desecration of one's personal honor.[11] In depicting the Black African woman in this situation, Islas may be attempting to show not only the violent character of this kind of person but also both the concrete and the abstract ability of Black African blood to dishonor respectable Spaniards. The kitchen setting is the social antithesis of the parlor setting, and it further emphasizes the

supposed negative qualities of the Black African woman. Finally, Islas takes this opportunity to highlight the exotic fruits and vegetables of the country. In the foreground, he illustrates fourteen different kinds of fruits and vegetables. Their numbering corresponds to the list of fruits inscribed on the upper part of the canvas under the title "Fruits from the Country." It might be speculated that Islas was comparing the odd and exotic fruits to the Spaniard–Black African couple and their mulatto daughter.

While Islas reverts to familial tranquility in the following panel, this returned calmness is situated in a new locale: the economic spaces of

Figure 3.30. Andrés de Islas. *N. 4. De Español, y Negra; nace Mulata.* 1774. Oil. 75 x 54 cm. Museo de América, Madrid.

colonial Mexico. In *N. 5. De Español, y Mulata; nace Morisco* (No. 5. From a Spanish man and a mulatto woman, a morisco boy is born), the neatly and simply dressed couple labor intently in a cigarette shop, while their morisco son looks on (figure 3.31). The door on the left side of the canvas may indicate that the shop opens onto a street. The fifth panel's emphasis on labor contrasts with the cultured leisure of the Spaniard-castizo couple, and associates the Black African–Spaniard lineage—unlike the Spaniard-Indian group—with manual labor.

Figure 3.31. Andrés de Islas. *N. 5. De Español, y Mulata; nace Morisco.* 1774. Oil. 75 x 54 cm. Museo de América, Madrid.

Figure 3.32.
Andrés de Islas.
N. 6. De Español,
y Morisca; nace
Albino. 1774. Oil.
75 x 54 cm.
Museo de
América, Madrid.

Returning to a domestic interior, Islas illustrates a group identified with the words *N. 6. De Español, y Morisca; nace Albino* (No. 6. From a Spanish man and a morisca woman, an albino boy is born) (figure 3.32). The unshaven(?) Spaniard, attired in what appears to be a robe, sits writing at a table. The morisca woman, dressed in a fitted bodice with a flower-patterned skirt accented with ribbons, hands her albino son a doughnut-shaped object, perhaps a cookie. The child holds a toy and looks over to his father. The interior of the room is decorated with framed pictures and a mirror reflecting a candle.

In the final panel of the Spaniard–Black African lineage, a domestic scene is repeated in *N. 7. De Español, y Alvina, nace; Torna-atrás* (No. 7.

From a Spanish man and an albina woman, a torna-atrás boy is born) (figure 3.33). Seated in front of what appears to be a tapestry-covered wall, and dressed in a suit and cape as if he has just arrived for a visit, a Spanish man holds his dark brown–skinned son, who is dressed in a tiny blue waistcoat with a red vest and pants, white stockings, and black shoes. His albina mother holds the child's tiny tri-corner hat in her right hand. She is dressed in a fitted white bodice and a black skirt and holds a red jacket and fan. Her whitish hair is pulled back into a gauzy net. Curiously, this concluding panel of the Spaniard–Black African series places the lineage in a neutral, almost positive light: not as cultured as the concluding

Figure 3.33. Andrés de Islas. *N. 7. De Español, y Alvina, nace; Torna-atrás.* 1774. Oil. 75 x 54 cm. Museo de América, Madrid.

panel of the Spaniard-Indian lineage, but by appearance and circumstances, quite socially acceptable. Islas seems to display ambivalence about the nature of the third generation of the Spaniard–Black African lineage.

Islas introduces the Indian–Black African genealogy beginning with panel eight. In *N. 8. De Indio, y Negra; nace Lobo* (No. 8. From an Indian man and a Black African woman, a lobo boy is born), we are taken to the open-air stand of a food vendor (figure 3.34). The Black African woman, neatly dressed with her sleeves rolled up, has a table of prepared foods in

Figure 3.34.
Andrés de Islas.
*N. 8. De Indio,
y Negra; nace Lobo.*
1774. Oil. 75 x 54
cm. Museo de
América, Madrid.

front of her. She is pointing her knife at her raggedly dressed lobo son, who holds a plate of food. The Indian man, dressed in torn and tattered clothing, has his hand open as if begging for food. The triad is placed in front of bamboo fencing, indicating that they are not on a street with stone buildings in the heart of the city, but perhaps on its outskirts.

As in the Rodrígues Juárez series, Islas breaks from this genealogy to show a mestizo-Indian group. Unlike the mestiza woman in panel 3, the mestiza woman in *N. 9. De Indio, y Mestisa; nace Coyote* (No. 9. From an

Figure 3.35.
Andrés de Islas.
*N. 9. De Indio, y
Mestisa; nace
Coyote.* 1774. Oil.
75 x 54 cm.
Museo de
América, Madrid.

Figure 3.36.
Andrés de Islas.
N. 10. De Lobo, y Negra; nace Chino. 1774. Oil.
75 x 54 cm.
Museo de América, Madrid.

Indian man and a mestiza woman, a coyote boy is born) is associated with an Indian mate instead of a Spaniard and is shown with lower calidad (figure 3.35). She is dressed in loose-fitting Indian-like clothing. The Indian man wears a striped shirt with short pants and sandals and carries his tilma, or cape, and hat. On his back are rolled, woven straw mats, possibly for sale. The coyote child stands between his parents, turning toward his mother. The group, possibly street vendors, is placed in front of a building likely on a city street.

N. 10. De Lobo, y Negra; nace Chino (No. 10. From a Lobo man and a Black African woman, a chino boy is born) returns to Islas's interpretation

of Indian–Black African descent (figure 3.36). Placed again at the outskirts of the city, as marked by the cane wall and swampy background, a Black African woman, neatly dressed in a white-and-blue European-style dress, sits in front of a vat of milky white liquid. Her chino son, wearing a red waistcoat with blue pants and white stockings, grabs the edge of the vat. The child's father, dressed in a loose-fitting white tunic and blue pants with a red scarf, is walking away with a bowl of the liquid.

Islas returns the viewer to the city in the panel entitled *N. 11. De Chino, e India; nace Cambuxo* (No. 11. From a chino man and an Indian woman, a cambujo boy is born) (figure 3.37). As in the previous panel, we are shown

Figure 3.37.
Andrés de Islas.
*N. 11. De Chino,
e India; nace
Cambuxo.* 1774.
Oil. 75 x 54 cm.
Museo de
América, Madrid.

a street-vending scene with the triad located in front of an edifice. The large wooden doors are ajar, revealing an interior column. Clad in traditional Indian attire, the seated Indian woman serves tamales from a large pot. The cambujo child, wearing a loose shirt, straddles his mother's right leg while reaching for the pot's rim. The chino man, a water carrier wearing a simple tunic and pants, eats a tamale and drinks a bowl of water(?).

The next panel takes the viewer to the interior of a cobbler's workshop. In *N. 12. De Cambuxo, e India; nace; Tente en el aire* (No. 12. From a cambujo man and an Indian woman, a tente en el aire girl is born), the cambujo cobbler is seated at his workbench working on a pair of shoes (figure 3.38). He looks over to the Indian woman, dressed in European-style clothing,

Figure 3.38. Andrés de Islas. *N. 12. De Cambuxo, e India; nace; Tente en el aire.* 1774. Oil. 75 x 54 cm. Museo de América, Madrid.

Figure 3.39.
Andrés de Islas.
*N. 13. De Tente en el
aire, y Mulata; nace
Albarasado.* 1774. Oil.
75 x 54 cm. Museo de
América, Madrid.

who is cooking an egg on a makeshift griddle. The tente en el aire child
stands behind her mother. Islas shows us details of the equipment and
materials found in the cobbler's shop.

Panel 13, *N. 13. De Tente en el aire, y Mulata; nace Albarasado* (No. 13.
From a tente en el aire man and a mulatto woman, an albarasado boy is
born), continues the Black African–Indian genealogy (figure 3.39).[12] The
triad is shown on the street at the mulatto woman's makeshift fruit stand.
The ragged albarasado boy holds a plate while his mother places a fruit on
it. His father taps him on the shoulder with a cloth(?) and points toward
the street.

The next two panels conclude this lineage with illustrations labeled *N. 14. De Albarasado, e India; nace Barsino* (No. 14. From an albarasado man and an Indian woman, a barcino boy is born) and *N. 15. De Varsino, y Cambuxa; nace Campamulato* (No. 15. From a barcino man and a cambuja woman, a campamulato boy is born) (figures 3.40 and 3.41). Like the previous group, these casta triads are represented as vendors. Standing in the open countryside, the albarasado man, dressed in jacket, shirt, and pants, holds a small tray of what are likely sweets. He offers one to the

Figure 3.40. Andrés de Islas. *N. 14. De Albarasado, e India; nace Barsino.* 1774. Oil. 75 x 54 cm. Museo de América, Madrid.

Indian woman, who is in traditional dress and carrying live turkeys, perhaps taking them to sell at a market. Their barcino children stand between them, the older boy carrying his sibling. In panel 15, we are returned to the city streets, where a neatly dressed cambuja woman, holding her campamulato baby, sits next to her scantily dressed barcino partner in front of an open-air vegetable stand. Panels 13, 14, and 15 display people who may have come from the environs of the city to sell food products.

Figure 3.41.
Andrés de Islas.
*N. 15. De Varsino,
y Cambuxa; nace
Campamulato.*
1774. Oil. 75 x 54
cm. Museo de
América, Madrid.

Figure 3.42. Andrés de Islas. *N. 16. Indios Mecos bárbaros.* 1774. Oil. 75 x 54 cm. Museo de América, Madrid.

The final panel of the Islas casta series is titled *N. 16. Indios Mecos bábaros* (No. 16. Barbarous Meco Indians) (figure 3.42). As in the previous two sets, these Indians, considered to be wild, are shown barefooted and scantily dressed in feathered loincloths. With her long hair covering her breasts, the woman carries two children in a basket on her back. Far from city streets, in an untamed wilderness, the couple is shown with bows and arrows to illustrate their dependence on hunting for subsistence.

 Compared to the panels of Miguel Cabrera, those of Andrés de Islas depict more visual variation in mixed-blooded people. While remaining aware of the skin color and clothing, Islas concentrates on the social and

economic contexts of these casta lineages. The artist accomplishes this by utilizing an omniscient gaze, which allows the observer to see places that would rarely, if ever, be visited by the elite. He takes us to the workshops of cobblers and cigarette makers. Strolling from the workshops, we pass people in tattered clothing who are selling and eating food. Islas enables the viewer to see private domestic places and moments: a nursing mother, the leisure activity of an elite couple, and even quarreling lovers. Islas's paintings, while loosely referencing the sistema de castas, can be more accurately described as visual constructions of the essence of Spanish and non-Spanish calidad. Unlike Cabrera, Islas allows the mestizo-Spaniard-castizo triad to appear honorable and wealthy, performing no manual work; by appearance and circumstances, they are of the calidad of Spaniards. In contrast, other people of mixed blood are portrayed as, poor, plebeian street vendors and manual laborers.[43] Islas's work argues that spatial associations are an integral part of calidad. Domestic privacy is a Spanish prerogative; a public situation is a condition of lower calidad.

Further, Islas brings the marketplace and the marketing theme into his casta series more coherently than Cabrera does by associating the casta triads with economic subsistence activities equated with economic ordering. More importantly, he implicitly directs the viewer to do what one does in the marketplace: use judgment to assess and evaluate. Thus, the discerning act of viewing is applied, not just to commodities, but also to people. Assessment and evaluation were integral processes to determining market value and, by analogy, calidad, as we saw in Doña Margarita Castañeda's case. Islas proposes that the surveilling eye is like the assessing eye of the marketplace.[44] In sum, the artist's gaze constructs people who are knowable by the social and economic manifestations of their calidad. Here Islas implicitly references the libro de españoles and the libro de castas.

We might ask, then, are the people who populate Islas's images really examples of the sistema de casta hierarchy? The answer, I suggest, is: yes and no. Islas's series is best understood as a palimpsest: the presence of a casta taxonomy is evident, but simultaneously, this classification system is being erased and overwritten with the more pervasive and comprehensive eighteenth-century notion of urban bodies, or people permanently imprinted with their calidad. The meanings of casta nomenclature did not

remain static throughout the century, especially in consideration of the demographic shifts occurring after the middle of the century. Rather, by the end of the century, the cognizance of the existence of a multiplying plebe or gente vulgar population made casta nomenclature a vestige of past formulations.

Preliminary analysis of the Islas series indicates that by the last quarter of the eighteenth century, casta paintings have less to do with the division of people according to postulated blood distinctions. Instead, Islas proposes visually that late-colonial people are not socially unrelated units; he uses surveillance to articulate a large mass of people who, while differentiable, are not segmented as in earlier series like that attributed to Rodrígues Juárez and, to a lesser degree, like the Cabrera series. Clearly, almost one-half of Islas's paintings—panels 8 to 15—show us a network of people who are not really divergent but share common city spaces, who are deprived of sufficient food and adequate clothing, and who must labor constantly. In other words, Andrés de Islas presents the colonial spectator with a view of the expanding gente vulgar population of midcentury Mexico City. To a certain degree, these populachos are presented within a physiognomic rationale through contrast with the gente decente and through visual promotion of the assumption that their declining economic and physical conditions prove their declining moral character.

This comprehensive approach continued into the next decade. For example, in a 1780s series, an anonymous artist combined two triads in a single panel. Across this eight-panel casta series, the decline in status is evident: in the first panel, *1. De Español e India, Mestizo. 2. De Español y Mestiza, Castiza* (1. From a Spanish man and an Indian woman, a mestizo boy. 2. From a Spanish man and a meztiza woman, a castiza girl), we see the upper-level castas in the marketplace, looking and buying (figure 3.43). By the sixth panel, *11. De Indio y Cambuja, Albarazado. 12. De Indio y Albarazada, Torna atrás de pelo lacio* (11. From an Indian man and a cambuja woman, an albarazado boy. 12. From an Indian man and an albarasada woman, a straight-haired torna-atrás girl) (figure 3.44), the tattered Indian and cambuja point to the violent and base behavior of the Indian and the albarasada woman. Thus, in the final quarter of the century, casta imagery emphasized not casta taxonomy but a physiognomic view of colonial bodies marked by calidad, that is, the appearance, circumstances, and assumed inherent character of types of mixed-blooded persons.

Figure 3.43. Unknown. *1. De Español e India, Mestizo. 2. De Español y Mestiza, Castiza.* 1780s. Oil. 35.5 x 47.7 cm. Private collection, Mexico.

Figure 3.44. Unknown. *11. De Indio y Cambuja, Albarazado. 12. De Indio y Albarazada, Torna atrás de pelo lacio.* 1780s. Oil. 35.5 x 47.7 cm. Private collection, Mexico.

In summary, at the end of the seventeenth century, Sigüenza y Góngora asked the new viceroy to understand concepts of authority reflected in a new way through distinct "Mexican" visual metaphors. In doing so, Sigüenza y Góngora announced the potential of a discriminating and discerning eye that would both observe and construct a distinctive reality for the inhabitants of metropolitan New Spain. This eye would become evident in the escudos de monja and monja coronada paintings, which, as visual practices, worked to "construct a specific institutional and local identity for the creole elite."[45] The late-eighteenth-century genre of casta paintings expands this eye in an attempt to clearly define what elite identity was *not*—that is, not poor, not laboring, not dressed in tatters, and thus, not debased as were the depicted urban poor.

Further, very clear shifts occur in the optical range of this eye that serve to promote an increased diagnostic function. In showing isolated triads of people without social context, the 1725 panels attributed to Rodrígues Juárez may be seen as having a limited viewing field. Following portraiture conventions, these figures are placed in narrow, neutral spaces. Subsequently, a broader field of view is introduced, which gives spatial depth to the composition and changes the imagery to emphasize a more complex, contextual view of calidad. This change is traced through Cabrera. Ultimately, the eye attains a panoptic viewing field, that is, the penetrating, diagnostic surveillance of the plebeians utilized by Islas and in the 1780s panels. The prominence of this panoptic viewing authority is affirmed in figure 3.45, another panel by an unknown artist titled *De Alvina y Español produce Negro torna atrás* (From an albina woman and a Spanish man, a Black torna-atrás boy is produced) and dated 1775. The triad, shown in European-style attire and placed on a rooftop, takes up about one-eighth of the panel and is not the focal image. Instead, it is the Alameda, a main park of Mexico City, that takes up most of the compositional space, and it is the action of the Spaniard as he peers through his telescope that draws the viewer's attention. Here we observe the Spaniard fulfilling a most persistent colonial desire: surveillance of the people and spaces of Mexico City.[46]

In looking at and comparing the casta images of Rodrígues Juárez, Cabrera, Islas, and the noted unknown artists, we have seen what appears to be an increasingly detailed observation of kinds and lineages of people, the very people whose names would have appeared in the libro de

Figure 3.45. Unknown. *De Alvina y Español produce Negro torna atrás*. Late eighteenth century. Oil. 46 x 55 cm. Banco de México, S.A. Collection.

españoles and the libro de castas. But for the most part, these are non-existent people, and thus, as a visual practice, these images diagnose markers of hybridity and simultaneously actually construct the colonial bodies and their spaces. The impetus for this construction will be the topic of the next chapter.

Regulating and Narrating
the Colonial Body

Plaza Mayor de la ciudad de México (Plaza Mayor of Mexico City), painted by Juan Antonio Prado in 1767 (figure 4.1), documents the crowded and bustling central plaza of late-colonial Mexico City.[1] As in the Islas casta series and the single panel showing the albina-Spaniard couple looking at the Alameda, it is a surveilling eye that provides the viewer with a comprehensive survey of this central urban space. In this panoramic scene,

Figure 4.1. Juan Antonio Prado. *Plaza Mayor de la ciudad de México*. 1767. Oil. 212 x 266 cm. Museo Nacional de Historia de México, INAH, Mexico.

a triad of architectural features is located. They are: the cathedral on the right; the viceroy's palace marked by a crenellated wall at the bottom of the painting; and finally, the parián, or marketplace, the large, trapezoidal building with many vendor stalls in front of it. These architectural markers correspond to the colonial ordering units of eighteenth-century New Spain: religion, the state, and the economy.

This seemingly straightforward narrative image conceals a curious visual enigma. Within the pictorial composition, the three buildings, the notations of authority, are fragmented and situated on the edges of the picture. Instead, vendors, artisans, elite people, vagrants, and thieves— diverse people—fill and define the urban vitality of this city space. The *Plaza Mayor* image and the Cabrera and Islas casta images, then, share another point of convergence by presenting colonial people in *relationship to* and/or *interaction with* colonial metropolitan spaces. More than a mimetic representation of a late-colonial urban scene, this image may be read as emphasizing the intimate correspondence between Mexico City's colonial bodies and urban spaces. In this chapter, through an examination of eighteenth-century primary sources and recent scholarly research on the urban reforms of late-colonial Mexico City, I further examine how the visual construction of colonial bodies was embedded in bureaucratic reaction to demographic changes which, beginning in the second third of the century, attempted increasingly vigorous regulation and renovation of colonial bodies and spaces.

Recent theoretical literature about urban spaces and bodies provides important perspectives for analyzing the meaning of such regulations and renovations.[2] More than collections of buildings, streets, and parks, a city, as a manifestation of authority, attempts to delimit, structure, and manage the social habits and identities of the people who occupy its spaces. Concurrently, these same people or bodies constantly refute and transform the city's ordering to meet ever changing needs and desires.[3] More than simple places or architectural units, the spaces of eighteenth-century Mexico City were narrative spaces, that is, places where kinds of colonial bodies were described, inscribed, and constructed. Simultaneously, these bodies operated daily at multiple social and economic levels and constantly mediated and transformed these metropolitan narrative spaces to fit their lived existences. As such, city spaces and city inhabitants were not separate entities. Instead, because they were mutually defining and

interwoven, narration of the regulation and renovation of colonial space and the colonial body coalesced and converged in the trope of the body. This trope would come to signify the protean and ambiguous conditions and interactions between corporeal entities and metropolitan spaces. It was also a site for the enunciation of colonial power's ability to construct and circulate knowledge about elite and nonelite bodies and their respective spaces. Encountered in written and visual documents, the use of the body trope intensified as hybridity became an increasingly prevalent reality of late-colonial existence.

MEXICO CITY: AN ABBREVIATED DESIGN OF PARADISE

In his book *The Lettered City*, Angel Rama summarizes the origin of the relationship between colonial Mexico City and its inhabitants. He writes:

> The ideal of the city as the embodiment of social order corresponded to a moment in the development of Western civilization as a whole, but only the land of the new continent afforded a propitious place for the dream of the "ordered city" to become a reality. . . . Spanish conquerors became aware of having left behind the distribution of space and way of life characteristic of medieval Iberian cities— "organic," rather than "ordered" . . . Gradually and with difficulty, they adapted themselves to a frankly rationalizing vision of an urban future, one that ordained a planned and repetitive urban landscape and also required that its inhabitants be organized.[4]

Mexico City, then, was perceived as an ordered and orderable environment, despite the chaotic reality of lived conditions.

Writings about late-colonial Mexico City by inhabitants and visitors confirm this order and boast of the vitality of the urban space of the city. In 1777, Juan de Viera [1719/20–1781], a resident of the city, published *Breve y compendiosa narración de la ciudad de México* (A brief and summary account of Mexico City). The appearance of this comprehensive tour of the streets, plazas, and public and private buildings of Mexico City confirms the late-colonial interest in viewing city spaces as narrate-able. Viera begins by stating unequivocally that the richness and beauty of the noble City of Mexico overshadow the "ancient opulent cities like Rome. Mexico's climate, its location, the grandness of its edifices, and its fertility

and abundance make it an abbreviated design of paradise; its plan is so beautiful that one can neither describe nor imagine it."[5] Viera goes on to describe the streets, houses, and buildings of the city in great detail.

On the other hand, eighteenth-century travelers like Monsignor Chappe d'Auteroche [1728–1769], a visiting French scientist, wrote more straightforwardly and less admiringly of the city. In 1768, Chappe wrote, "The streets of Mexico are very wide and perfectly strait [sic], and almost all intersect each other at right angles. . . . There is no very remarkable edifice in Mexico. The viceroy's palace is in a spacious and pretty rectangular square. . . . The only merit of this palace is that it is built very solid."[6]

The grandeur of Mexico City was undeniable—so was its urban blight. Hipólito Villarroel, an administrator, wrote quite disparagingly about the city in 1785, stating that its conditions were deplorable.[7] In fact, at the time of Villarroel's critical words, the systematization and refurbishing of metropolitan spaces were also urgent themes in diverse legal, administrative, and literary documents.[8]

Numerous eighteenth-century documents—including *cédulas reales* (royal decrees), *bandos* (edicts), *ordenanzas* (ordinances), and documents associated with the *alcaldes mayores* (*cuartel*, or city sector, officials) and *obras públicas* (public works)—reveal that there was intense concern about Mexico City's infrastructure as well as its disarray and unsanitary conditions. From a review of over two hundred documents, it seems that this concern intensified after 1760. Three words emerge more and more frequently across this array of documents: *aseo* (hygiene), *limpieza* (cleanliness), and a heading that often appears with both of these terms, *policía* (civic order). An example is the 1795 bando entitled "Limpieza, Policía. Bando que reitera la observancia de los publicados en 31 de Agosto de 90 y 26 de Marzo de 91, para el aseo y limpieza de las calles de esta capital añadiendo algunas reformas" (Cleanliness, civic order. Edict to reiterate the public observances published on 31 August [17]90 and 26 March [17]91, for the hygiene of the streets of this capital, adding some reforms).[9]

"Policía," loosely translated as good civic order or good government and associated exclusively with urban dwelling, was defined by one seventeenth-century Spanish writer as the "police council which governs small things of a city like adornment and cleanliness . . . the science and

mode of governing a city and a republic."[10] In the eighteenth century, "policía" was associated with law and order but was nuanced to amplify its meaning and, as we shall see, its functioning. Richard Kagan cogently summarizes "policía" as "a combination of two concepts: one public, linked to citizenship in an organized polity, the other connected to personal comportment and private life, both inseparable from urban life."[11] Analysis of archival documents indicates that, in Mexico City, policía was concerned not just with the maintenance of buildings but also with an array of metropolitan spaces as they defined and managed the colonial body.

role of architecture

Across these documents, three major objectives emerge as the focuses of such reorganizational activities: (1) reordering of colonial space to improve surveillance of city inhabitants, that is, colonial bodies; (2) cleaning of colonial spaces to promote improved maintenance (health) of the colonial body; and (3) better control and separation of elite and non-elite bodies and their behaviors and activities.

Initially, Mexico City had been conceived as a simple, two-part division of space according to kinds of people: Indians were divided from Spaniards with the creation of the traza. As discussed in chapter 2, however, the growth in the population and the spatial centrality of the parián as an economic nexus made this simple partition unsustainable. Due in part to a highly destructive 1692 plebeian uprising over the shortage of wheat and corn, and in part to the Bourbon Enlightenment–derived propensity for ordering (as seen in the establishment of the intendancies), it was recognized that the city needed to be subdivided into manageable units. A 1696 attempt to divide the city into *cuarteles*, or sections, is recorded in reales cédulas.[12] Subsequently, the 1713 bando entitled "Good civic order of the city of Mexico. Acknowledging that it was divided into six cuarteles" announces a plan that divided the city into six units with an administrator for each.[13] This scheme was supplanted by a 1750 plan for seven cuarteles, which, again, was outlined on paper but never implemented.[14]

Finally, in December 1782, an ordinance announced a plan that created eight "cuarteles principales ó mayores" (principal or major cuarteles), each with four smaller jurisdictions known as "cuarteles menores" (minor cuarteles), for a total of thirty-two units in the city.[15] The ordinance announcing the detailed metropolitan division begins by stating,

The enormous expansion of this City, the irregular location of the neighborhoods and poor areas of the city, and the location of the inhabitants of these areas, which makes it impossible to register them and in many of them [the areas] even to move, and the innumerable residents, especially plebeians, has always made it difficult for the few Ministers of the Royal Criminal Court, and judges, to carry their vigilance to all parts [of the city], much less to make their nocturnal patrols.[16]

After a brief explanation of previous attempts at such division, the viceroy also does not fail to mention his own observation of "la diversidad de gentes, é inmensa plebe de todas castas, que habitan lo interior y extremos de la Ciudad en sus Barrios" (the diversity of people and immense plebeian population of all castas, who inhabit the interior and exterior of the City in its neighborhoods).[17]

In 1786 the king approved this final plan, which also called for each cuartel mayor to have a chief administrative official called an alcalde mayor, also known as the *alcalde de quartel ó barrio*. This individual was required to live in the cuartel and was charged with supervision of his unit. Each cuartel menor had a constable for further oversight.[18] The alcaldes were mandated to preserve social control and were required to watch over the daily activities of their assigned districts and to keep detailed and accurate records, including a list of inhabitants citing each person's name, last name, calidad, marital status, and office held, as well as an inventory of all commercial establishments and workshops. In addition, this local overseer was to make sure that municipal services were maintained, and he communicated with other alcaldes to obtain information about changes in residences. One such report was forwarded to Viceroy Matías de Gálvez from Juan Pascual de Fagoaga, alcalde mayor of Nejapa, in May of 1783. In a format resembling an accounting sheet, Alcalde de Fagoaga provided information about the general estate of each person in his jurisdiction, specifying his or her house address, casta designation, and sex.[19] This system promoted better coordination among law enforcement agencies, municipal authorities, and the judicial system.

Concomitantly, the cuartel system made surveillance of people easier. Such observation was further augmented by supplementary regulations that attempted to provide lighting for the streets at night. In 1762, it was ordered that the residents of houses should place a lamp at every door and

balcony and keep it lit until eleven o'clock at night, but residents did not completely comply. The order was reiterated in 1783 in a bando entitled "Good Government, Street Lighting. Edict that warns that night lamps be placed on all houses without distinction of the class or privileges of the subjects who occupy them."[20] This order was repeated in January of 1785 and a year later in February of 1786, but for the most part, the streets remained dark at night.[21]

Reliable night illumination was an important administrative priority of Viceroy Juan Vicente de Güemes Pacheco y Padilla, the second Count of Revillagigedo, who in April of 1790 ordered the night watchmen to install and maintain a thousand lamps. He further ordered alcaldes to care for the lights and imposed punishments for those who destroyed or defaced the streetlights.[22] In addition, in the 1790s, a signage system that clearly marked streets and plazas was put into place.[23] City spaces were now integrally organized for daytime and nighttime surveillance. Clearly, by 1780, there was an awareness of the *numeroísimo*, or multitudinous, population, especially the plebeian segment, and tightened city order was the reaction.

In calling for a reordering of urban spaces, writers like Villarroel explicitly cited the disorderly and unsanitary physical conditions of Mexico City's streets and plazas caused by unkempt street vendors and such activities as maintaining livestock within the city limits.[24] One 1660s *obras públicas* document from the accountant of the Tribunal for Policía of the city ordered that garbage dumps be removed from the city's plazas and that the streets be improved.[25] In the first decade of the eighteenth century, a royal edict provided money for improvement of streets and cleaning of canals.[26] This continued throughout the century; in 1763, Viceroy Croix described his attempts to repair and clean the streets.[27] In his instruction to his successor, Croix noted that the cleaning of the streets and canals cost between 12,000 and 14,000 *pesos* per year. He added that cleanliness was important for the beauty of the city and the health of the residents, and that he had worked to establish various ordinances for his successor.[28] In 1769, a bando entitled "Civic Order. Edict for the cleaning, hygiene, and paving of the streets of Mexico and for the building of latrines" laid out a number of street maintenance regulations.[29] Less than two years later, another bando told residents to sweep the streets and not to dump dirty water or excrement on the streets.[30]

Viceroy Revillagigedo II, seems to have had an intense and persevering interest in the physical infrastructure of the city, and 1790 was a year of intense public works activity under his tutelage. In May 1790, a bando called for street paving, and on 6 August 1790, another bando called for street cleaning and the improvement of houses that were in disrepair.[31] On 31 August, the viceroy also established a major sanitation program. This program was announced with a bando and, on 7 September 1790, by the *Gaceta de México*, a monthly newspaper, which published the viceroy's *bando de limpieza* (sanitation edict). The bando begins with the affirmation that "One of the most essential points in good civic order [*policía*] is the cleanliness of towns, which not only contributes to the comfort of the residents but also promotes health, an object of major concern. . . ."[32] The edict goes on to state that insufficient attention and resources had been given to this need, and enumerates a number of regulations relating to the management of garbage and sanitation for all residents of "every status, calidad, or condition."[33] These regulations included the following stipulations:

> Every day of the year, two garbage collectors, announced by a bell ringing, will pass through the street to remove offal and garbage.
>
> Garbage can not be thrown in the streets; garbage must be in front of the house every morning.
>
> The carcass of an animal must be removed within twelve hours of its death.
>
> The indecent abuses [referring to human waste] of the plebeians of both sexes, which dirties the streets and plazas, will be watched by patrols [the *pulquerías*, stands where the intoxicating drink *pulque* was sold, were considered the worst offenders].
>
> Every factory must build a latrine.
>
> Factory offal is not allowed on the street and has to be removed at the factory owner's expense.[34]

Success must have been limited because the regulations were reiterated in March 1791 and again in January 1795.[35] In this final iteration, the viceroy begins,

Amid the vigilance, attention, and precaution that have preserved for me the public tranquility of the inhabitants of this city, I have not lost sight of how notable are its abundant provision, its cleanliness, improved conditions of the streets, and other points of interest that have distinguished and influenced the health of its numerous residents.[36]

He then repeats the regulations of 1790 and establishes new fines for infractions of the law and harsher punishment for repeated violations of the ordinances, including having offenders pick up garbage for a specified period of time.

Street cleaning was supplemented by better street organization. In 1793, Revillagigedo synthesized his vision with the production of a map of the city (figure 4.2).[37] In August 1793, a bando announced a street plan showing the alphabetic order of the streets and cuarteles, along with other

Figure 4.2. Diego García Conde. *Plano general de la ciudad de México*. 1805. Engraving. 1.8 x 2.5 m. Museo de la Ciudad, Mexico City.

Figure 4.3. Unknown. *Vista de la Alameda de México*. Oil. 46 x 55 cm. Museo de América, Madrid.

street markers.[38] The map, which shows a bird's-eye view of the grid organization of the city, lists its streets on the right. In 1794, Ignacio de Castera, master architect of the city, proposed to reform certain barrios, realign certain streets, and improve water circulation.[39]

Besides the comprehensive reorganization and regulation of the city, city leaders also addressed specific problematic spaces as part of this eighteenth-century refurbishing. Certain public spaces were used for *paseo*, a ritualized promenade that was a common leisure activity of the elite. During the paseo, elite status was displayed through ostentatious clothing and coaches, which were paraded for all to see. In the 1770s, Viceroy Croix and Viceroy Bucareli renovated the Alameda, a park located a few blocks from the Plaza Mayor that was a favorite place for paseo. Figure 4.3 shows the park before these renovations, while figure 3.45 shows the refurbished version. The renovations increased the park's size and added two avenues that crossed it diagonally, as well as trees, fountains, and an enclosing wall with a continuous bench around the perimeter.[40]

Unfortunately, in the late eighteenth century, the peace and tranquility of the Alameda became threatened by street smells, the noise of vendors, and the violence of thieves. In August 1791, an order was given to place sentinels at the entrances to the park to keep out improperly dressed people and provide better security of the Alameda in order to preserve the harmony of the paseo.[41]

Monitoring people was especially constant in the eighteenth century. Viceroy Croix did not mince his words about the plebeians, whom he derogatorily called populachos, when, in 1771, he warned his successor that

> There are many mixed-blooded people among the plebeians, from which arise a being that is exceedingly wicked, and their major characteristics [are] drunkenness, gambling, lechery, and thievery.[42]

The viceroy stated that these people, who inhabited the streets of Mexico City, had a penchant for knives and were constantly involved in brawls resulting in murders, with victims left in the city streets. In fact, he wrote, during the first month of his administration, twenty-nine such cadavers were counted.[43] He went on to explain his street improvements. Thus, the spaces frequented by plebeians were also part of this renovation.

Bandos and ordenanzas attempted to renovate and discipline the populachos' spaces, their activities, and their bodies. As Croix pointed out in 1771, drunkenness was a constant problem. Pulque, a drink made of fermented maguey, was a popular beverage among the poor throughout the colonial period. It caused intoxication, which often resulted in rowdiness and other criminal behavior. As a result, pulquerías, stands where pulque was sold, were under constant surveillance and regulation by authorities. Although the drink was constantly named as another cause of plebe depravity, the government refused to ban pulque because its production and sale were critical for the local economy and produced imperial tax revenue.[44] In fact, in 1795 a tax on pulque was used to pay for some of the city's renovations.[45] Various laws tried to control the production and consumption of this populacho beverage and its admixtures. Ordinances written in 1671 required that pulquerías be freestanding, with a roof and one wall, allowing three sides open to public observation. In 1724, the pulquerías were ordered to install plaques with the names of the establishments clearly visible from the street.[46] By 1780, pulquerías had to

be registered. These various regulations were then repeated and expanded in 1793.[47]

Other popular activities also came under scrutiny. For example, in March 1779, Viceroy Bucareli issued a bando ordering tighter regulation of dance schools. While the viceroy did not prohibit the licit and honest activities of men and women in these schools, he did denounce certain disorders occurring in some schools of dance, particularly their late hours and "European customs" (probably referring to French customs, which were viewed as decadent). Bucareli then mandated specific regulations to remedy these problems.[48] Viceroy Revillagigedo II was also concerned by activities that involved the close interaction of men and women: specifically, *baños de temascales* and *lavaderas* (public sweat baths and baths). Outlining new regulations that promoted hygiene but more emphatically separated men and women, the viceroy exhorted the cuartel officials to be scrupulous in their "vistas de ojos y reconocimento de dichas casas" (oversight and observation of these sites).[49]

Perhaps the most intense and largest gathering place of the populachos was the area of the parían. In hopes of clearing the unsightly and disorderly makeshift stalls in front of the parían, Revillagigedo II established a new principal market in the Plaza Volador, near the royal palace. Citing good policía, the viceroy's bando established a numerical order for the stalls of the Plaza Volador which dictated which materials and goods could be sold in specific areas of the market; the bando also established administrators and other regulations.[50]

A final example of this spatial reordering and regulation can be seen in the case of semiprivate workspaces. A series of ordinances required that artisans had to make and sell their products in the same location. Their shops had to have direct access to streets. In this way, inspection and observation of work were made easier.[51]

Particularly notable in Prado's *Plaza Mayor* painting are the diverse people in an array of distinct clothing going about their daily activities. Besides watching the procession, elite and non-elite Spaniards, castas, and Indians stand at vendors' stalls buying and selling fresh food and other goods. Individuals also talk, gossip, and stroll throughout the canvas. In the lower right-hand corner, a small vignette shows a thief being caught. Few heads turn to observe this scene, and most proceed with their

activities. The dense population and constant activity pictured here made Mexico City vibrant but also unsettled colonial authorities.

As various viceroys clearly explicated, and the reiteration of bandos and edicts confirmed, plebeian bodies were constantly at odds with the ongoing renovation and regulation of urban spaces. Colonial authorities' reaction to populacho thwarting of spatial regulation was an increase in scrupulous regulation of all colonial bodies. To this end, Spanish authorities tenaciously pursued numerous laws that attempted to monitor and control marriage, dress codes, and behavior for elite and non-elite bodies.

Mimicry of elite bodies was also a continuing consideration. This fact is pointed out in a 1790 bando that proclaimed that the king could not maintain the quality and distinction (*lustre*) of titles of nobility in the Americas because certain individuals had deceived the king as to their true worthiness. In the future, it was announced, no titles would be bestowed on anyone who resided in the Americas without sufficient justification, including verification of noble blood, appropriate marriage partner, and evidence of sufficient income to support the distinction of the title. It was added that, for the title of Castile, secret declaration from witnesses verifying the "tres calidades de Nobleza, Riqueza, Servicio personales" (three standards of nobility, wealth, and personal service) would also be required.[52]

Various marriage laws had been promulgated and reiterated throughout the colonial period in attempts to separate Spaniards from Indians.[53] In an endeavor to safeguard noble Spanish blood, the 1776–1778 Pragmatic Sanction on Marriages allowed parents and civil officials to stop marriages if they were between social unequals or with "mulatos, negros, coyetes e individuos de castas y razas semejantes tenidos y reputados públicamente por tales" (mulattos, Black Africans, coyotes, and mixed-blooded persons and similar races/lineages considered and reputed publicly as such).[54] As late as 1804, the Crown sought to forbid marriages between a Spanish noble and a person of mixed blood.[55] These marriage decrees were calculated to maintain purity of Spanish blood and impede the proliferation of castas by management of the sexuality of the colonial body.

Sumptuary laws dictated what colonial bodies could and could not wear. Again, these laws seem not to have been effective because such regulations had to be constantly repeated. For example, the 10 February

1716 royal pragmatic "Against the Abuse of Clothing and Other Super-fluous Expenses" referred to an edition of the pragmatic published on 26 November 1691, as well as to an even earlier decree dated 9 October 1684.[56] The 1716 pragmatic stated that not only were earlier sumptuary laws being reiterated but, in addition, all men and women of every status and calidad were prohibited from wearing fine, luxurious fabrics—such as brocades, certain silks, or fabrics with gold and silver embroidery—that were not made in the kingdoms of Spain. Neither real nor fake gems could be used on garments except for wedding costumes. Further, because of the abuse of fake jewelry sets consisting of necklaces, earrings, and bracelets, it was forbidden to sell, buy, or wear fake jewels that imitated diamonds, emeralds, rubies, or topaz.[57] Notably, wearing of real jewels was not forbidden.

While opulent overdressing was a concern, nudity was a common problem among the populachos and was viewed not as the result of abject poverty but as yet another indication of plebeian depravity. In 1791, a royal decree prohibited unseemly (lack of) clothing because such attire introduced dissolute and intolerable manners. It went on to require that factory workers wear a shirt, a jacket or vest, short pants, and shoes. The decree also mandated that the Indians use their own traditional costumes and not "imitate people of other castas."[58] One of the more interesting sumptuary proclamations began with Viceroy Revillagigedo II's statement:

> Cleanliness and hygiene is one of the three principal objectives of civic order [policía]; and this does not only encompass the street and plazas of the cities, but also the persons who inhabit them whose decent and respectable dress much influences good manners, at the same time as adorning the bold, and contributing to the health of individuals. . . . [Revillagigedo intends] to eradicate from the neighborhoods of this beautiful capital the indecent and disgraceful nakedness in which a large part of its plebeians are presented, with no other clothing than a disgusting cloak or filthy tatters that does not cover them externally".[59]

The announcement also goes on to remind the reader of the king's 1791 pronouncement and states that such nudity indicates extremely "vehement idleness or bad manners" determined by one's destiny according to one's calidad and other circumstances.[60] Colonial bodies in public spaces then had to be marked by clothing appropriate to their status, and any exposure

of the nude or seminude plebeian body was also problematic. Earlier decrees, which sought to bring regulation to the colonial body, particularly the plebeian body, were constantly reiterated, and throughout the eighteenth century, more stringent laws were promulgated.

Along with the social spaces and conditions of the colonial body, its activities and behaviors were also under regulatory scrutiny. While streets may have been orderly, lighted, and moderately clean, the human exchanges that occurred between and among colonial bodies in the streets were chaotic and even vicious; thus, uncontrolled behaviors were another constant irritation to colonial authorities. Drunkenness continued throughout the century, as evidenced by a late-eighteenth-century bando entitled "Inebriation. Edict imposing penalties on individuals who as a result of this vice are found unconscious or [exhibiting] public indecency in the streets." The edict imposed a jail sentence on such drunken persons.[61]

The idle plebeian was thought to be the cause of thievery and other street crimes. In February 1767, beggars and vagrants were ordered to demonstrate that they were employed within thirty days from the issuance of the decree. Those who could not meet this requirement were confined to poorhouses, drafted into the army, or employed as convict laborers in public-works projects.[62] In addition, popular street diversions were seen as dangers that needed to be stopped. In October 1731, an ordinance prohibited the playing of certain games throughout the city, especially at pulquerías, markets, plazas, and the Alameda;[63] these, of course, were places where the populachos congregated.

Colonial authorities actively supported certain public activities such as paseos and *pelota*, an early form of jai alai, and tirelessly thwarted others, including festivals celebrating saints, *colloquia* (family gatherings where short religious plays were presented), *posadas* (Christmas parties), *jamaicas* (charity sales), and the most egregious of all festivals, *carnaval*, a massive pre-Lenten affair that engulfed the whole city.[64] Not coincidentally, paseos and pelota were the entertainment of the elite, and the other activities were amusements of the populachos.

The shift to regulated carnaval celebrations provides an interesting example of this social management. In the seventeenth century, government regulators became more and more apprehensive about the

chaotic and uncontrolled atmosphere produced by carnaval. During Shrovetide, the three days before Ash Wednesday, behavior became unbridled and unruly. Along with numerous dances, paseos, and balls, there were masked individuals roaming the city, making fun of authority, dressing as clerics, and most distressingly, wearing the clothing of the opposite sex. The masking and the inversion of roles and gender were particularly upsetting to authorities and were banned late in the seventeenth century in hopes of imbuing Shrovetide with honesty and self-control.[65] In the eighteenth century, severe punishments were promulgated for these activities, including six years in jail for nobles and two hundred lashes and six years of work in a factory for those of dark color. By the end of the century, these penalties seem to have successfully brought carnaval under control.[66]

Throughout the colonial period, theater was another popular diversion for all classes. Juan Pedro Viqueira Albán's research documents its history and demonstrates that, in the eighteenth century, viceroys took special interest in the theater because it was another site of depraved plebeian behavior and, at the same time, it offered an opportunity to reform plebeians.[67]

The theater performance regulations of 1786, which summarized and expanded regulations of 1763, 1765, 1779, and 1781, began by alluding to a need to reform earlier abuses in order to promote decency and decorum in accordance with good manners.[68] Actors were directed to be modest in their dress and presentation and to avoid provocative dance, no matter what character they were playing. Actors were warned to practice their lines and, except for lead actors, they were to have only one assistant. Spectators were warned to avoid catcalls, jeering, and expressions of appreciation that were overly effusive.

In 1790, Viceroy Revillagigedo II refurbished the Coliseo, the municipal theater, by ordering repair of the building and appointing a censor of plays.[69] Through theater redesign, the viceroy sought to transform the public into silent spectators: invisible, clandestine observers of an action supposedly out of their sight. Earlier theater design aimed to have the actors and audience share the same space through decoration and connecting stairs between the stage and the audience area. With eighteenth-century regulation, theater space was changed to emphasize separation of

these two areas. Connecting stairs were removed, and scenery was sim-
plified to emphasize the break in the continuum from reality to illusion.[70]
Theater reforms of the eighteenth century, then, repeated the themes found
in edicts and decrees: space and bodies were not and could not be
conceived as separately constituted entities; instead, space and bodies
needed ordering, renovation, and regulation.

In sum, numerous official documents of the eighteenth century, par-
ticularly after midcentury, indicate that the Bourbon government believed
emphatically that the bodies of New Spain could be contained and
ordered.[71] The mandated cuartel division and the cleaning, lighting, and
signage of streets and plazas were concentrated not just on the physical
spaces, but also on the maintenance and disciplining of colonial bodies.
The constant reiteration of these regulations evident in archival documents
is indicative of their failure to control the body. Populacho bodies
constantly challenged these ordering structures of city spaces with their
perceived debased presence and habits. And, in turn, reiterated and
increased regulations attempted to counteract such appearances and
behaviors.

Viceroy Revillagigedo II culminated these renovations by making the
Plaza Mayor the physical—and perhaps metaphorical—centerpiece in his
refurbishing of Mexico City. The establishment of the new Volador market,
discussed above, was a preparatory step to implementing a vision of an
expansive open central plaza space accentuated with four fountains. Obras
públicas documents from 1791–1792 indicate that the pavements of the
Plaza Mayor floor were lowered and that an architect, an engineer, and
sculptors collaborated in the planning of the fountains to be placed in the
plaza.[72] A plaque on one of the fountains proudly summarized
Revillagigedo II's achievements:

> In the glorious reign of Charles IV, being Viceroy the Most Excellent
> Juan Vicente de Güemes Pacheco de Padilla, Count of Revillagigedo
> II, between 1790 and 1794 the principal streets were paved: 545,039
> square varas of paving were laid, 16,535 square varas of drainage
> canals and 27,317 square varas of sidewalks with piping underneath;
> and the plazas for markets were formed and arranged.[73]

In excising the makeshift vending stands from the economic hub of the
Plaza Mayor, and ostensibly the plebeian bodies associated with them,

Revillagigedo II attempted to articulate a body of pristine, elite control. The bodies that used and traversed this space, however, constantly thwarted the viceroy's vision of an orderly urban space.

In 1795 Viceroy Baniciforte expanded his predecessor's vision by proposing to erect an equestrian statue of King Carlos IV in the middle of the Plaza Mayor. The viceroy's bando announcing and describing the temporary erection of a wooden prototype of the statue is long and detailed. In a highly sycophantic mode, he stated that the magnificent metropolis of Mexico City had enjoyed many benefits of royal patronage and only lacked a great and beautifying statue of the king placed in the center of this capital that would visually represent the virtues of the king.[74] The new statue prompted further improvement of the Plaza Mayor, under the guidance of Don Antonio Valazquez, director of architecture of the Royal Academy of San Carlos. The statue was set up on a tall pedestal and surrounded by an elliptical enclosure. Four elaborate entrances interrupted the low parapet walls of the enclosure and were guarded by sentries in small guard stations.

A three-day celebration beginning on 9 December 1796 marked the erection of the (temporary wooden) equestrian statue, which coincided with the birthday of the queen, María Luisa de Bourbon. A bando that was reprinted in the *Gaceta de México* provided unusually long descriptions of this massive celebration. As one would expect of this opulent and luxurious capital, the city was elaborately decorated, and elite participants were sumptuously attired. The *Gaceta* reported that the carriages and coaches were elegant, the costumes colorful, the elite attire brilliant, and the hairdos of exquisite taste. The description went so far as to state, "It offered a spectacle that sweeps the imagination."[75]

The account also described the magnificent illuminations that occurred on three successive evenings. One thousand lights were placed on the façade and cornices of the Portales de las Flores, an entrance to the Plaza Mayor near the viceroy's palace. One hundred eight trees, each two yards wide and four yards high, were covered with 9,280 lights/candles and placed in the Plaza Mayor. Within the plaza, a series of letters supported by fifty-nine large, wooden containers spelled out: "Vivan nuestra amados soberanos Carlos Quarto y María Luisa de Borbón" (Long live our beloved sovereigns Carlos IV and María Luisa de Bourbon). The cathedral was copiously lit, as were the Casa de Ayuntamiento (with 2,400 lights)

Figure 4.4. José Joaquín Fabregat. *Vista de la Plaza de México*. 1797. Print after a drawing by Rafael Jimeno y Planes. Nettie Lee Benson Latin American Collection, The University of Texas at Austin, Austin, Texas.

and the parián (with 1,800 lights). The royal palace was illuminated with 1,800 lights distributed in three rows across the façade, with a large picture of the king and queen lit with 2,400 lights. More lights, as well as flags, banners, and tapestries, decorated other major buildings of the city. All the streets of this beautiful city, and its churches, convents, and schools, were illuminated and adorned with fine hangings and other decorations.[76]

The *Gaceta* report went on to state that all classes, sexes, and ages were in the plaza demonstrating "La Lealtad Americana" (American loyalty).[77] The continuing celebration included parades of high officials, nobles, and one hundred beautifully dressed and coiffed ladies of the court. Sixteen bullfights and music and dance into early morning hours also entertained the participants.[78] An engraving by José Joaquín Fabregat, dated 1797 and entitled *Vista de la Plaza de México* (View of the Plaza Mayor of Mexico City), was commissioned by Viceroy Baniciforte to represent the Plaza Mayor with all its "new adornment" (figure 4.4).[79] Here, although the vantage point is different than in Prado's Plaza Mayor painting, the architectural triad of the cathedral, the viceroy's palace, and the parián is

still evident. In striking contrast to Prado's image of the plaza, the make-shift market stalls are gone and replaced by a walled and gated elliptical enclosure that holds the equestrian statue of Carlos IV.

In what must have been an incredible visual display during those three days of December 1796, this celebration revealed the culminating efforts of the late-colonial reforms, which attempted to regulate the non-elite body but were also a locus for the spectacle of elite colonial power. A simple assessment of Fabregat's 1797 print and Prado's 1767 painting may be that they represent the early- and late-eighteenth-century physical upgrading of Mexico City, respectively. As we have seen, however, archival documents tell a different story: reform of metropolitan spaces was the physical manifestation of the reform of the colonial body. Identification, ordering, maintenance, and control of the elite and the non-elite body were the focal points of numerous edicts and laws promulgated in the late eighteenth century. This prescribed order, of course, was not reality, as a story told by a contemporary writer will elucidate.

THE ITCHING PARROT: A LITERARY NARRATION OF THE LATE-COLONIAL BODY

Eighteenth-century documents and scholarly research repeatedly confirm the construction, regulation, and spectacle of colonial spaces and bodies through the trope of the regulated body. Additional elaboration of the colonial body is found in José Joaquín Fernández de Lizardi's late-colonial novel *El periquillo sarniento* (The itching parrot).[80] Fernández de Lizardi was born in 1776 in Mexico City into criollo social status but not wealth. He was well educated, but his limited financial circumstances required that he be an amanuensis, or scribe.[81] There is evidence that Fernández de Lizardi was a reckless youth: in 1794, his father reported the eighteen-year-old Lizardi to authorities for possessing a deck of cards used for fortune-telling and off-color jokes.[82] By 1808 or so, Lizardi seems to have found his life's calling in the form of writing verse and pamphlets; by his death in 1827, Lizardi had become a well-regarded political journalist.

In February 1816, two chapters of a work entitled *El periquillo sarniento* appeared in a local publication in Mexico City. Subsequently, Lizardi began to expand this material into a book format; three of the four parts were published serially between 1816 and 1820 as *El periquillo sarniento*.

Censors did not approve the fourth section of the book for publication at that time. Lizardi firmly dates the action of his story in the 1770s through early 1800s. Three-quarters of the narrative explores late-colonial life, while the ramifications of independence are the themes of the final section. The novel's narrative form allowed Lizardi to dramatize many aspects of colonial life. Now recognized as the first Spanish-American novel, *El periquillo sarniento* demonstrates the aesthetic of realism and social purpose that was also promoted in late-colonial theater productions. "Identifying himself with the artisan class, he [Lizardi] compared his task as a writer to that of a shoemaker, who served society by carefully creating a useful product."[83]

The useful product that *El periquillo sarniento* gives the reader is an amazing journey through late-colonial Mexico City. While Lizardi describes the same urban landscape as Juan de Viera did in his 1777 narration of the city, through Lizardi's taste for verisimilitude, the reader is able to perceive the human dimension of the built space by peering into elite existences, as well as into the wretched lives of impoverished plebeians. From Lizardi's other writings, it is clear that he saw an opportunity to tell a story that was somewhere between fact and fiction in order to illustrate moral and ethical principles. Further, he was aware of writing to an audience whom he believed to be ignorant, that is, "unskilled in interpretation, one who cannot disentangle the moral message from the story and who, therefore, needs explicit comment and restatement."[84]

Reading *El periquillo sarniento* places the reader among the locations and people referred to in the edicts and decrees examined above and pictured in Prado's painting. The story begins with Pedro Sarmiento, a reformed *pícaro*, or delinquent, telling his children that he was born between 1771 and 1773 in rich and opulent Mexico City. Now ill and infirm, Pedro has sincere remorse for his life of debauchery, and proceeds to tell his children his life story so that they may understand and avoid the moral calamity that marked Pedro's early years.[85] This first chapter immediately establishes not only Pedro's paternalistic authority but also his experiential authority to describe the gritty details of his life to us, his impressionable readers, with impeccable authenticity.

Pedro describes his parents as criollos who, while not excessively wealthy, had a comfortable life. From the moment he was born, Pedro claims, despite his bloodline and the kindness and goodness of his parents,

it was inevitable that he would become a pícaro. His inherent and latent moral deficiencies found fertile ground to germinate in the conditions of his early nurturing: a mother who was too lenient and superstitious, and the fact that Pedro was handed over to Indian, Black African, and "white" wet nurses of dubious repute. He explains how

> The first foods that nurture us make us acquire some property of those who ministered to us . . . because it is certain, I say: that my first wet nurse was of cursed temperament, thus I became bad intentioned . . . because she who was not drunk, was greedy; she who was not greedy, was French [meaning immoderate]; she who did not have this evil, had others; and she who was healthy, all of a sudden became pregnant.[86]

Clearly, Lizardi reiterates eighteenth-century views on the moral quality of lower-class people, but he simultaneously opens for consideration the possibility that "good" lineage alone does not inevitably assure moral or ethical rectitude.

The story continues with Pedro's education. During his upper-level schooling, his delinquency is further nurtured when he falls in with the wrong crowd. At this time, he receives the derogative nickname "Periquillo Sarniento," or itching parrot. When Pedro completes his schooling, his father suggests that he take up some useful work. Pedro refuses, clinging to his desire to lead the carefree life of the leisured wealthy. Initially, he tries to live off his affluent friends; eventually, he squanders his small inheritance, is forced to leave respectable society, and plunges into the lived vitality of the urban poor.

The subsequent part of the novel is structured as a series of moralizing parables that introduce us to a myriad of late-colonial characters while chronicling Pedro's increasing corruption as a cardsharp, thief, gambler, and charlatan whose admitted interests are drinking, games, dancing, and women.[87] Through misrepresentation of himself, he also obtains proper paying positions as a scribe and a pharmacist, but his penchant for the "good life" and his innate moral deficiencies constantly undermine any success or attempts at self-improvement.

Pedro's fluctuating fortunes take his readers to all parts of Mexico City. In the urban settings, we visit the houses and shops of the gente decente, the elite and middle class, many of whom are victims of Periquillo's

thievery and swindling. A significant part of this tour consists of locales that the eighteenth-century bandos and ordenanzas are constantly trying to monitor and regulate, that is, pulquerías, taverns, hospitals, flophouses, markets, and jails, which are inhabited by the gente vulgar or populachos. The places, people, and actions are described with impeccable authenticity. For example, one evening, after being evicted from one employer's house for incorrigible behavior, Periquillo makes a run for the city.

> At eight I was at the Portal de las Flores, dying of hunger, which had been increased by the exercise I had done with so much walking. I did not have anything of value on my body except a small silver medal that I had bought for five reales. . . . it took some work to sell it at this time, but ultimately I found someone who gave me two and half [reales] for it, of which I spent one real to have supper and one-half real for cigarettes.[88]

The Portales de las Flores locates Pedro at the heart of Mexico City in proximity to the parián, where he would most likely be able to sell his small medal, and thus makes this scene quite plausible.

Throughout the novel, Lizardi acquaints the reader with the kinds of people one would expect in such divergent social spaces as those of Mexico City—that is, the gente decente, who are cultured, moral, and honest, and the gente vulgar, who, in Lizardi's words, are "muchachos malcriados y necios, que después son unos hombres vagos, viciosos y perdidos" (bad-mannered and foolish boys that later are [become] lazy, depraved, and degenerate men).[89]

Well aware of the tenets of physiognomics, Lizardi, who cites the writings of Feijoo, verbally depicts Periquillo's body as legible and mappable for moral deterioration. While illustrating these social stereotypes, he simultaneously expands on the critical perspective that argues that a person's appearance can be deceiving or a person can misrepresent himself. Pedro tells us that after the death of his father,

> For six months I was in my house putting on the life of a good hypocrite because I prayed the rosary every evening as was the custom of my deceased father, I went on the street very little, I did not participate in any entertainment, I spoke of virtue; . . . in a word, I pretended very well the role of the hombre de bien.[90]

As discussed in chapter 2, the hombre de bien, or gentleman, appears in

Spanish literature as a man of irreproachable and meritorious character; being an hombre de bien was also a prized personal attribute and, to a certain degree, a social category. Lizardi utilizes the character of the hombre de bien to show ambiguity, as Periquillo contends that it is possible to mislead others into believing that he is an hombre de bien by mimicking the explicit behaviors and appearances expected of such a man.

Lizardi repeatedly illustrates that good characters can be found in bad places and that reputedly decent people can be immoral and corrupt. For example, during one of his stays in jail, Pedro is befriended by a mixed-blooded man named Don Antonio. Pedro initially assumes that this man is like the other criminals in the jail, but he then learns that a certain nobleman had tried to seduce Antonio's wife and that she refused his advances. Angered by this rebuke, the nobleman schemed to have Don Antonio carry contraband from Veracruz and arranged for the unsuspecting Don Antonio to be caught with the illegal goods and sentenced to jail by authorities.[91] Despite this injustice and the fact that debased men surround him in jail, Don Antonio remains honest and ethical. Through his encounter with Antonio, Pedro comes to admit that "lower color [mixed blood] and tattered clothing do not always signify wicked men; once in a while, they may conceal some souls as honorable and sensible as that of Don Antonio."[92]

Likewise, we are introduced to gente decente who have evil and immoral qualities, such as Dr. Purgante. This doctor, who by blood and position should be respectable and honorable, is not only dishonest but also a fraud. His medical knowledge is minimal, and he confuses and overwhelms his naïve patients by babbling Latin terms during his consultations. As his name suggests, his cures consist of purgatives. Periquillo serves as an assistant to the doctor, and eventually he steals Dr. Purgante's cape and mule and a trunk of other goods, and becomes a charlatan doctor himself, practicing among the Indians in a small village outside of Mexico City.[93]

Throughout the novel, Lizardi, through Pedro/Periquillo's recounting, takes on the voices of his characters. He speaks in the broken and idiomatic street language of Indians, thieves, and country people, and he is also able to mimic the pompous speech of deceitful doctors, teachers, and lawyers. These styles are offset by the narrator's own clear and "simple language which simultaneously corrected and satirized that of the

others."[94] He also allows righteous characters like Don Antonio to speak in this clear and forthright fashion.

While three sections of the book describe the problems with life in New Spain at the end of the eighteenth century, the fourth section of the novel offers an extended discussion of how these problems might be remedied. After a trip to Manila and an encounter with a utopian culture, Periquillo returns to Mexico and is finally reformed.

Although the novelistic format of *El periquillo sarniento* is a European literary form, Lizardi adapted it to the story he needed to tell of life in late-colonial Mexico and the dilemmas of social reform. Analysis of this novel, particularly the sections set in the last quarter of the eighteenth century, indicates that its literary mechanisms and organizing structures use and reiterate the body trope found in coeval colonial documents. Just as urban reforms reflect the extension of the surveillance privileges of colonial power, the omniscient eye of Pedro as narrator allows surveillance of people and places not easily or comprehensively accessible to any eighteenth-century person. The presence of this surveillance was so critical to Lizardi's narrative that the original editions of *El perquillo sarniento* included thirty-six engraved images along with the text.[95] While these prints illustrate specific scenes from the text, they may also be seen as augmenting the surveillance that permeates the narrative.

Through this surveillance, the reader can read about and "see" people, with special attention paid to their persons, their spaces, and their actions. The people and spaces of greatest concern to colonial authorities—the gente vulgar and the city streets, taverns, et cetera—are found throughout the pages. Moreover, as Pedro becomes Periquillo, he explores the body trope through the slow metamorphosis of his elite body into a populacho body. Periquillo's changing clothing, the spaces he inhabits, and the often illegal actions he undertakes mark this change in the text and in the illustrations. He always seeks to wear the fine clothing of an hombre de bien, but his clothes are repeatedly stolen, gambled away, or sold for food money, and he becomes unkempt and tattered. In one of the more desperate scenes, Pedro describes himself as "completely barefooted . . . ; my over pants were dark, patched, and riddled with holes; my shirt, after being ripped, was almost black with filth; my jacket was torn. . . ."[96]

Surveillance of the declining condition of Periquillo's body toward seminakedness, filth, hunger, and illness fills the pages of this novel. This

surveillance parallels Viceroy Revillagigedo II's observations of the bodies of the poor, whom he described as having "indecent and disgraceful nakedness in which a large part of its plebeians are presented, with no other clothing than a disgusting cloak or filthy tatters that does not cover them externally."[97]

This surveillance does not stop with external appearance but proceeds to penetrate below the skin, revealing interior mental capacity as Lizardi takes on the voices of various characters. These explorations of interior psychological conditions correspond to the reforms aimed at theatrical realism, which called for the avoidance of the abstraction of virtue, vice, and social group and promoted verisimilitude, realism that revealed the character's inner being and coherence.

Lizardi's discourse on the body also alludes to one of the key elements of physiognomics in the literature of Spain: the hombre de bien, or gentleman, and its extension, *hombría de bien*, gentlemanliness.[98] Here, using physiognomical rationale, the male body was seen as legible through assessment of "external bodily characteristics as a system of signs representing the invisible inner character of masculine persons. . . ."[99] This rationale also constructed an "ideal body, moderate and restrained in its gestures, control of which is for those men who would be virtuous gentlemen (*hombres de bien*)."[100] In his novel, Lizardi often refers to the character and characteristics of the hombre de bien. In mimicking his father's appearance and behavior, Periquillo asserts that he was well aware of the exterior attributes of an hombre de bien. Alluding to classical text, Lizardi inserts this verse into the text:

El hombre de bien vivir
y aquel que a ninguna daño,
no ha menester el escudo ni flechas emponzoñadas.
Por cualesquieres peligros pasa y no se sobresalta,
seguro que en su defensa
es un conciencia sana.[101]

> [The hombre de bien lives and that which no one can injure, he has no need of the shield or the poisonous arrows. For whatever danger occurs, he is not frightened, sure that his defense is a healthy conscience.]

Here Lizardi references the internal conditions as well. Overall,

Lizardi's treatment of hombría de bien and his analysis of bodies in New Spain echo the Spanish essayists' notion of physiognomics as providing a certain amount of legibility to bodies and allowing the mapping of bodies.[102]

In sum, *El periquillo sarniento* mirrors, and often extends and promotes, the colonial discourse of renovation and regulation through the trope of the body by expanding on the lived conditions of late-eighteenth-century Mexico. As in the primary documents, the body in Lizardi's writing is employed to contrast the elite space/elite body with the plebeian space/plebeian body. From the initial description of Pedro's early nurturing by degenerate wet nurses, Lizardi firmly utlizes the body trope by giving his character two bodies, Pedro's and Periquillo's, and inscribes each in specific spatial domains. In giving Pedro two distinct bodies, Lizardi, using physiognomic rationale, highlights the elite body as a brilliant, clean, refined identity—in other words, recalling the description in the *Gaceta de México*, "a spectacle that sweeps the imagination."[103] In contrast, he presents the plebeian body as dirty, depraved, and, echoing the words of the viceroy's edict, in need of covering to hide "the indecent and disgraceful nakedness."[104]

SHIFTING VISUAL PRACTICES AND THE DISCOURSE OF RENOVATION AND REGULATION

The post-1750s production of the casta genre painting of Miguel Cabrera and Andrés de Islas is embedded in this meandering and tangled colonial discourse on renovation and regulation of the body found in late-colonial documents and in Lizardi's novel. We have seen that, through time, the casta genre shifts the viewing structure to a comprehensive, panoptic field of vision. This shift may be seen as marking a change in the terms by which people in the paintings are being explicated. Early series, like the 1720s set attributed to Rodríguez Juárez, display a limited viewing frame, with human figures located in narrow spaces. The people are identified to a certain extent by their clothing and skin color but most directly through the inscribed text of each panel that links the images to the sistema de castas taxonomy.

After the middle of the eighteenth century, the visual appearance of these plebeian bodies in specified spaces is given increased importance in

order to denote a specific qualitative state of being, calidad, rather than a place within a taxonomy. As seen in the 1773 Andrés de Islas series, the use of the sistema de castas nomenclature was probably anachronous and even an obsolete remnant of an older schema. Within these later paintings, the viewing field promotes a diagnostic gaze, which overwrites an older hierarchical rationalization of miscegenation with the construct of calidad.

The visual format of the casta genre does not stagnate through the century; rather, it alters to reflect the shifts in the formulation of the body. In particular, the activation of the surveying gaze, evident in the Cabrera series and intensified in the Islas series, signals that the circumstances prompting this visual practice are set in the confluence of midcentury artistic innovations. As discussed in chapter 3, after the 1730s, facing the production of immense retablos, painters realigned their strategies to promote comprehensive iconographic programs.[105] The later casta series can be seen as paralleling this move to comprehensive, unsegmented visual programs.

In 1753, Islas and Cabrera, along with other well-known artists, attempted to found a painting academy in Mexico City. While the establishment of this institution was unsuccessful, clearly these highly respected artists saw the possibility for culturally distinct artistic practices. The use of an incipient classicism in secular art was an example of this distinction.[106] This naïve classicism, as it is called by Marcus Burke, is evident in the casta genre and animates the Cabrera and Islas series with a visual explicitness that augments their new interest in comprehensive iconographic programs.

These transformations in visual practices also reflect the intensification of the discourse of renovation and regulation of colonial bodies and spaces. From a survey of regulatory edicts, decrees, and laws governing marriage, guilds, city planning, and apparel, it is clear that the objective of the laws was to control and construct the colonial body. In addition, the regulations may be understood as attempting to restrain casta mimicry of Spaniards through effective location of the casta body in selected economic and social spaces and through control of its appearance. The objective of the colonial discourse of renovation and regulation was to construct a social reality for colonial bodies and spaces, particularly plebeian bodies and spaces. Whether in bandos or in Lizardi's narrative, this discourse emphasized subjects who were seen as entirely knowable.

The secular art of the casta genre paintings, such as those by Cabrera and Islas, became a strategic tool that both reproduced and circulated this knowable plebeian body. Thus, as in written documents, the gaze/surveillance in the casta genre images gave visual form to the body by illustrating and circulating imagined knowledge about the protean conditions of, and interactions among, colonial bodies and spaces.

Even a late image like Fabregat's engraving of the refurbished Plaza Mayor, a print that explicitly depicts the central plaza as almost devoid of people, is, in fact, an image that remembers the urban density through the cleared space, marks a new Bourbon social vision, and recalls the collective experience of urban vitality. City inhabitants, in fact, are not absent. In truth, they *are* signified by the ordered spaces, and the walled enclosure is a visual metaphor for the orderly and disciplined colonial body constantly alluded to in the ordinances and edicts. In this print, the modern inhabitants of the city are remembered, experienced, and metaphorically present as the confined, guarded space of the elliptical enclosure.

As a perfect appurtenance of the colonial discourse, the gaze within the casta genre corresponds to the surveillance strategies found in late-colonial documents. Thus, the panoptic gaze that articulates calidad in casta paintings parallels the surveillance employed by cuartel alcaldes and constables, the eyes of colonial authority, to promulgate information and knowledge about cuartel inhabitants and their activities. The panoptic gaze of casta paintings is also analogous to the omniscient gaze of Pedro, as Lizardi's narrator, who takes the reader on a tour through the city. For example, panels 2 and 3 of the Islas series (figures 3.28 and 3.29) display Spanish bodies, specified by European costumes and leisure activities, who are found in elite domestic spaces denoted by narrow, interior private rooms filled with furniture, draperies, pictures, and windows open onto garden views. Here, elite identity is defined by the absence in appearance, circumstance, and concomitant character of any traces of mixed-blood calidad. These negative characteristics are articulated in the next panel, number 4 (figure 3.30), in which we are taken to a kitchen space to witness the heated argument between a Spaniard and a Black African woman. Continuing through the lineages displayed in the Islas panels, we move outside the private domain and into the public ways and side streets. Here, we survey the poor and sometimes tattered plebeians in maligned idleness or undertaking the debased activities of artisans and street vendors. The

diagnostic and regulatory eye has an interest in these people and spaces because surveillance produces physiognomic knowledge and, as a result, presumed control.

Casta images present the viewer with the impossible object of the knowable and visible populacho body and its spaces as direct antitheses to the elite body and its private, narrow spaces.[107] I say "impossible" because the colonial bodies and spaces of these paintings are not really knowable; in fact, they are imagined and unstable. Like the reiterated laws and decrees that attempted to control and stabilize the protean body, the casta genre must also incessantly reiterate its trope through the serial format and the repeated production and copying of the series. This visual reiteration certifies that the colonial body *cannot* be fixed but can only be situated in a liminal space of constructed colonial identity that is always unsuccessfully attempting to counterbalance the ambiguities and vicissitudes of the imaginings of colonial discourse.

Thus, the visual practice of casta genre painting was an extension and a perfect tool of the late-colonial discourse of New Spain. The use of an incipient classicism allowed presentation of a seeming reality of populacho depravity, described by colonial authority but presented as a natural truth in the images. As evidenced by the case of Doña Margarita and heard in the frustrated voice of the repetitive bandos, ordenanzas, and cédulas, the lived experiences of late-colonial Mexico City were constant reminders of the speciousness of this evanescent body construction. This constructed truth had to be reiterated in visual practices, as well, perhaps in the hope that seeing would assure believing.

From Populacho to Citizen:
The Re-vision of the Colonial Body

O NE OF THE MOST well known paintings of nineteenth-century Mexico is José Obregón's *Discovery of Pulque* (figure 5.1). The 1860s image recounts the legend of the discovery of the fermented maguey drink, pulque, by a young Indian woman, whom we see as she presents it to the Aztec-Mexica king. At the time of its exhibition, the painting received enthusiastic critical acclaim. The Indians depicted are not the unkempt vagrants of the streets or the barbarous subsistence hunters of the untamed countryside seen in casta paintings. Further, the vaunted attention that the painting bestows on the discovery of pulque is extraordinary, given that less than eighty years earlier, pulque was seen as the corrupting drink of the depraved gente vulgar.

This painting and others like it have been identified by scholars as seminal works in the development of a nationalist art of the nation-state that Mexico was striving to become during the 1800s.[1] Working in a neoclassic academic style, Obregón depicts noble Indians as a cultured, intellectually inquisitive people located among their artistic and archi-tectural achievements. The nationalist agenda had forced a complete restructuring of artistic imagery: a new discourse of origin and authenticity and its corollary trope of the historically placed body are fully formulated and announced here.

It is not the intention of this chapter to undertake an extended study of the history of art in nineteenth-century Mexico. This has been well accomplished in various earlier scholarly studies. Instead, as a means to concluding this study of eighteenth-century visual practices, I will address the last lingering problem identified initially in chapter 3: While por-traiture would continue, why does the production of the casta genre paintings cease at the beginning of the nineteenth century?[2] In addition, I will speculate on how the genre of casta paintings was the springboard for a nineteenth-century refashioning of the body trope.

Figure 5.1. José Obregón. *Discovery of Pulque*. Exhibited in 1869. Oil. 73.25 x 91 cm. Museo Nacional de Arte, Instituto Nacional de Bellas Artes (INBA), Mexico City.

Without a doubt, specific historical events required an end to the production of casta paintings. These include the fact that, by the early nineteenth century, political revolution was well under way and would result in the September 1822 ban of the use of casta designations in legal records[3] and the 1824 national constitution, which declared citizens' equality before the law. Obviously, once republican citizenship was available to all people, the negative demarcation of "kinds" of citizens could no longer be illustrated.

In addition, an institutional impact on art production resulted from the 1778 establishment of the School of Engraving. The founding of the academy was coeval with the general expansion of regulation in New Spain in the 1770s through the 1790s, and it institutionalized art production in a new way. In 1783, the school became the Royal Academy of Fine Arts of San Carlos. This founding is visualized in the late-eighteenth-century

Figure 5.2.
Attributed to
Andrés López.
*Retrato de Matías
de Gálvez*. Oil.
226 x 155 cm.
Museo Nacional del
Virreinato, INAH,
Tepotzotlán,
Mexico.

painting *Retrato de Matías de Gálvez* (Portrait of Matías de Gálvez)
attributed to Andrés López (figure 5.2). Here, under the steady hand of
Viceroy de Gálvez, two shoeless, unkempt, and dark-skinned boys, holding
paper and perhaps a canvas, appear perplexed as they look at each other
and point in opposite directions. The young boys, who may represent
artisans, are set in dramatic contrast to the two focused and well-dressed
young men seated behind them who are sketching, using a classical
sculpture as a model. The painting attests that the academy took
production over from guilds and artisans and subjected it to a controlling

bureaucracy that established new, comprehensive educational and icono-graphic programs for artistic production. In particular, academic art formulated new kinds of bodies across canvasses, sculptures, and engravings. In a period of such seismic political and social change, then, it is predictable that the imagery of casta paintings would be affected.

Understanding the historical circumstances of the end of the eighteenth century and the beginning of the nineteenth century does not fully explain, at a deeper, structural level, how the discourse of order and regulation and its trope of body shifted and changed as well. We return to *El periquillo sarniento* as a starting point for this exploration.

The fourth section of Lizardi's work, which was initially banned from publication, explores significant questions about political dependence and independence. In this final section of the novel, Pedro embarks on a trip to Manila. During the trip, he meets a Black African man and proceeds to have an extended conversation about the premises of slavery and its human degradation. "How can the inferiority of a person be measured?" and "How can the subjection of a person be justified?" Lizardi asks.[4] Although they are evident in other parts of the novel, here Lizardi directly confronts the assumptions of unquestioned social hierarchy through the most despised body of colonial culture, that of the Black African. On this body, Lizardi will initiate his elaboration of a new formulation of the body trope.

On his return journey to New Spain, Pedro is shipwrecked on Saucheofú, an imaginary island. Islanders find Periquillo, naked and injured, sprawled out on a beach. He is nursed back to health, given fine clothing, and taught the language of Saucheofú.[5] Once he has recovered, the *tután*, or viceroy, of Saucheofú questions Periquillo about what he does for a living. Charlatan that he is, Periquillo explains that he is a count, the Count of Ruidiera (noise/chatter), and proudly and emphatically declares that in his country his noble status precludes any manual labor. Once the tután stops laughing at Pedro's statement, he explains that in Saucheofú, nobles must participate in manual labor, and he chides that "if in your country the nobles cannot know how to value their hands [work] to obtain subsistence, nor can they understand anything else."[6] With the tután as his guide, Periquillo surveys a utopian society, one that has none of the social and economic defects of New Spain chronicled in the earlier sections of the book. He explores the conditions of this utopian state where social order is based not on a person's calidad but on the

individual's contribution to, and maintenance of, this order. Unlike Mexico City, Saucheofú has no filthy, idle, or naked bodies; everyone is employed. Nobles and priests toil along with common people; there are no lawyers because everyone is equal before the law, and laws are applied equitably without regard to social status. All citizens are required to wear insignias distinguishing nobles from plebeians and identifying marriage status and occupation. Thus, Lizardi asserts that unified and indivisible visual identification is a critical part of Saucheofú citizenship, and identity cannot be mimicked—as Periquillo is able to do—or confused, as it can be in New Spain.[7]

Lizardi begins this allegorical section of his story with a vision of Periquillo's naked and broken body lying on a desolate beach. His physical condition may be seen as a metaphor for the exposed and faulty hierarchical social system that marked New Spain's economic and political structure. The utopian experience of Saucheofú transforms Periquillo: he is clothed and made healthy, and he learns a new language. As a result of the experience of Saucheofú, he understands a different kind of body. The body metaphor explored in earlier sections of the book—with elites as the heads and non-elites as the hands and feet—is dissembled, as elite bodies are required to work in Saucheofú through the mandate of manual labor for all classes. Here, Lizardi communicates that he sees independence in New Spain as bringing forth new ways of reassembling or constructing the body. Upon Periquillo's return to New Spain, the third and final manifestation of his body appears: it is the body of Don Pedro. Don Pedro is a true hombre de bien, a decorous and morally meritorious individual who is a productive citizen. Here, in the unified and indivisible identity of the citizen, the reader is presented with an abstract and metaphorical body signifying an emerging ideal and an independent nation. Thus, the concluding section of Lizardi's novel traces the shift of Pedro's body from a concrete example of the multiple estates and calidades of the body of the New Spanish subject to a unified and metaphorical abstraction of the body of citizen Don Pedro.

In removing Periquillo from the vicissitudes of Mexico City to purely imaginary places to examine issues of political dependence, independence, and social order, Lizardi presents his readers with a new body and its new spaces. The colonial body of the earlier sections of the book has been transformed and reformed into a utopian body and located in the new

space of an emerging ideal nation. The conclusion of Lizardi's novel corroborates the slow shift from the late-colonial conception of the body to a nationalist view of the body.

This shifting notion of the colonial body and its space was evident in other aspects of the culture. In 1790, a play originally titled *México rebelado* (Mexico in rebellion), and retitled as the less offensive *México segunda vez conquistado* (Mexico conquered a second time), opened to a full house. The drama told the story of the capture, torture, and execution of the noble Aztec king Cuauhtémoc by Hernan Cortés, the Spanish conquistador, who was portrayed as less than honorable. According to reports, while most of the audience enthusiastically applauded the performance, peninsulares were angered by the play because it presented facts that were "inaccurate, untrue, and contrary to the character of the nation."[8] Subsequent performances were cancelled. Censors, however, defended their original approval of the play by saying that verisimilitude was a goal of the theater and that *México segunda vez conquistado* was based in authentic history and recreated real events. The problem with the play, they explained, was that it had been poorly performed by amateurs and that, as a result, realism had been lost.[9]

The play presented the Indian body as a topic of history, instead of ridicule or depravity, marking a new theme for the late-colonial period. This use of the Indian political figure to explicate political themes had also been advocated in Sigüenza y Góngora's program for his 1680 arch. The theatrical treatment of Cuauhtémoc's story one hundred years later may be seen as a means to reencounter the early history of New Spain and to formulate the question of independence through the themes of origin and authenticity.

Further, reminders of the early cultures—"ancient Mexicanos," as they were called—proliferated at the end of the eighteenth century. The urban refurbishment ordered by Viceroy Revillagigedo II also brought significant monuments of the Indian past into public view. For example, on 13 August 1790, the same year *México segunda vez conquistado* was performed and closed, a semi-anthropomorphic monolith was found during the repair of the cobblestones in the Plaza Mayor. Later called the Coatlicue, the statue was removed from the plaza at midnight and transported to the Royal and Pontifical University in Mexico City by order of the Spanish viceroy. In December of the same year, a circular monolith with a human face

surrounded by concentric bands of relief elements carved on one side was discovered. Identified as the Calendar Stone or Sun Stone, the monument was left on display in the plaza. Almost immediately, Antonio de León y Gama, a well-regarded and erudite mathematician and astronomer with a scholarly interest in preconquest antiquity, began to measure, draw, and analyze the sculptures. His finished work was published in June 1792.[10]

From the preface and introduction to León y Gama's work, it is clear that these monoliths caused some mild consternation. It seems that any writings on Indian culture required the imprimatur of ecclesiastic and civil officials; thus León y Gama's essay is preceded by official approvals. Joseph Rafael Olmeda from the Real Universidad de México approves the manuscript on the basis that it reveals the true calendric system of the ancient Mexicans. He also contends that León y Gama's essay refutes the disparaging allegation made by certain foreign writers about the preconquest history of Mexico.[11] Viceroy Revillagigedo also gives his endorsement, as does Joseph Pichardo, the priest from the Oratorio de San Felipe Neri. Pichardo points out that León y Gama understood the important meanings of the monuments and the reasons they were made. This priest concludes that the manuscript contains nothing that contradicts the Holy Faith.[12]

In the introduction to the book, León y Gama explains that the second monument, identified as the Sun Stone or Calendar Stone, is

> an original and instructive document, that manifests many parts of the history of the [Mexican] chronology and the exact means that they had to mark the dates to celebrate the Mexican festivals and for their political government.[13]

The author goes on to warn that despite its importance, the monument, now exposed to public viewing, without even a custodian, cannot be preserved from vandalism by the "gente rústica y pueril" (coarse and puerile people).[14] He argues that security is important because both sculptures shed light on ancient literature of the arts and sciences of the Indians of the Americas. As further justification for the historical importance of the monuments, León y Gama points out that such interest in antiquities was even fomented by King Carlos III with his construction of an expensive museum in Pórtici displaying excavated materials from Herculeum and Pompeii.[15]

León y Gama claims that his exegesis would reveal the meaning of the complex symbols and characters of the Mexican culture. He explains that the conquering Spaniards, who did not understand these symbols, had demolished many monuments that they believed supported Indian superstitions when, in actuality, the monuments had represented Indian history. Summarizing the extended study that is to follow, León y Gama concludes that, as a complex calendar, the Calendar Stone manifested the great intellectual achievements and identity of the ancient Indians.[16]

There is, however, more to León y Gama's story. It seems that shortly after the June 1792 publication of *Descripción histórica*, José Alzate y Ramírez, a well-known writer, acrimoniously disputed certain details of León y Gama's study. León y Gama responded to Alzate's caustic criticism with an essay entitled "Advertencias Anti-Críticas" (Notice against criticism).[17] For the most part, this new essay was a point-by-point rebuttal to Alzate's criticism.

Analysis of León y Gama's riposte offers some interesting insights into the crosscurrents of late-colonial culture. León y Gama explains that his study of Indian history was quite extensive and included knowledge of the Indian language. He goes on to reiterate the reasons for his study.

> I undertook to write the ancient history of New Spain, in the time of its paganism, as well as the years subsequent to the conquest, in order to dispel the innumerable errors, mistakes, and poor understanding that most historians have made due to lack of accurate [primary] documents and mature reflection to support the events, and to give a clear idea of those who were known as the mexicanos, and other people who populated this part of North America . . . with no other end than to serve my country and have it result in useful material.[18]

León y Gama's objective, then, is to promote, through his study of Indian chronology, a true history of New Spain. After announcing his intentions, León y Gama proceeds to refute Alzate's objections. These included queries about León y Gama's knowledge of mineralogy and astronomy and the validity of certain documents used in the study.

One of the more striking assertions made by Alzate was that one of León y Gama's primary sources was not authentic. Alzate alleged that it was written by a mestizo, not an Indian. León y Gama justifies his scholarly reasoning for using this source and then also claims that he knew the

differences in character between Indians and mestizos because of his daily business encounters with these people in Mexico City. Although both Indians and mestizos knew Spanish well, he states that the Indians adulterated "our language" and were better able to explain themselves in their native language. Further, he dares Señor Alzate to go to the corridors of public buildings, where he would find "real" Indians with last names like Cortés, Mendoza, Peña, Luna, and Mendez, which were properly "our Spanish" surnames. It was ridiculous, León y Gama concludes sarcastically, to believe someone was a mestizo just because of a surname.[19]

Alzate's and León y Gama's arguments and counterarguments indicate a perception of the existence of an original and authentic preconquest history. Their debate is about the right to authorship of this history and to the certification of its authenticity. León y Gama's discussion about mestizos and Indians demonstrates an implicit belief that authenticity is not found in appearances or surnames but in an inherent, original condition emanating from historical context as exemplified by one's language usage. In this way, León y Gama foreshadowed the nineteenth-century ideas of national identity as located not in calidad based in physiognomic evaluation but in citizenship evaluated through origins and authenticity.

This "authentic" history, while based on legitimate ethnohistoric documents, was nonetheless a constructed history that sought to find origins for the emerging nation. Antiquities became an essential source of the new imagery for this emerging history and its discourse of origin and authenticity. This new imagery was comprehensively formulated in the nineteenth century through the artistic production of the Academy of San Carlos. The expanding discourse of origin and authenticity, which began as an undercurrent of discussion in the late eighteenth century, was later promoted by academic art and ultimately made the visual practice of casta imagery no longer viable. Specifically, casta paintings produced the verisimilitude of a knowable, tractable body; academic paintings promoted a transmutable, metaphorical body for republican consumption. Casta paintings could not promote this nationalistic discourse because their imagery represented the body of colonial renovation and regulation. They did not invoke the glorious past or allude to a utopian future that was needed to tell the story of an emerging nation in the late eighteenth and nineteenth centuries.

Figure 5.3. Attributed to Manuel Serrano. *Indios de la Sierra de Oaxaca*. Nineteenth century. Oil. 92 x 136 cm. Museo de América, Madrid.

The shift to nationhood required a breaking up and reconstituting of the colonial body, as we saw with Periquillo's body. With Mexican independence in 1821, the national government recognized the educational importance of institutions like the Academy of San Carlos. As the government attempted to redirect public attention away from the issue of colonial status, visual practices became one of the strategies for focusing on national identity as well as explicating and maintaining control of the new nation.[20] In this context, it is possible to speculate that the imagery of casta paintings was broken up or transformed into three genres of nineteenth-century painting that formulated the nation into three distinct, but interlocking, bodies. First, the stigmatized bodies of casta paintings became the ethnographic body of the nation as cultural geography. Here the diverse people of Mexico and their common daily—and sometimes celebratory—activities are romanticized in a genre known as *costumbrista* painting.[21] For example, in figure 5.3, a common card game is under way. In the eighteenth century, the individuals in this painting would have had their calidad noted on the canvas; in the nineteenth century, such notation

is superceded by a scene that emphasizes the lived aspects of Mexican life. Secondly, the panoramic spaces and backgrounds of casta paintings became the body of the nation as physical geography. Landscape painting, also known as *cuadros nacionales* (national paintings), aimed to show the vastness of Mexico.[22] Here, the land of Mexico, in its pristine and idyllic beauty, was used to germinate a new nation.

Figure 5.4. Petronilo Monroy. *Allegory of the Constitution of 1857.* Exhibited 1869. Oil. Approx. 170 x 90 cm. Museo Nacional de Arte, Mexico City. (This is a small study of a larger canvas that is in the Palacio Nacional.)

Finally, certain critical figures from the casta genre were incorporated into the mounting interest in visualizing a historical, allegorical body of the nation. Using a full neoclassicizing mode, history painting came to serve this goal. As in European academies, history painting was given great prestige because it was considered to embody the objectives of high art. Heroes and events of the revolution filled Mexican academic canvasses. Importantly, two figures from casta genre paintings, the Indian and the mestizo, were maintained and recast in nineteenth-century academic imagery.

Stacie Widdifield points out that, over the colonial centuries, the use of indigenous culture had provided an unlimited "source for Mexico to justify, if not reinvent, its own history and shore up structures of power and strategies of social control."[23] Within casta series, Indians were identified in distinct formulations: the female mates of Spanish males who produced mestizo offspring; mates of mixed-blooded persons; unkempt vagrants or street vendors; and barbarous subsistence hunters. With the move toward independence, the body of the Indian became the critical nexus in the discourse of origin and authenticity. The Indian of academic painting was constructed in a historical light as a complex "simulacrum of the Indian, [with] the aura of an elite culture from which the present of the nineteenth century could claim a legitimizing descent."[24] These nineteenth-century representations also contained the regulatory associations of casta references. Specifically, the use of neoclassicism also maintained the Indian as a figure that was the continual object of conquest and westernization.[25]

Nationalist art also tried to reform the meaning of the mestizo. We have seen that, except at the very beginning of the colonial period, offspring of Spaniards and Indians were considered bastards, unlucky accidents of population growth. In genre paintings of castas, the mestizo is formulated in two ways. Mestizo blood that continued to mix with Spanish blood was perceived to be purifiable. That is, the mestizo-Spaniard union produced the castizo, and castizo blood combined with Spanish blood became fully purified, with the offspring returning to the calidad of a Spaniard. On the other hand, if mestizo blood mixed with Black African, Indian, or other casta blood, the result could only be further degeneration. Two examples are the chamiso offspring of castizo and mestiza shown by Cabrera (figure 3.25) and the coyote offspring of Indian and mestiza illustrated by Islas (figure 3.35), both of which clearly show deteriorated calidad. In casta

paintings, then, the mestizo held the potential for the widest transformations.

Nineteenth-century visual practices recognized the tranformative possibilities of the mestizo by representing the mestizo as a Europeanized Indian, the perfect reference to the distinctiveness of Mexican identity.[26] This mestizo was first visually formulated in genre paintings of castas and, in the nineteenth century, became the perfect sign of the Indian past brought into the national present. The mestizo protean potential was visualized in the painting *Allegory of the Constitution of 1857*, painted by Petronilo Monroy around 1869 (figure 5.4). Here a mestiza woman is "in many ways the embodiment of the national . . . instead of a picture of a fractious nation that must demand difference and otherness to constitute its Mexicanidad. . . ."[27]

Nationalist painting took these Indian and mestizo representations, removed them from the present, and placed them in originating and allegorical time. While the Indians of casta painting emphasize a social present, *Discovery of Pulque* narrates Indians of the legendary past. Instead of the Indians of the pulquerías and filthy streets of Mexico City, these are enlightened Indians—those placed among the antiquities discovered in the late eighteenth century, those whom León y Gama sought to discover in his exegesis of the Calendar Stone, and those who were idealized in *México segunda vez conquistado*. Likewise, mestizo protean potential was visualized in *Allegory of the Constitution of 1857*. Here, miscegenation becomes positively transformed through its displacement to—or replacement in—the creative timelessness of allegory. As seen in Lizardi's final chapters, it is through this legendary and allegorical or utopian time, not the present, that the abstraction of transformative citizenship could best be formulated.

Thus, the intense focus on the body during the eighteenth century formed a foundation for the notions of the allegorical and historical body and embodiment found in Obregón's and Monroy's paintings. This critical and central trope in *The Discovery of Pulque* and *Allegory of the Constitution of 1857* continued the exploration of the body found in the eighteenth-century secular art of portraiture and casta painting. The eighteenth-century corporeal discourse of estates and calidad and their respective contexts, however, was superceded by a nineteenth-century discourse of origins and authenticity, in association with cultural and

physical geography. Historical and allegorical time, so critical to the writings of León y Gama and Lizardi, became the framing device that transformed the eighteenth-century body into the new kinds of bodies found in these nineteenth-century paintings. Thus, portraiture and casta paintings, visualized only in the present, had depicted the knowable, tractable, estate-defined body. Academic paintings, looking to the imaginary past and envisioned future so critical for nation building, took this disparate and constructed territory of the colonial body and produced the unified metaphorical body of originating nationalist history and the allegorical body of nation.

Epilogue
Dreams of Order

> That disturbance of your voyeuristic look enacts the complexity and
> contradiction of your desire to see, to fix cultural difference in a
> containable, *visible* object.
>
> Homi Bhabha, *The Location of Culture*

Grateful for the diminishing of light in the early evening, Gregoria Piedra
stepped from her house and walked cautiously down the street on her way
to the Plaza Mayor. Unable to avoid intermittent brushes with other
pedestrians, she tried to maintain her invisibility by keeping her head
upright and looking straight ahead in order to deflect any furtive glances.
The sharp smells of street food filled her nostrils, while the cacophonous
squawks of vendors rang in her ears. She relished this freedom to explore
and enjoy the smells, sounds, and activities of Mexico City. Only the
occasional piercing stare of a cuartel watchman, who seemed to be trying
to recognize her, disturbed her enjoyment. She reminded herself to nod
her head and stride calmly past the remembering eyes.

Gregoria's neighbors on Calle de San Juan had talked incessantly about
the grand adornments that had been put up for the celebration of Queen
María Luisa de Bourbon's birthday. On this seventh day of December of
1796, she intended to see the decorations on her way to evening mass in
the cathedral. Turning the corner onto the Plaza Mayor, she found herself
on the edge of a small group of people gathered around a plaque that
marked one of the newly installed fountains. Gregoria recognized her
neighbor, Viejo Mendoza, reading the inscription to the group, and
stopped to listen as the old man hesitantly read the words aloud:

In the reign of Charles IV,
in the viceregency of the Most Excellent Juan Vicente
de Güemes Pacheco de Padilla, Count of Revillagigedo,
the street plan of the city was laid out, glazed tiles

to mark the name of every street and plaza were set in place, the houses
were numbered, annexes marked,
the façades of many buildings were painted, and a
regimen of general cleanliness was undertaken.[1]

Taking in the meaning of these words, a mulatto woman, dressed in tattered clothes, who stood next to Gregoria shouted out, "The viceroy is describing gachupín Mexico City, not my Mexico City." A few in the gathering laughed in recognition of the truth in the mulatto woman's words and turned to nod additional agreement with the woman, but their eyes came to rest on Gregoria. Only Viejo Mendoza recognized her and, thankfully, he averted his eyes and said nothing. She turned quickly and continued her stroll across the Plaza Mayor toward the cathedral.

The plaza's adornments were indeed magnificent. Buildings and trees glowed with thousands of lights, bright banners hung across other buildings, and large portraits of the king and queen were placed on the façade of the viceroy's palace. While Gregoria was staring up at the portraits, a pointing finger caught her peripheral vision. Looking to her left, she saw the mulatto woman from the fountain pointing her out to a constable. Frozen for half a minute, Gregoria lurched to the right, scrambled through the dense parián crowds, and entered the darkened rear of the cathedral. Sliding into a pew, she slowed her breathing and turned her head slightly to make sure that she had not been followed. Relieved to see that the constable had not entered the back of the church, Gregoria listened to the Gloria of the mass. Her thoughts drifted to an attempt to understand why her appearance so disturbed authorities. She hurt no one and simply wanted to be invisible so that she might move freely about the city. Abruptly, a large hand grabbed the shoulder of her velvet jacket. "Scandalous woman!" growled an old priest in a low voice. "How dare you defile this holy place? You will come with me, now!" he demanded. Outside the cathedral, the priest pushed Gregoria toward the constable. The constable's eyes scanned her body as he stepped up to her and declared, "Gregoria Piedra, known as La Macho, I arrest you for the crime of trying to deceive by denying your sex and dressing like a man."

Archival documents provide the specific historical facts of the Inquisition inquiry into the habits of Gregoria Piedra, which I have introduced

through this fictitious narrative. A document dated 6 April 1796 from Don Augustín José Montefano y Larrea is a response to a request from the Inquisition Tribunal for information about Gregoria. Don Augustín, the administrator of the jail holding Gregoria, wrote that she was a *"muger hombrada"* (a masculinized woman), dark skinned, with the hair of a mulatto. Born in Mexico City, she lived on Calle de San Juan, where she was known as Gregoria, La Macho. She was seen dressed in the clothing of both men and women, but she more often wore men's clothing; it was also reported that she played pelota and was often accompanied by women. Gregoria had been put in the city jail four times for being clothed in the garments of men. Most egregiously, she was caught by a priest in a church wearing male clothing and expelling the holy host from her mouth. She was placed in the ecclesiastic jail and then transferred to the city jail. Don Augustín added that Gregoria also claimed to have served as a soldier in the Free Black regiment or in the calvary.[2] The documents do not reveal what happened to Gregoria once this report was made.

The case of Gregoria affirms how ambiguous identity could be in late-colonial New Spain. Eighteenth-century edicts had strictly forbidden wearing the clothing of the opposite sex. It would seem that no amount of order or orderliness stipulated by the viceroys could fix or secure anyone's identity.

Gregoria was a woman who had the pluck to change her gender identity and roam through the streets of Mexico City; she even dared to play pelota, a game usually only played by elite Spanish males, and she claimed to have been a soldier. Mimicking a male would have given her a certain amount of invisibility and allowed her to explore activities that were forbidden to females. However, Gregoria, La Macho, disrupted colonial surveillance by not conforming to the gaze's prescriptions for gender identity. Explaining her full reason or reasons for this behavior is, of course, impossible; the fact that she could and did switch her identity verifies that the power of colonial authorities to control the colonial body and its spaces was largely illusionary. In fact, as we have seen, Revill-agigedo's attempts, as outlined in the inscription, to order, name, cover up, and clean the spaces and people of the city were constantly thwarted. Gregoria's story confirms that all the supposedly rigid boundaries of late-colonial life were arbitrary and vacillating, vulnerable to rupture and breach at every turn.

I conclude this study with Gregoria's case because the ambiguity of her body, and of the spaces she inhabited daily, epitomizes the social setting for the secular art of late-colonial New Spain. Casta paintings and portraiture attempted to fix and stabilize colonial identity. Using the trope of the body, the visual practices of casta paintings, in particular, shifted through time to reflect increasing attempts at regulation and renovation. In emphasizing visibility, casta paintings would have the viewer believe that to be made visible was to be known, to be given a fixed identity, to mirror a natural truth. To the contrary, the complexity of hybridity lived daily by people like Mauricia Josefa and Gregoria constantly overwhelmed attempts at rigid division. These women could not be delimited by numerous regulations or contained in any book. Somehow, I can imagine Gregoria, recently released from jail, wearing a crisp blouse, a skirt, and a colorful shawl, with a pearl necklace and matching earrings, peering at the casta paintings of Miguel Cabrera and smiling broadly. For Gregoria, these pictures confirmed that ambiguity brings chaos to all dreams of order.

Notes

INTRODUCTION

1. Juana Gutiérrez Haces, "*The Painter's Cupboard*," in *Mexico: Splendor of Thirty Centuries* (Boston: Bulfinch Press, 1990, exhibition catalog), 435–436.

2. All translations are mine unless otherwise noted. The term "Indian," a translation for the Spanish word "*indio*," is used throughout the text to refer to the indigenous people of New Spain. In general, I have followed Spanish usage for Spanish words. Personal adjectives referring to specific individuals have endings (o/a) that reflect the gender of the person to whom they refer. Spanish nouns are sometimes pluralized by adding -es instead of just -s. Unless otherwise noted, all transcriptions reflect the original text of the archive documents.

CHAPTER ONE

1. In this book, I use the term "criollo"—instead of its translation, "creole"—to refer to an American-born Spaniard.

2. "Petición de aclaración de la partida de bautismo de Margarita Casteñeda, colocados en los libros correspondientes de los de color quebrado siendo ella española," Archivo General de la Nación (hereafter AGN), Matrimonios, 1789, vol. 87, exp. 4 bis., fojas 21–26. In the archive documents, Bivian is also spelled "Vivian"; for consistency, I use Bivian in all references to and quotations from this manuscript. The names Christobal and Castañeda have also been standardized.

3. Ibid., 21ob–22.

4. Ibid., 22–22ob.

5. It should be noted that the term "gachupín" made the elite status of Spaniard a liability and, particularly in the late eighteenth century, emphasized the foreignness of certain sectors of the elite. See Sonya Lipsett-Rivera, "*De Obra y Palabra*: Patterns of Insults in Mexico, 1750–1846," *The Americas* 54, no. 4 (April 1998): 511–539. Gachupines were also viewed as groping foreigners concerned with extracting and exploiting American wealth. See Jaime E. Rodrígues O., ed., *Mexico in the Age of Democratic Revolutions, 1750–1850* (Boulder and London: Lynne Rienner Publishers, 1994), 266.

6. "Petición de aclaración," AGN, Matrimonios, 1789, vol. 87, exp. 4 bis., fojas 22ob–23.

7. Ibid., 23–230b.

8. Ibid., 230b–24.

9. Dennis Nodin Valdés, "The Decline of the *Sociedad de Castas* in Mexico City" (Ph.D. diss., University of Michigan, 1978), 125. Interestingly, Valdés goes on to point out that by the early nineteenth century, the title *"don"* could be bought for fourteen hundred pesos and did not specifically exclude people who could not prove their blood was pure.

10. See Ann Twinam, *Public Lives, Private Secrets: Gender, Honor, Sexuality and Illegitimacy in Colonial Spanish America* (Stanford, California: Stanford University Press, 1999), 41–55.

11. See Robert McCaa, *"Calidad, Clase,* and Marriage in Colonial Mexico: The Case of Parral, 1788–1790," *Hispanic American Historial Review* 64, no. 3 (1984): 477.

12. Carolyn Dean, in *Inka Bodies and the Body of Christ* (Durham and London: Duke University Press, 1999), 4–6, provides a salient discussion on the colonial Peruvian body as a constructed artifact and the human body as an embodied identity.

13. See McCaa, *"Calidad, Clase,"* and also Richard Boyer, *Cast [sic] and Identity in Colonial Mexico: A Proposal and an Example* (Storrs, Conn.: Center for Latin American and Caribbean Studies, 1997).

14. See Nancy Fee, "The Patronage of Juan de Palafox y Mendoza: Constructing the Cathedral and Civic Image of Puebla de los Angeles, Mexico" (Ph.D. diss., Columbia University, 2000), 89; and Julio Caro Baroja, "Religion, World Views, Social Classes and Honor During the Sixteenth and Seventeenth Centuries in Spain," in *Honor and Grace in Anthropology*, trans. Victoria Hughes and ed. J.G. Peristiany and Julian Pitt-Rivers (Cambridge: Cambridge University Press, 1992), 91–102.

15. Alejandro Cañeque, "The King's Living Image: The Culture and Politics of Viceregal Power in Seventeenth-Century New Spain" (Ph.D. diss., New York University, 1999), 4–16.

16. Ibid., 349 n. 79.

17. Ibid., 26–27.

18. Ibid., 186.

19. Ibid., 324–326.

20. Rebecca Haidt, *Embodying Enlightenment: Knowing the Body in Eighteenth-Century Spanish Literature and Culture* (New York: St. Martin's Press, 1998), 5.

21. Ibid., 125.

22. Ibid., 107.

23. Ibid., 108.

24. Ibid., 1–12.

25. In an April 1778 *cédula* (decree) reiterating earlier marriage laws, the king indicated

his keen awareness of miscegenation in New Spain and justified the need for the law by noting the "diversidad de clases y castas de sus habitantes y otras causas que no concurren en España" (the diversity of classes and mixed-bloods of its [New Spain's] inhabitants and other causes [factors] that do not combine to occur in Spain). "Real Cédula. Declarando la forma en que se ha de guardar y cumplir en las indias la Prágmatica sanción de 23 de Marzo de 1776 sobre contraer matrimonio," in *Colección de documentos para la historia de la formación social de Hispanoamérica, 1493–1810*, ed. Richard Konetzke, vol 3.1, 1691–1779 (Madrid: Consejo Superior de Investigaciones Científicas, 1962), nos. 247, 438.

26. Elizabeth Anne Kuznesof, "Ethnic and Gender Influences on 'Spanish' Creole Society in Colonial Spanish America," *Colonial Latin American Review* 4, no. 1 (1995): 160.

27. Ibid.

28. Twinam, *Public Lives*, 42.

29. For an excellent overview of the evolution of racial concepts, see Matthew Frye Jacobson, "Introduction: The Fabrication of Race," in *Whiteness of a Different Color: European Immigrants and the Alchemy of Race* (Cambridge: Harvard University Press, 1998), 1–12.

30. Nicholas Hudson, "From 'Nation' to 'Race': The Origin of Racial Classification in Eighteenth-Century Thought," *Eighteenth-Century Studies* 29, no. 3 (Spring 1996): 252.

31. Kenan Malik, *The Meaning of Race: Race, History and Cultures in Western Society* (New York: New York University Press, 1996), 77.

32. A. Owen Aldridge, "Feijoo and the Problem of Ethiopian Color" in *Racism in the Eighteenth Century*, ed. Harold E. Pagliaro (Cleveland and London: The Press of Case Western Reserve University, 1973), 268–277.

33. Ibid., 265–266.

34. Ibid., 267–270.

35. Ibid., 274.

36. Magnus Mörner, *Race Mixture in the History of Latin America* (Boston: Little, Brown and Company, 1967), 55–59.

37. Douglas Cope, *The Limits of Racial Domination: Plebian Society in Colonial Mexico City, 1660–1720* (Madison: University of Wisconsin Press, 1994), 16–17.

38. See note 25 above.

39. Sr. Dn. Pedro Alonso O'Crouley, *A Description of the Kingdom of New Spain*, 1774, trans. and ed. Seán Galvin ([San Francisco]: John Howell Books, 1972).

40. Ibid., 20.

41. Ibid., 20–21.

42. Ibid., 20.

43. An important problem related to this case, and to eighteenth-century visual culture, that is not explored in the present study is the question of gender formation. A study I am now writing considers the relationship between certain women and the construction of gender in private and public sites, especially the marketplace, a site where women are commonly located in casta painting imagery. In particular, I believe gender in Doña Margarita's case and the visual culture of eighteenth-century Mexico may also be reviewed in light of economic production shifts that were occurring in early modern cultures. See, for example, Merry Wiesner, *Women and Gender in Early Modern Europe* (Cambridge: Cambridge University Press, 1997); Elizabeth Honig, "Desire and Domestic Economy," *The Art Bulletin* 83, no. 2 (June 2001): 294–315; and Elizabeth Honig, *Painting and the Market in Early Modern Antwerp* (New Haven: Yale University Press, 1998).

44. Bill Ashcroft, Gareth Griffiths, and Helen Tiffin, *Key Concepts in Post-Colonial Studies* (London: Routledge, 1998), 42.

45. Gyan Prakash, ed., *After Colonialism: Imperial Histories and Postcolonial Displacements* (Princeton: Princeton University Press, 1995), 3–4.

46. Ashcroft, *Key Concepts*, 139.

47. Homi Bhabha, *The Location of Culture* (New York: Routledge, 1994), 85–86.

48. Ibid. See also Ashcroft, *Key Concepts*, 13.

49. Bhabha, *Location of Culture*, 86–92.

50. Ibid., 36–37. For a discussion of the implication of hybridity in the colonial Peruvian context, see Dean, *Inka Bodies*, 161–163.

51. Bhabha, *Location of Culture*, 45.

52. Ibid., 70–71.

53. Ibid., 76–77.

54. Michel Foucault, *Discipline and Punish: The Birth of the Prison*, trans. Alan Sheridan (New York: Pantheon Books, 1979), 213–214.

55. See Bhabha, *Location of Culture*, 76.

56. "Petición de aclaración," AGN, Matrimonios, 1789, vol. 87, exp. 4 bis., fojas 24–25.

57. Twinam, *Public Lives*, 59–89.

58. "Petición de aclaración," AGN, Matrimonios, 1789, vol. 87, exp. 4 bis., foja 25.

59. Twinam, *Public Lives*, 128, 220.

60. Twinam discusses a case in the archives of Venezuela in which the adulterina status of a woman was discovered by her husband; see *Public Lives*, 154–156.

61. An extended study of birth status and birth rights is found in Twinam, *Public Lives*.

CHAPTER TWO

1. For a discussion of portraiture conventions in colonial New Spain, see Abby Sue Fisher, "*Mestizaje* and the *Cuadro de Casta*: Visual Representation of Race, Status, and Dress in Eighteenth Century Mexico" (Ph.D. diss., University of Minnesota, 1992), 75–76; Elisa Vargaslugo, "Austeridad del alma," *Artes de México* no. 25 (July–August 1994): 45–51; and Marita Martínez de Río de Redo, "Magnificensia barroca," *Artes de México* no. 25 (July–August 1994): 52–64.

2. Martínez de Rio de Reda, "Magnificensia barroca," 59. See also Elizabeth Q. Perry, "*Escudos de Monjas*/Shields of Nuns: The Creole Convent and Images of Mexican Identity in Miniature" (Ph.D. diss., Brown University, 1999), 66.

3. "Inquisición fiscal de Sto Oficio contra Mauricia Josepha de Apelo, española de estate soltera vecina de esta ciudad. Por dichos y hechos hereticales. Espontanea. Reclusa en el Hospico y declarada loca. México, Inquisición," AGN, Inquisición, 1768, tomo 1009, exp. 15, fojas 311–313, 332.

4. Ibid., 351–3510b.

5. Ibid., 351.

6. Ibid., 323.

7. The series is incomplete, with panels 3 and 6 missing. The remaining panels are divided between two collections. See María Concepción García Sáiz, *Las castas mexicanas: Un género pictórico americano* (Milan: Olivetti, 1989), 80. Panel 15 has been located in a private collection, according to Ilona Katzew; see Katzew, "Los cuadros de castas: Noticias sobre fuentes posibles en grabados y pinturas europeas," in *XVII Coloquio internacional de historia del arte: Arte, historia e identidad en América: Visiones comparativas* (Mexico City: Universidad Nacional Autónoma de México, 1994), 3:729–740.

8. Michael Meyer, William Sherman, and Susan Deeds, *The Course of Mexican History* (New York and Oxford: Oxford University Press, 1999), 251–253.

9. Major works on Bourbon Spain include: Timothy E. Anna, *The Fall of the Royal Government in Mexico City* (Lincoln: University of Nebraska Press, 1978); Linda Arnold, *Bureaucracy and Bureaucrats in Mexico City, 1724–1835* (Albuquerque: University of New Mexico, 1977); David Brading, *Miners and Merchants in Bourbon Mexico, 1663–1810* (Cambridge: Cambridge University Press, 1971); Mark A. Burkholder and D. S. Chandler, *From Impotence to Authority: The Spanish Crown and the American Audiencias, 1687–1808* (Columbia: University of Missouri Press, 1977); Susan Deans-Smith, *Bureaucrats, Planters, and Workers: The Making of the Tobacco Monopoly in Bourbon Mexico* (Austin: University of Texas Press, 1992); Richard L. Garner and Spiro E. Stefanou, *Economic Growth and Change in Bourbon Mexico* (Gainsville: University of Florida Press, 1993); Richard Herr, *The Eighteenth-Century Revolution in Spain* (Princeton: Princeton University Press, 1958); Jonathan I. Israel, *Race, Class and Politics in Colonial Mexico,*

1610–1670 (Oxford: Oxford University Press, 1975); John E. Kicza, *Colonial Entrepreneurs: Families and Business in Bourbon Mexico City* (Albuquerque: University of New Mexico Press, 1983).

10. Meyer, *Course of Mexican History*, 243–244.

11. Gabriel Haslip-Viera, *Crime and Punishment in Late-Colonial Mexico City, 1692–1810* (Albuquerque: University of New Mexico Press, 1999), 48.

12. Meyer, *Course of Mexican History*, 251.

13. Twinam, *Public Lives*, 243–248.

14. Cope, *Limits of Racial Domination*, 3.

15. Valdés, "Decline of the *Sociedad*," 2–3.

16. Juan de Viera [1719/20–1781], *Breve y compendiosa narración de la ciudad de México*, 1st. ed., with transcription by Beatriz Montes and Armando Rojas (Mexico City: Instituto Mora, 1992, facsimile), 28.

17. Valdés, "Decline of the *Sociedad*," 18.

18. Cope, *Limits of Racial Domination*, 13–14.

19. Valdés, "Decline of the *Sociedad*," 18.

20. Mörner, *Race Mixtures*, 165. In her dissertation project, María Elena Martínez, Ph.D. candidate at the University of Chicago, is researching the relationship between "purity of blood," known as limpieza de sangre, and the emergence of the sociedad de castas in early-colonial Mexico. (oral presentation at John Carter Brown Library at Brown University, 26 April 2000).

21. P. fray Francisco de Ajofrín, *Diario del viaje a la Nueva Espana* (Madrid: Impreta y Editorial, Maestra, 1958), 66.

22. Mörner, *Race Mixtures*, 53–58.

23. Ibid., 58.

24. García Sáiz, *Las castas mexicanas*, 27.

25. Cope, *Limits of Racial Domination*, 19.

26. Valdés, "Decline of the *Sociedad*," 55.

27. Patricia Seed, "Social Dimensions of Race: Mexico City, 1753," *Hispanic American Historical Review* 62 (1982): 575–576.

28. Valdés, "Decline of the *Sociedad*," 57–58.

29. Ibid., 40–42.

30. Ibid., 42.

31. Seed, "Social Dimensions of Race," 588.

32. Cope, *Limits of Racial Domination*, 87.

33. Seed, "Social Dimensions of Race," 569.

34. Cope, *Limits of Racial Domination*, 22.

35. Ibid., 49.

36. O'Crouley, *Description of the Kingdom*, 20.

37. Valdés, "Decline of the *Sociedad*," 188–189.

CHAPTER THREE

1. See Guillermo Tovar de Teresa, "Arquitectura efímera y fiestas reales," *Artes de México* no. 1, 3rd ed. (winter 1993): 34–47.

2. Carlos Sigüenza y Góngora, "Teatro de virtudes políticas que constituyen a un príncipe" (1680), in *Seis obras*, ed. William G. Bryant (Reprint, Madrid: Biblioteca Ayacucho, 1984), 189.

3. For a reconstruction of the arch, see Helga von Kügelgen, "'Así "repercute" la gloria del mundo' Aproximación a la reconstrucción de los arcos de triunfo de Don Carlos de Sigüenza y Góngora y Sor Juana Inés de la Cruz," in *XVII Coloquio internacional de historia del arte: Arte, historia e identidad en América: Visiones comparativas* (Mexico City: Universidad Nacional Autónoma de México, 1994), 3:707–727.

4. Sigüenza y Góngora, "Teatro de virtudes," 186, 187.

5. Ibid., 188.

> manifesté las virtudes más primorosas de los mexicanos emperadores para que mi intento se logre sin que a la empresas se las quebranten las leyes: <<El alabar, pues, a los príncipes más buenos (prosigue el discretísmo Plinio) y por medio de ellos, como al través de un espejo, mostrar a la posteridad la luz que de ellos emana, tiene mucho de utilidad, nada de arrogancia>>.

6. See Cañeque, "The King's Living Image," 70.

7. von Külgelgen, "Así 'repercute' . . . ," 707–712.

8. Perry, "*Escudos de Monjas*," 44–47.

9. Ibid., 174–177.

10. Ibid., 120–122.

11. Ibid., 195.

12. Ibid., 195–196. For a discussion of the development of the distinct visual style of late-colonial Mexico, see Marcus B. Burke, *Treasures of Mexican Colonial Painting: The Davenport Museum of Art Collection*. (Santa Fe: Museum of New Mexico Press, 1998), 55–56.

13. See García Sáiz, *Las castas mexicanas*, 91.

14. Kelly Donahue-Wallace traces some of the history of censorship in the religious genres in chapter 6 of her dissertation, "Prints and Printmakers in Viceregal Mexico City, 1600–1800" (Ph.D. diss., University of New Mexico, 2000), 267–279.

15. See Katzew, "Los cuadros de castas: Noticias."

16. Ilona Katzew, "Casta Painting, Identity and Social Stratification in Colonial Mexico," in *New World Orders: Casta Painting and Colonial Latin America*, ed. Ilona Katzew (New York: Americas Society, 1996), 13–14.

17. Perry, "*Escudos de Monjas*," 186–187.

18. Cited in Efrain Castro Morales, "Los cuadros de castas de Nueva España," *Jahrbuch für Geschichte von Staat, Wirtschaft un Geellschaft Lateinamerikas* Band 20 (1983): 680. Castro Morales notes that the Andrés de Arce y Miranda manuscript is in a private collection in Puebla, Mexico (p. 690). Also cited in Katzew, "Casta Painting," 14.

19. Burke, *Treasures*, 101.

20. García Sáiz, *Las castas mexicanas*.

21. Fisher, "*Mestizaje*."

22. Ilona Katzew, ed., *New World Orders: Casta Painting and Colonial Latin America* (New York: Americas Society, 1996).

23. Ilona Katzew, "Ordering the Colony: Casta Painting and the Imaging of Race in Eighteenth-Century Mexico" (Ph.D. diss., New York University, 2000). At the time of the writing of this manuscript, Katzew's dissertation was not accessible.

24. For example, see Castro Morales, "Los cuadros de castas"; Elena Isabel Estrada de Gerlero, "The Representation of 'Heathen Indians' in Mexican Casta Painting," in *New World Orders*, ed. Katzew, 42–56; J. Jorge Klor de Alva, "*Meztizaje* from New Spain to Aztlán: On the Control and Classification of Collective Identities," in *New World Orders*, ed. Katzew, 58–72; and Katzew, "Los cuadros de castas: Noticias."

25. García Sáiz, *Las castas mexicanas*.

26. María Concepción García Sáiz, "The Artistic Development of Casta Painting," in *New World Orders*, ed. Katzew, 31–33.

27. Ibid., 48.

28. Fisher, "*Mestizaje*," 139, 143.

29. Katzew, "Casta Painting," 13.

30. Ibid., 27.

31. Valdés, "Decline of the *Sociedad*," 167–169, 213.

32. García Sáiz, *Las castas mexicanas*, 54–59. Single images of casta figures are thought to have existed as early as 1711. See García Sáiz, "Artistic Development," 30–33.

33. García Sáiz, *Las castas mexicanas*, 26.

34. Ibid., 74–76.

35. García Sáiz, "Artistic Development," 34.

36. Burke, *Treasures*, 59–60.

37. Ibid., 60

38. Ibid.

39. García Sáiz, *Las castas mexicanas*, 26.

40. Burke, *Treasures*, 38.

41. Lipsett-Rivera, *"De Obra y Palabra,"* 517.

42. This panel is not illustrated in the García Sáiz catalog. I thank Maria Luisa Ferrer Garcés, of the Museo de América, Madrid, for pointing out and providing this Andrés de Islas panel.

43. Cope, *Limits of Racial Domination*, 19.

44. Katzew and others have suggested that casta painters had access to and were influenced by Flemish paintings and prints of peasant family groups. See Katzew, "Los Cuadros de Castas: Noticias." I believe that while images of estates may have served as sources for casta series, so did market scenes from the same Flemish sources. Elizabeth Honig has shown that seventeenth-century Antwerp was the center of a huge art market that proliferated original and copied images that were sold throughout Europe, including in Spain. These likely were sent to New Spain or arrived with visitors. The Flemish market scenes of the seventeenth century developed out of complex social and economic conditions that equated social order with economic order. Additional research is needed to ascertain if these concepts were transferred to New Spain as well. See Elizabeth Alice Honig, *Painting and the Market in Early Modern Antwerp* (New Haven: Yale University Press, 1998), 111–135.

45. Perry, *"Escudos de monjas,"* 3.

46. Ilona Katzew, ed., *New World Orders*, 23, and Richard Kagan, *Urban Images of the Hispanic World, 1493–1793* (New Haven: Yale University Press, 2000), 158–159, also see this as an interesting and important painting. They offer, however, two very distinct interpretations of the panel.

CHAPTER FOUR

1. Marcus Burke attributes and dates this painting in his *Pintura y escultura en Nueva España: El barroco* (Mexico City: Grupo Azabache, 1992), 172, 174. In contrast, Gustavo Curiel et al. identify the same painting as *Visita de un virrey a la catedral de México*, by an anonymous artist, and date it to the first half of the eighteenth century in *Pintura y vida cotidiana en México, 1650–1950* (Mexico City: Fomento Cultural Banamex, A.C., 1999), 70–71. As I will argue in this chapter, the later dating is more likely because the painting is consistent with the visual practices of the last quarter of the century.

2. Useful to me have been the writings of Angel Rama in *The Lettered City*, trans. and ed. John Charles Chasteen (Durham: Duke University Press, 1996) and Henri Lefebvre in *The Production of Space*, trans. Donald Nicholson-Smith (Oxford, England: Basil Blackwell Ltd., 1991).

3. Elizabeth Grosz, *Space, Time, and Perversion: Essays on the Politics of Bodies* (New York: Routledge, 1995), 108–109.

4. Rama, *The Lettered City*, 1.

5. Juan de Viera, *Breve y compendiosa narración de la ciudad de México*, 1st ed., with transcription by Beatriz Montes and Armando Rojas (Mexico City: Instituto Mora, 1992, facsimile), 1.

6. Chappe d'Auteroche, Mon., *A Voyage to California, to observe the transit of Venus. by Mons. Chappe d'Auteroche. With an historical description of the author's route through Mexico, and the natural history of that province. Also, a voyage to Newfoundland and Sallee, to make experiments on Mr. Le Roy's time keepers. By Monsieur de Cassini.*, trans. from the French by Cassini (London: Printed for Edward and Charles Dilly, 1778), 40–41.

7. Hipólito Villarroel, *Enfermedades políticas que padece la capital de esta Nueva España: En casi todos los cuerpos de que se compone y remedios que se le deben aplicar para su curación si se quiere que sea útil al Rey y al público* (1785; reprint, Mexico City: Consejo Nacional para la Cultura y las Artes, 1994), 186.

8. See Sonia Lombardo de Ruiz, ed., *Antología de textos sobre la ciudad de México en el período de la Ilustración (1788–1792)* (Mexico City: Instituto Nacional de Antropología e Historia, 1982), 12–17.

9. AGN, Bandos, Enero 2 de 1795, vol. 18, exp. 46, foja 261.

10. Sebastián Covarrubias, *Tesoro de la lengua castellana o española* (1611; Madrid, 1979, facsimimile), 875, quoted in Kagan, *Urban Images*, 27.

11. Kagan, *Urban Images*, 27.

12. "Ronda en la ciudad de México. Aprueba haberla dividido en ocho cuarteles," AGN, Reales Cédulas Originales, Octubre 2 de 1696, vol. 27, exp. 64, foja S. 2.

13. "Policía de la ciudad de México. Enterado que se dividió en seis cuarteles," AGN, Reales Cédulas Originales, Julio 6 de 1713, vol. 36, exp. 23, foja S. 1.

14. Eduardo Báez Macías, ed., "Ordenanzas para el establecimiento de alcaldes de barrio en la Nueva España. Ciudades de México y San Luis Potosí," *Boletín del Archivo General de la Nación* 10, nos. 1–2 (January–June 1969): 51–74.

15. "Alcaldes de barrio. Policía. Ordenanza de la división de México en cuarteles, creación de alcaldes de barrio y reglas de su gobierno con un mapa de la ciudad," AGN, Bandos, Diciembre 4 de 1782, vol. 12, exp. 36, fojas 101–122.

16. Ibid., 102.

La dilatada extension de esta Ciudad: la irregular dispoion de sus barrios y arrabales,

y la situacion de las habitaciones es éstos, que los hace imposibles al registro, y en muchos de ellos aun al tránsito, y su numerosísimo Vecindario, especialmente de la Plebe, han dificultado en todos tiempos, que el corto número de Señores Ministros de la Real Sala del Crimen, y Jueces Ordinarios, pueda llevar su vigilancia á todas partes, y muchos menos visitarlas con las Rondas nocturnas.

17. Ibid., 1050b.

18. "Aprueba la división de la ciudad en cuarteles y las ordenanzas dictadas para su gobierno," AGN, Reales Cédulas Originales, Julio 22 de 1786, vol. 134, exp. 140, foja S. 5. See also Juan Pedro Viqueira Albán, *Propriety and Permissiveness in Bourbon Mexico*, trans. Sonya Lipsett-Rivera and Sergio Rivera Ayala (Wilmington, Del.: Scholarly Resources, Inc., 1999), 175.

19. "Censo. Juan Pascual de Fagoaga, Alcade Mayor de Nejapa, remite al virrey Matías de Gálvez un informe del estado general de las personas que habitan esa jurisdicción, especificando pueblos, castas, y sexos. Jurisdicción de Nejapa," AGN, Alcaldes Mayores, Mayo 14–27 de 1783, vol. 7, fojas 136–138.

20. "Policía, Alumbrado. Bando que previene se pongan faroles de noche en todas las casas de México sin distinción de clases ni fueros de los subjetos que las ocupan," AGN, Bandos, Noviembre 6 de 1783, vol. 12, exp. 67, foja 387.

21. "Policía, Alumbrado. Bando que inserta el decreto de 6 Noviembre de 83 sobre el modo en que ha de observarse la iluminación de las calles de México," AGN, Bandos, Enero 29 de 1785, vol. 13, exp. 61, foja 299. "Policía, Alumbrado. Bando que prefija el término de un mes con apercibimiento para que se pongan faroles de noche en todas las calles de México e impone penas a los que los roben o rompan," AGN, Bandos, Febrero 13 de 1786, vol. 14, exp. 51, foja 206.

22. "Alumbrado, Policía. Reglamento para el gobierno que ha de obervarse en el alumbrado de las calles de México," AGN, Bandos, Abril 7 de 1790, vol. 15, exp. 56, foja 158. "Alumbrado, Policía. Adición al reglamento anterior," AGN, Bandos, n.d., vol. 15, exp. 57, foja 161. "Dispisiciones de policía. Uniforme para los alcaldes de Barrio. Limpieza de las calles. Alumbrado," AGN, Ayuntamientos, 1790, vol. 219. "Alumbrado, policía. Bando que publicando el alumbrado establecido en esta capital impone penas a los que robaren o quebraren los faroles y a los que hicieren armas contra los guardas," AGN, Bandos, Abril 15 de 1790, vol. 15, exp. 60, foja 175.
Interestingly, Revillagigedo II paid for the lighting by imposing a tax on wheat. "Alumbrado, policía. Bando que avisa la imposición de tres reales en cada carga de harina que entre en México para la subsistencia de este utilísimo establecimiento," AGN, Bandos, Noviembre 26 de 1790, vol. 15, exp. 94, foja 249. See also Ernesto Lemoine Villicaña, "El alumbrado público en la ciudad de México durante la segunda mitad del siglo XVIII," *Boletín del Archivo General de la Nación* 4, no. 4 (1963): 783–818.

23. Revilligedo, proud of his achievements, had plaques placed on each of the four fountains he had built in the Plaza Mayor. One of the plaques read:

En el reinado de Sr D. Cárlos IV, hal [sic] ándose encargado del gobierno de este reino el Exmo. Sr. D. Juan Vicente de Pacheco Padilla conde de Revillagigedo, se levantó el plan de esta ciudad, se colocaron azulejos en todas sus calles y plazas expresando sus nombres, se numeraron las casas, se marcaron las accesorias, se pinataron las fachadas de muchos edificios, y se estableció la limpieza general.

Francisco Sedano, *Noticias de México, recogidas por D. Francisco Sedano . . . desde el año de 1756, coordinades, escritas de nuevo y puestas por órden alfabético en 1800. Primera impresión, con un prólogo del Sr. D. Joaquín García Icazbalceta. Y con notas y apéndices del presbitero V. de P. A. Ed. de la "Voz de México"* (1800; reprint, Mexico: Imprenta de J. R. Barbedillo y Ca., 1880), 189. The plaque is translated in Kenneth Mills and William B. Taylor, *Colonial Spanish America: A Documentary History* (Wilmington, Del.: Scholarly Resources, Inc., 1998), 333.

> In the reign of Charles IV,
> in the viceregency of the Most Excellent Juan Vicente
> de Güemes Pacheco de Padilla, Count of Revillagigedo,
> the street plan of the city was laid out, glazed tiles
> to mark the name of every street and plaza were set in place,
> the houses were numbered, annexes marked, the façades of many buildings were
> painted, and a regimen of general cleanliness was undertaken.

24. See Lombardo de Ruiz, ed., *Antología de textos*, 12–17.

25. "Don Francisco de Cordoba Villafranca, contador de Tribunal Mayor de Cuentas y Juez de Caerias, Calzadas y Policía de la Ciudad, recibe ordenes del Virrey Don Francisco Fernandez de la Cueva para que haga retirar muladares de plazas y aderezar las calles . . . ," AGN, Obras Públicas, 1660–1661, vol. 27, exp. 1, foja 5.

26. "En la Real Cédula de 3 de Diciembre de 1707, sobre nuevo asiento de alcabalas del consultado por lo cual ofrecieron a Felipe V, 10,000 pesos para las obras de Palacio real del México, el soberano ordena aplicar lo necesario para aderezo de calles, calzadas, y acequias . . . ," AGN, Obras Públicas, 1713–1770, vol. 35, exp. 5, fojas 135–225.

27. See *Instrucción del virrey marqués de Croix que deja a su sucesor, Antonio María Bucareli* (1771; reprint, Mexico City: Editorial Jus, 1960), 56; and Haslip-Viera, *Crime and Punishment*, 115.

28. *Instrucción del virrey*, 76.

29. "Policía. Bando para la limpieza, aseo, y empedrados de las calles de México y para que se fabriquen en las casas lugares comunes," AGN, Bandos, Octubre 26 de 1769, vol. 7, exp. 48, fojas 173–181.

30. "Policía. Bando para que diariamente se barran las calles y no se viertan aguas sucias o de excremento," AGN, Bandos, Febrero 26 de 1771, vol. 8, exp. 2, foja 18.

31. "Empedrado, Policía. Reglamente que ha de observarse en el empedrado puesto nuevamente en práctica en las calles de México y providencias para su conservación y las

de las caerias, a también se ha dado nuevo," AGN, Bandos, Mayo 1 de 1790, vol. 15, exp. 63, foja 181. "Policía. Bando que inserta y manda observar el artículo 68 de la ordenanza de que previene la limpieza de los pueblos, la igualdad y empedrados de las calles, la proporción de las fábricas que se hicieren de nuevo y el reparo de los edificios que amenazaren ruina," AGN, Bandos, Agosto 6 de 1790, vol. 15, exp. 76, foja 68.

32. "Limpieza de calles, Policía. Bando que avisa con anticipacion el establecimiento de carros para recoger inmundicias y basuras: Divide en 14 artículos los menores puntos de este nuevo proyecto en que también se incluye la construcción de letrinas en las casas y advierte a los vecinos que cada uno este prevenido para el día que se ponga en práctica en la calle que vive, lo que se avisara cuatro días antes por carteles," AGN, Bandos, Agosto 31 de 1790, vol. 15, exp. 80, foja 208.

33. *Gaceta de México*, vol. 4, 7 September 1790 (Mexico: D. Felipe de Zuñiga y Ontiveras), 158.

> Uno de los puntos más esenciales de todo buen Policía es la limpia de los Pueblos, por lo que contribuye, no sólo a la comodidad de los vecinos, sino principalmente a su salud, objeto de mayor atención; pero que sin embargo ha merecido muy poco en esta capital, según lo acreditan las experencias y los insuficientes medidas tomadas hasta ahora logro . . . y para que todos los vecinos estantes y habitantes de cualquier estado, calidad o condición que sean, sin distinción de clase ni personas cumplen con lo que sean con cada uno corresponde modo de publicarse.

34. Ibid., 158–160.

35. "Policía, Limpieza. Bando con expresión de capítulos que debe observarse para la limpieza prevenida en bando de 31 de agosto de 90," AGN, Bandos, Marzo 26 de 1791, vol. 16, exp. 9, foja 15. "Limpieza, Policía. Bando que reitera la observancia de los publicados en 31 de Agosto de 90 y 26 de Marzo de 91, para el aseo y limpieza de las calles de esta capital añadiendo algunas reformas," AGN, Bandos, Enero 2 de 1795, vol. 18, exp. 46, foja 261.

36. *Gaceta de México*, vol. 8, 12 January 1796, 21.

> En medio de la vigilancia, atención y cuidado que me ha merced la quietud pública de los habitantes de esta capital, no he perdido de vista como es notario, su abundante provisión de mantenimeinto, su aseo, el cómodo piso de las calles, y otros puntos que le interesan dan lustre, e influjen en la salud de sus numerosos vecindarios.

37. The map was published in 1807.

38. "Calles de México. Cuaderno que manifiesta por orden alfabético los nombres de las calles y cuarteles a que tocan, con un resumen del numero a que ascienden y del de los callejones, puentes, plazas, posadas, corrales y barrios," AGN, Bandos, Agosto 20 de 1793, vol. 17, exp. 41, foja 179.

39. "Proyecto de Maestro Mayor de Arquitectura de la ciudad Don Ignacio de Castera para reformar los barrios, alinear las calles y mejorar la circulación de las aguas por medio de una acequia maestra . . . ," AGN, Obras Públicas, 1794–1796, vol. 2, exp. 1, foja 61.

40. Viqueira Albán, *Propriety*, 171; see also *Instrucción del virrey*, 78.

41. *Gaceta de México*, vol. 4, 1791, 383.

42. *Instrucción del virrey*, 53.

> Hay mucha casta de gentes entre los populachos, de lo que dimanan el ser sumamente viciosos, y el mayor carácter es el de la embriagues, juego, lujuria y ratería, que vulgarmente son macutenos.

43. Ibid.

44. "Pulque. Circular que hace varias declaraciones sobre la exacción de derechos a los indios, espaoles y castas prevenidas en bandos anteriores," AGN, Bandos, Septiembre 5 de 1788, vol. 14, exp. 119, foja 370. See also William B. Taylor, *Drinking, Homocide and Rebellion in Colonial Mexican Villages* (Stanford: Stanford University Press, 1979).

45. "Sobre la necesidad de aplicar los fondos de los impuestos de dos granos sobre cada arroba de pulque al fondo de obras públicas de la ciudad. CD. México," AGN, Obras Públicas, 1795, vol. 3, exp. 4, fojas 273–306.

46. Viqueira Albán, *Propriety*, 174.

47. "Pulquerías. Circular para que se formen padrones de las tiendas y puestos de pulquerías a fin de que paguen la contribución señalada por ley," AGN, Bandos, Julio 1 de 1780, vol. 11, exp. 65, foja 180. "Pulquerías. Ordenanzas para su gobierno," AGN, Bandos, Enero 25 de 1793, vol. 17, exp. 4, foja 31.

48. "Escuelas de Danza, Policía," AGN, Bandos, Marzo 15 de 1779, vol. 11, exp. 5, foja 9.

49. "Baos y Lavaderas. Bando que prescribe reglas para su gobierno y el de los temascales," AGN, Bandos, 21 Agosto de 1793, vol. 17, exp. 42, fojas 186–188. Supplemental regulations were put into place in December of the same year. "Baos, Temascales y Lavaderos—apéndices al reglamento," AGN, Bandos, Diciembre 31 de 1793, vol. 17, exp. 57, fojas 250–253.

50. "Mercados. Reglamento para los de México especialmente para el establecimiento en la plazuela del volador," AGN, Bandos, Noviembre 11 de 1791, vol. 16, exp. 39, fojas 98–103. This bando is reproduced in *Documentos varios para la historia de la Ciudad de México a fines de la época colonial (1769–1815)* (Mexico: Rolston-Bain, 1983, facsimile), IX.

51. Jorge Gonzalez Angulo Aguirre, *Artesanando y ciudad a finales del siglo XVIII* (Mexico City: Fondo de Cultura Económica, 1983), 73.

52. "Títulos de Castilla. Bando con inserción de Real Cédula que previene las pruebas que han de dar los sujetos que los pretenden en estos dominios y el modo en que ha de recibirse," AGN, Bandos, 22 Noviembre de 1791, vol. 16, exp. 40, fojas 104–1050b.

53. For example, "Pragmática. Que se observe en los reinos de indias e islas filipinas, el decreto que declara varios puntos de los que comprende la real pragmática sobre matrimonios," AGN, Reales Cédulas Originales, Febrero 27 de 1793, vol. 154, exp. 184, foja S. 2.

54. See chapter 1, note 25 above.

55. The pragmatic mentioned above was repeated in 1804.

56. "Pragmática Contra el Abuso de Trajes y Otros Gastos Superfluos," in *Colección*, ed. Konetzke, vol. 3.1, 1691–1779, nos. 92, 124–125.

57. Ibid., 125–126.

58. *Gaceta de México*, vol. 4, 6 September 1791, 241; reiterated in *Gaceta de México*, vol. 11, 29 May 1799, 333.

59. *Gaceta de México*, vol. 11, 29 May 1799, 332.

> Limpieza y aseo es uno de los tres principales objetos de policía; y esta no sólo comprehende las calles y plazas de poblaciones, sino también las personas que las habitan cuyo trage honesto y decente influye mucho en las buenas costumbres, al mismo tiempo que adorna la audad, y contribuye a la salud de sus individuos. . . . desterrar del vecindario de esta hermosa capital, la indecente y vergonjosa desnudez con que se presenta una gran parte de su plebe, sin otra ropa de un asquerosa manto ó inmunda girga que no alcanza a cubirirla externamente.

60. Ibid., 333–334.

> Siendo como es en los hombres la denudez un indicio vehementísimo de ociosidad ó malas costumbres formándosele causa para darle el destino que convenga, según su calidad y demás circunstancias.

61. "Embriaguez. Bando imponiendo penas a los individuos que por resultas de este vicio se hallasen privados de sentido o dando escándalos en las calles," AGN, Bandos, Julio 8 de 1795, vol. 18, exp. 72, foja 319.

62. Haslip-Viera, *Crime and Punishment*, 42.

63. "Juegos prohibidos. Don Juan Acua, Marques de Casafuerte que en ningún lugar de esta ciudad, y especialmente en las pulquerías, baratillos, plazas y Alameda se juegan rayuela, tangano ni pelota sino sólo los permitidos por las ordenanzas, por perjudicar el asiento de Naipes," AGN, Ordenanzas, Octubre 5 de 1731, vol. 12, exp. 128, foja 257.

64. Viqueira Albán, *Propriety*, 103.

65. Ibid., 104–107.

66. Ibid., 108.

67. Ibid., 67.

68. "Coliseo. Reglamento para su dirección económica y gubernativa mandada observar por el excelentísimo señor virrey," AGN, Bandos, Abril 11 de 1786, vol. 14, exp. 24, fojas 62–75. This edict is also reproduced in facsimile in *Documentos varios para la historia de la Ciudad de México a fines de la época colonial (1769–1815)* (Mexico: Rolston-Bain, 1983, facsimile), IV. The same regulations are also found in "Autos sobre el reglamento para el teatro," AGN, Ayuntamientos, 1786, vol. 195.

69. Irving Leonard, "The 1790 Theater Season of the Mexico City Coliseo" *Hispanic Review* 19, no. 2 (April 1951): 108.

70. Viqueira Albán, *Propriety*, 72.

71. Ann Twinam points out that while the political and financial reforms of the Bourbons are well understood, the social reforms have not been studied as carefully. See Twinam, *Public Lives*, 311.

72. "Sobre una cantidad de dinero que se entrego al Maestro Mayor Don Joseph Damian Ortiz de Castro para rebajar la Plaza Mayor de la Ciudad. Cd. México," AGN, Obras Públicas, 1791, vol. 4, exp. 12, fojas 395–397. "Sobre la construcción de las fuentes de la Plaza Mayor . . . ," AGN, Obras Públicas, 1791–1792, vol. 36, exp. 15, fojas 354–366.

73. Mills, *Colonial Spanish America*, 333. The following is found in Francisco Sedano's *Noticias de México*, 188-189:

> En el feliz reinado de Sr D. Cárlos IV, y governando esta Nueva España el Exmo. Sr. D. Juan Vicente de Güemes Pacheco Padilla conde de Revillagigedo, se hicieron en las principales calles de esta ciudad, desde el año de 1790 al de 1794 545,039 varas cuadradas de espedrado, 16,535 de targea, 27,317 de banqueta, colc ndo [sic] las cañerias debajo de ellas, formando y ordenando la plazas del mercado.

74. "Descripción de las fiestas celebradas en la imperial corte de México con motivo de la solemne colocación de una estatua equestre de nuestro augusto soberano el Señor Don Carlos IV en la Plaza Mayor," AGN, Bandos, [n.d.c.] 1796, vol. 18, exp. 108, fojas 456–463v. This edict is also reproduced in facsimile in *Documentos varios para la historia de la Ciudad de México a fines de la época colonial (1769-1815)* (Mexico: Rolston-Bain, 1983, facsimile), XIV. The finished bronze statue was erected in 1803.

75. *Gaceta de México*, vol. 8, 9 December 1796, 231.

76. Ibid., 232.

77. Ibid., 234. See also "Estatua ecuestre. Bando para que se adornen los balcones y haya iluminación, por las noches en esta capital en los días 9, 10, y 11 de diciembre en celebrado de su colocación," AGN, Bandos, Noviembre 18 de 1795, vol. 18, exp. 98, foja 425.

78. *Gaceta de México*, vol. 8, 9 December 1796, 235.

79. "Descripción de las fiestas," AGN, Bandos, [n.d.c.] 1796, vol. 18, exp. 108, foja 463v.

80. José Joaquín Fernández de Lizardi, *El periquillo sarniento* (1816; reprint, Mexico: Editorial Porrúa, 1998).

81. Nancy Vogeley, "José Joaquín Fernández de Lizardi (1776–1827)," in *Latin American Writers*, ed. Carlos A. Solé and Maria Isabel Abreu (New York: Charles Scribner's Sons, 1989), 1: 120.

82. Ibid.

83. Ibid., 121.

84. Ibid., 122.

85. Fernández de Lizardi, *El periquillo*, 12.

86. Ibid., 14.

> Los primeros alimentos que nos nutren nos hacen adquirir alguna propiedad de quien nos los ministra, . . . porque es cierto esto, digo: que mi primera nodriza era de un genio maldito, según que yo salí de mal intensionado . . . porque la que no era borracha, era golosa; la que no era golosa, estaba gálica; la que no tenía este mal, tenía otro; y la que estaba sana, de repente resultaba encinta. . . .

87. Ibid., 110.

88. Ibid., 228.

> A las ocho estaba yo en el Portal the las Flores, muerto de hambre, la que aumentaba con el ejercicio que hacía con tanto andar. No tenía en el cuerpo cosa que valiera más que una medallita de plata que había comprado en cinco reales . . . me costó mucho trabajo venderla a esas horas; pero, por último, hallé quien me diera por ella dos y medio, de los que gasté un real en cenar y medio en cigarros. . . .

89. Ibid., 112.

90. Ibid., 96.

> Seis meses estuve en mi casa haciendo una vida bien hipócrita; porque rezaba el rosario todas las noches, según la costumbre de mi difunto padre, salía muy poco a la calle, no asistía a ninguna diversión, hablaba de la virtud . . . en una palabra, hice tan bien el papel de hombre de bien.

91. Ibid., 155.

92. Ibid., 194-195.

> color bajo y los vestidos destrozados no siempre califican a los hombres perversos, antes a veces pueden esconder algunas almas tan honradas y sensibles como la de Don Antonio.

93. Ibid., 235-247.

94. Vogeley, "Fernández de Lizardi," 122.

95. I thank Dr. Beatriz de Alba-Koch for pointing this out to me. See de Alba-Koch, *Ilustrando la Nueva España: Texto e imagen en "El Periquillo Sarniento" de Fernández de Lizardi* (Cáceres, Spain: Universidad de Extremadura, Servicio de Publicaciones, 1999), 96-98.

96. Fernández de Lizardi, *El periquillo*, 228.

> estaba descalzo enteramente . . . ; los de encima eran negros de terna, parchados y agujereados; mi camisa, después de rota, estaba casi negra de mugre; mi chupa era angaripola rota. . . .

97. *Gaceta de México*, vol. 11, 29 May 1799, 332.

98. Haidt, *Embodying Enlightenment*, 125.

99. Ibid., 107.

100. Ibid.

101. Fernández de Lizardi, *El periquillo*, 263.

102. Haidt, *Embodying Enlightenment*, 110.

103. *Gaceta de México*, vol. 8, 9 December 1796, 231.

104. Ibid., vol. II, 29 May 1799; see note 4.59.

105. Burke, *Treasures*, 58–60.

106. Ibid., 48.

107. See Bhabha, *Location of Culture*, 45.

CHAPTER FIVE

1. Stacie G. Widdifield, *The Embodiment of the National in Late Nineteenth-Century Mexican Painting* (Tucson: University of Arizona Press, 1996), 91–93.

2. For late examples of casta paintings, see García Sáiz, *Las castas mexicanas*, 211.

3. Doris M. Ladd, *The Mexican Nobility at Independence, 1780–1826* (Austin: University of Texas at Austin Institute of Latin American Studies, 1976), 122.

4. Fernández de Lizardi, *El periquillo*, 346–350. See Vogeley, "Fernández de Lizardi," 123.

5. Fernández de Lizardi, *El periquillo*, 358–360.

6. Ibid., 361.

7. Ibid., 228. See Beatriz de Alba-Koch, "'Enlightened Absolutism' and Utopian Thought: Fernández de Lizardi and Reform in New Spain," *Revista Canadiense de estudios Hispánicos* 24, no. 2 (Winter 2000): 295–306.

8. Enrique de Olavarría y Ferrari, *Reseña histórica del teatro en México, 1538–1911*, 3rd ed. (Mexico: Editorial Porrúa, 1961), 3:83. Also quoted in Viqueira Albán, *Propriety*, 78–79.

9. de Olavarría, *Reseña histórica*, 84–86.

10. Antonio de León y Gama, *Descripción histórica y cronológica de las dos piedras que con ocasión del nuevo empredrado que está formando en la plaza principal de México, se hallaron en ella el año de 1790* (1792; reprint, Mexico: Miguel Angel Porrúa, 1978, facsimile).

11. Ibid., no page number [following page viii].

12. Ibid.

13. Ibid., 2.

un documento original é instructivo, que manifiesta mucha parte de la historia de la

Cronología, y el modo exácto que tenian de medir el tiempo los Mexicanos para celebrar sus fiestas, y para su gobierno politico . . .

14. Ibid., 4.

15. Ibid.

16. Ibid., 5–6.

17. This essay is included in the second edition of León y Gama's study, which was published posthumously. Antonio de León y Gama, *Descripción histórica*, 2d. ed. (1832; reprint, Mexico: Migue Angel Porrúa 1978, facsimile), 1–40.

18. Ibid., 4.

emprendí escribir la historia antigua de la Nueva España, asi del tiempo de la gentilidad, como de los años posteriores á su conquista, para desvanecer innumerables errores, equivocaciones y malas inteligencias en que han incurrido los mas historiadores por falta de documentos fieles, y de una madura relleccion para convinar los succesos, y dar una clara idea de lo que fueron los mexicanos, y otros naciones que poblaron esta parte de América septentrional . . . ; no con otro fin que el de servir á mi patria, y serle en alguna materia útil.

19. Ibid., 12–15.

20. Widdifield, *Embodiment*, 16.

21. The relationship between the demise of casta imagery and the rise of costumbrista imagery has been suggested but not fully explored by other scholars. See Widdifield, *Embodiment*, 126; Curiel et. al., *Pintura y vida cotidiana*, 156–157.

22. Widdifield, *Embodiment*, 70.

23. Ibid., 78.

24. Ibid., 10.

25. Ibid., 10–11.

26. Ibid., 105.

27. Ibid., 13.

EPILOGUE

1. See chapter 4, note 23 above.

2. "El Señor Inquisición Fiscal de este Sto. Oficio contra Gregoria Piedra, alias la macho," AGN, Inquisición, Agosto 1796, tomo 1349, exp. 28, fojas S. 1–8.

Glossary

alcalde mayor: A district (cuartel) governor.

bando: An edict announcing regulations.

cacique: An Indian noble.

calidad (pl. *calidades*): Translatable into English as "quality" or "status," the concept of calidad is more precisely understood as a differentiating, defining, and ordering of the diverse people who inhabited New Spain by kind or type. Calidad represented one's social body as a whole, which included references to skin color but also often, more importantly, occupation, wealth, purity of blood, honor, integrity, and place of origin.

casta: A person of mixed Indian, Spanish, and/or Black African blood.

cédula: A royal decree.

criollo: A Spaniard born in New Spain.

cuartel (pl. *cuarteles*): A city sector.

gracias al sacar: Petitions requesting official legitimacy.

gachupín (pl. *gachupines*): Derogative term for a peninsular Spaniard.

hombre de bien: A gentleman morally and ethically above reproach.

libro de castas: The baptismal record book for people designated to be of mixed blood.

libro de españoles: The baptismal record book for people designated to be of pure Spanish blood.

limpieza de sangre: A certification of purity of blood that was required to obtain certain social and civil prerogatives.

ordenanza: An ordinance, bylaw.

petimetre: In Spanish literature, a fop and counter to the hombre de bien.

parían: The marketplace located on the Plaza Mayor.

paseo: A promenade, where Mexico City elite walked or rode in carriages.

peninsular (pl. *peninsulares*): A Spaniard born in Spain.

populacho (also spelled *popolacho*): A derogatory term for a plebeian.

pulque: An intoxicating drink made from the fermented sap of the maguey plant.

pulquería: A place where pulque was sold.

raza: Literally translated as "race" but better understood as "lineage." The word connoted generational association with Jews and Moors and was used in Spain as a means to legitimatize the discrimination against and persecution of non-Christians and their descendants.

sociedad de castas (also *sistema de castas*): A ranked system of mixed-blooded people.

traza: The city area reserved for Spanish residents.

Bibliography

UNPUBLISHED MANUSCRIPT SOURCES

Archivo General de la Nación (AGN), Mexico City.

 Instituciones Coloniales
 Grupos Documentales
 Alcaldes Mayores
 Ayuntamiento
 Bandos
 Inquisición
 Matrimonios
 Obras Públicas
 Real Cédulas

 Hemeroteca
 Gaceta de México

PUBLISHED PRIMARY SOURCES

de Ajofrín, P. fray Francisco. *Diaro del viaje a la Nueva España*. Madrid: Imprenta y
 Editorial, Maestra, 1958.
Chappe d'Auteroche, Mon. *A voyage to California, to observe the transit of Venus. by Mons.*
 Chappe d'Auteroche. With an historical description of the author's route
 through Mexico, and the natural history of that province. Also, a voyage to
 Newfoundland and Sallee, to make experiments on Mr. Le Roy's time keepers.
 By Monsieur de Cassini. Translated from the French by Cassini. London:
 Printed for Edward and Charles Dilly, 1778.
Colección de documentos para la historia de la formación social de Hispanoamérica,
 1493–1810. Edited by Richard Konetzke. Vol. 3.1, 1691–1779. Madrid: Consejo
 Superior de Investigaciones Científicas, 1962.
Covarrubias, Sebastián. *Tesoro de la lengua castellana o española*, 875. 1611. Reprint,
 Madrid, 1979. Facsimile. Quoted in Richard Kagan, *Urban Images of the*
 Hispanic World, 1493–1793 (New Haven: Yale University Press, 2000), 27.
Croix, Carlos Francisco de Croix, marqués de. *Instrucción del virrey marqués de Croix que*

deja a su sucesor Antonio María Bucareli. 1771. Reprint, Mexico City: Editorial Jus, 1960.

Documentos varios para la historia de la Ciudad de México a fines de la época colonial (1769–1815). Mexico: Rolston-Bain, 1983. Facsimile.

Fernández de Lizardi, José Joaquín. *El periquillo sarniento.* 1816. Reprint, Mexico: Editorial Porrúa, 1998.

Gaceta de México, compendio de noticias de Nueva España. Vol. 3, 1788–1789; vol. 4, 1790–1791; vol. 5, 1792–1793; vol. 6, 1793–1794; vol. 8, 1795–; vol. 11, 1798–. Edited by Don Manuel Antonio Valdes. Mexico: D. Felipe de Zuñiga y Ontiveras.

de Galve, Condesa. *Two Hearts, One Soul: The Correspondence of the Condesa de Galve, 1688–1696.* Edited, annotated, and translated by Meredith D. Dodge and Rick Hendricks. Albuquerque: Univesity of New Mexico Press, 1993.

Gálvez, José de. *Informe sobre las rebeliones populares de 1767 y otros documentos inéditos.* 1767. Transcribed and edited by Felipe Castro Gutiérrez. Mexico City: Universidad Nacional Autónoma de México, 1990.

de León y Gama, Antonio. *Descripción histórica y cronológica de las dos piedras, que con ocasión del nuevo empedrado que se está formando en la plaza principal de México, se hallaron en ella el año de 1790.* 1792 and 1832. Reprint, Mexico: Miguel Angel Porrúa, 1978. Facsimile.

Lombardo de Ruiz, Sonia, ed. *Antología de textos sobre la ciudad de México en el período de la Ilustración (1788–1792).* Mexico City: Instituto Nacional de Antropología e Historia, 1982.

O'Crouley, Sr. Dn. Pedro Alonso. *A Description of the Kingdom of New Spain.* 1774. Translated and edited by Seán Galvin. [San Francisco]: John Howell Books, 1972.

Recopilación de leyes de los reynos de las Indias. 4 vols. 1681. Reprint, Madrid: Ediciones Cultural Hispánica, 1973.

Sedano, Francisco D. *Noticias de México, recogidas por D. Francisco Sedano . . . desde el año de 1756, coordinadas, escritas de nuevo y puestas por órden alfabético en 1800. Primera impresión, con un prólogo del Sr. D. Joaquín García Icazbalceta. Y con notas y apéndices del presbitero V. de P. A. Ed. de la "Voz de México."* 1800. Reprint, Mexico: Imprenta de J. R. Barbedillo y Ca., 1880.

Sigüenza y Góngora, Carlos. "Teatro de virtudes políticas que constituyen a un príncipe." 1680. In *Seis obras,* edited by William G. Bryant, 165–240. Reprint, Madrid: Biblioteca Ayacucho, 1984.

Viera, Juan de. *Breve y compendiosa narración de la ciudad de México.* 1st ed. With transcription by Beatriz Montes and Armando Rojas. Mexico: Instituto Mora, 1992. Facsimile.

Villarroel, Hipólito. *Enfermedades políticas que padece la capital de esta Nueva España: En casi todos los cuerpos de que se compone y remedios que se le deben aplicar para su curación si se quiere que sea útil al Rey y al público.* 1785. Reprint, Mexico City: Consejo Nacional para la Cultura y las Artes, 1994.

SECONDARY SOURCES

de Alba-Koch, Beatriz. "'Enlightened Absolutism' and Utopian Thought: Fernández de Lizardi and Reform in New Spain." *Revista Canadiense de Estudios Hispánicos* 24, no. 2 (Winter 2000): 295–306.

——. *Ilustrando la Nueva España: Texto e imagen en "El Periquillo Sarniento" de Fernández de Lizardi.* Cáceres, Spain: Universidad de Extremadura, Servicio de Publicaciones, 1999.

Aldridge, A. Owen. "Feijoo and the Problem of Ethiopian Color." In *Racism in the Eighteenth Century*, edited by Harold E. Pagliaro, 263–278. Cleveland and London: The Press of Case Western Reserve University, 1973.

Álvarez de Testa, Lilian. *Ilustración, educación e independencia: Las ideas de José Joaquín Fernández de Lizardi.* Mexico City: Universidad Nacional Autónoma de México, 1994.

Anna, Timothy E. *The Fall of the Royal Government in Mexico City.* Lincoln: University of Nebraska Press, 1978.

Archer, Christon I. "What Goes Around Comes Around: Political Change and Continuity in Mexico, 1750–1850." In *Mexico in the Age of Democratic Revolutions, 1750–1850*, edited by Jaime E. Rodrígues O., 261–280. Boulder and London: Lynne Rienner Publishers, 1994.

Arnold, Linda. *Bureaucracy and Bureaucrats in Mexico City, 1724–1835.* Tuscon: University of Arizona Press, 1977.

Ashcroft, Bill, Gareth Griffiths, and Helen Tiffin. *Key Concepts in Post-colonial Studies.* New York: Routledge, 1998.

Báez Macías, Eduardo, ed. "Ordenanzas para el establecimiento de alcaldes de barrio en la Nueva España. Ciudades de México y San Luis Potosí." *Boletín del Archivo General de la Nación* 10, nos. 1–2 (January–June 1969): 51–74.

Barringer, Tim, and Tom Flynn, eds. *Colonialism and the Object: Empire, Material Culture and the Museum.* New York: Routledge, 1998.

Bhabha, Homi K. *The Location of Culture.* New York: Routledge, 1994.

——. "In the Spirit of Calm Violence." In *After Colonialism: Imperial Histories and Postcolonial Displacements*, edited by Gyan Prakash, 326–343. Princeton: Princeton University Press, 1995.

——, ed. *Nation and Narration.* New York: Routledge, 1990.

Boyer, Richard. *Cast [sic] and Identity in Colonial Mexico: A proposal and an example.* Storrs, Conn.: Center for Latin American and Caribbean Studies, 1997.

——. "Negotiating *Calidad*: The Everyday Struggle for Status in Mexico." *Historical Archaeology* 31, no. 1 (1997): 64–72.

——. "Respect and Identity: Horizontal and Vertical Reference Points in Speech Acts." *The Americas* 54, no. 4 (April 1998): 491–509.

Brading, David. *Miners and Merchants in Bourbon Mexico, 1663–1810.* Cambridge: Cambridge University Press, 1971.

Brennan, Teresa, and Martin Jay, eds. *Vision in Context: Historical and Contemporary Perspectives on Sight*. New York: Routledge, 1996.

Burke, Marcus B. *Pintura y escultura en Nueva España: El barroco*. Mexico City: Grupo Azabache, 1992.

——. *Treasures of Mexican Colonial Painting: The Davenport Museum of Art Collection*. Sante Fe: Museum of New Mexico Press, 1998.

Burkholder, Mark A., and D. S. Chandler *From Impotence to Authority: The Spanish Crown and the American Audiencias, 1687–1808*. Columbia: University of Missouri Press, 1977.

Cañeque, Alejandro. "The King's Living Image: The Culture and Politics of Viceregal Power in Seventeenth-Century New Spain." Ph.D. diss., New York University, 1999.

Caro Baroja, Julio. "Religion, World Veiws, Social Classes and Honor during the Sixteenth and Seventeenth Centuries in Spain." In *Honor and Grace in Anthropology*, translated by Victoria Hughes and edited J. G. Peristiany and Julian Pitt-Rivers, 91–102. Cambridge: Cambridge University Press, 1992.

Carrera, Magali. "Locating Race in Late Colonial Mexico." *Art Journal* 57, no. 3 (Fall 1998): 36–45.

Castro Morales, Efrain. "Los cuadros de castas de Nueva España." In *Jahrbuch für Geschichte von Staat, Wirtschaft un Geellschaft Lateinamerikas* Band 20 (1983): 671–690.

Cope, R. Douglas. *The Limits of Racial Domination: Plebian Society in Colonial Mexico City, 1660–1720*. Madison: University of Wisconsin Press, 1994.

Costeloe, Michael P. "*Hombres de bien* in the Age of Santa Ana." In *Mexico in the Age of Democratic Revolutions, 1750–1850*, edited by Jaime E. Rodrígues O., 243–260. Boulder and London: Lynne Rienner Publishers, 1994.

Curiel, Gustavo, Fausto Ramírez, Antonio Rubial, and Angélica Valázquez. *Pintura y vida cotidiana en México, 1650–1950*. Mexico City: Fomento Cultural Banamex, 1999.

Dávalos, Marcela. *Basura, e ilustración*. Mexico City: Instituto Nacional de Antropolgía e Historia, 1997.

Dean, Carolyn. *Inka Bodies and the Body of Christ*. Durham and London: Duke University Press, 1999.

Deans-Smith, Susan. *Bureaucrats, Planters, and Workers: The Making of the Tobacco Monopoly in Bourbon Mexico*. Austin: University of Texas Press, 1992.

Donahue-Wallace, Kelly. "Prints and Printmakers in Viceregal Mexico City, 1600–1800." Ph.D. diss., University of New Mexico, 2000.

Estrada de Gerlero, Elena Isabel. "La reforma borbónica y las pinturas de casta novohispanas." In *XVI Coloquio internacional de la historia del arte: El arte y la vida cotidiana*, edited by Elena Estrada de Gerlero, 217–252. Mexico City: Universidad Nacional Autónoma de México: Instituto de Investigaciones Estéticas, 1995.

——. "The Representation of 'Heathen Indians' in Mexican Casta Painting." In *New*

World Orders: Casta Painting and Colonial Latin America, edited by Ilona
Katzew, 42–56. New York: Americas Society, 1996.

Farago, Claire, ed. *Reframing the Renaissance: Visual Culture in Europe and Latin America*. New Haven: Yale University Press, 1995.

Fee, Nancy. "The Patronage of Juan de Palafox y Mendoza: Constructing the Cathedral and Civic Image of Puebla de los Angeles, Mexico." Ph.D. diss., Columbia University, 2000.

Feijoo, Benito Jerónimo. *Teatro crítico universal, o, Discursos varios en todo género de materias, para desengaño de errores comunes*. Edited by Giovanni Stiffoni. Madrid: Editorial Castalia, 1986.

Fisher, Abby Sue. "*Mestizaje* and the *Cuadros de Casta*: Visual Representation of Race, Status, and Dress in Eighteenth Century Mexico." Ph.D. diss., University of Minnesota, 1992.

Foucault, Michel. *The Archaeology of Knowledge*. Translated by Alan Sheridan. New York: Pantheon, 1972.

———. *Discipline and Punish: The Birth of the Prison*. Translated by Alan Sheridan. New York: Pantheon Books, 1979.

García Sáiz, María Concepción. "The Artistic Development of Casta Painting." In *New World Orders: Casta Painting and Colonial Latin America*, edited by Ilona Katzew, 30–41. New York: Americas Society, 1996.

———. *Las castas mexicanas: Un género pictórico americano*. Milan: Olivetti, 1989.

Garner, Richard L., and Spiro E. Stefanou. *Economic Growth and Change in Bourbon Mexico*. Gainsville: University Press of Florida, 1993.

Gonzalbo Aizpuru, Pilar, ed. *Familias Novohispanas siglos XVI al XIX*. Mexico City: Colegio de México, 1989.

Gonzalez Angulo Aguirre, Jorge. *Artesanando y ciudad a finales del siglo XVIII*. Mexico City: Fondo de Cultura Económica, 1983.

———. *Planos de la ciudad de México, 1785, 1853 y 1896: Con un directoria de calles con nombres antiguos y modernos*. Mexico City: Instituto Nacional de Antropología e Historia. 1976.

Grosz, Elizabeth. *Space, Time and Perversion: Essays on the Politics of Bodies*. New York: Routledge, 1995.

Gutiérrez Haces, Juana. "*The Painter's Cupboard*." In *Mexico: Splendor of Thirty Centuries*, 435–436. Boston: Bullfinch Press, 1990. Exhibition catalog.

Habermas, Jürgen. *The Structural Transformation of the Public Sphere: An Inquiry into a Category of Bourgeiois Society*. Cambridge: MIT Press, 1989.

Haidt, Rebecca. *Embodying Enlightenment: Knowing the Body in Eighteenth-Century Spanish Literature and Culture*. New York: St. Martin's Press, 1998.

Haslip-Viera, Gabriel. *Crime and Punishment in Late-Colonial Mexico City, 1692–1810*. Albuquerque: University of New Mexico Press, 1999.

Hernández Franyuti, Regina. *Ignacio de Castera: Arquitecto y urbanista de la Ciudad de México, 1777–1811*. Mexico: Instituto de Investigaciones Dr. José María Luis Mora, 1997.

Herr, Richard. *The Eighteenth-Century Revolution in Spain*. Princeton: Princeton University Press, 1958.

Hillman, David, and Carla Mazzio, eds. *The Body in Parts: Fantasies of Corporeality in Early Modern Europe*. New York: Routledge, 1997.

Hoberman, Louis Schell, and Susan Migden Socolow, eds. *The Countryside in Colonial Latin America*. Albuquerque: University of New Mexico Press, 1996.

Honig, Elisabeth Alice. "Desire and Domestic Economy." *The Art Bulletin* 83, no. 2 (June 2001): 294–315.

———. *Painting and the Market in Early Modern Antwerp*. New Haven: Yale University Press, 1998.

Hudson, Nicholas. "From 'Nation' to 'Race': The Origin of Racial Classification in Eighteenth-Century Thought." *Eighteenth-Century Studies* 29, no. 3 (Spring 1996): 247–264.

Israel, Jonathan I. *Race, Class and Politics in Colonial Mexico*. Oxford: Oxford University Press, 1975.

Jacobson, Matthew Frye. *Whiteness of a Different Color: European Immigrants and the Alchemy of Color*. Cambridge: Harvard University Press, 1998.

Jaffary, Nora Elizabeth. "Deviant Orthodoxy: A Social and Cultural History of Ilusos and Alumbrados in Colonial Mexico." Ph.D. diss., Columbia University, 2000.

Johnson, Lyman L., and Sonya Lipsett-Rivera, eds. *The Faces of Honor: Sex, Shame and Violence in Colonial Latin America*. Albuquerque: University of New Mexico Press, 1998.

Kagan, Richard. *Urban Images of the Hispanic World, 1493–1793*. New Haven: Yale University Press, 2000.

Katzew, Ilona. "Casta Painting, Identity and Social Stratification in Colonial Mexico." In *New World Orders: Casta Painting and Colonial Latin America*, edited by Ilona Katzew, 8–29. New York: Americas Society, 1996.

———. "Los cuadros de castas: Noticias sobre fuentes posibles en grabados y pinturas europeas." In *XVII Coloquio Internacional de Historia del Arte: Arte, historia e identidad en América: Visiones comparativas*, 3:729–740. Mexico City: Universidad Nacional Autónoma de México, 1994.

———. "Ordering the Colony: Casta Painting and the Imaging of Race in Eighteenth-Century Mexico." Ph.D. diss., New York University, 2000.

———, ed. *New World Orders: Casta Painting and Colonial Latin America*. New York: Americas Society, 1996.

Kicza, John E. *Colonial Entrepreneurs: Families and Business in Bourbon Mexico City*. Albuquerque: University of New Mexico Press, 1983.

King, James F. "The Case of José Ponciano de Ayarza: A Document on *Gracias al Sacar*." *Hispanic American Historical Review* 31 (November 1951): 640–647.

Klor de Alva, J. Jorge. "Colonialism and Postcolonialism as (Latin) American Mirages." *Colonial Latin American Review* 1, no. 1 (1992): 3–24.

———. "*Meztizaje* from New Spain to Aztlán: On the Control and Classification of Collective Identities." In *New World Orders: Casta Painting and Colonial*

Latin America, edited by Ilona Katzew, 58–72. New York: Americas Society, 1996.

———. "The Postcolonization of the (Latin) American Experience: A Reconsideration of 'Colonialism,' 'Postcolonialism,' and 'Mestizaje.'" In *After Colonialism: Imperial Histories and Postcolonial Displacements*, edited by Gyan Prakash, 241–268. Princeton: Princeton University Press, 1995.

Kuznesof, Elizabeth Anne. "Ethnic and Gender Influences on 'Spanish' Creole Society in Colonial Spanish America." *Colonial Latin American Review* 4, no. 1 (1995): 153–179.

Ladd, Doris M. *The Mexican Nobility at Independence, 1780–1826.* Austin: University of Texas at Austin Institute of Latin American Studies, 1976.

Lefebvre, Henri. *The Production of Space.* Translated by Donald Nicholson-Smith. Oxford, England: Basil Blackwell Ltd., 1991.

Lemoine Villicaña, Ernesto. "El alumbrado pública en la ciudad de México durante la segunda mitad del siglo XVIII." *Boletín del Archivo General de la Nación* 4, no. 4 (1963): 783–818.

Leonard, Irving. "The 1790 Theater Season of the Mexico City Coliseo." *Hispanic Review* 19, no. 2 (April 1951): 104–120.

Lipsett-Rivera, Sonya. "*De Obra y Palabra*: Patterns of Insults in Mexico, 1750–1846." *The Americas* 54, no. 4 (April 1998): 511–539.

Lombardo de Ruiz, Sonia. *Atlas histórico de la ciudad de México.* 2 vols. Mexico City: Instituto Nacional de Antropología e Historia, 1996–1997.

———. "Las reformas borbónicas en el arte de la Nueva España (1781–1821)." In *Y todo . . . por una nación: Historia social de la producción plástica de la Ciudad de México, 1761–1910.* Coordinated by Eloís Uribe, 15–31. Mexico City: Instituto Nacional de Antropología e Historia, 1987.

MacLachlan, Colin M. *Criminal Justice in Eighteenth Century Mexico.* Berkeley and Los Angeles: University of California Press, 1974.

Malik Kenan. *The Meaning of Race: Race, History and Cultures in Western Society.* New York: New York University Press, 1996.

Martínez, María Elena. Oral presentation at John Carter Brown Library at Brown University, 26 April 2000.

Martínez de Río de Redo, Marita. "Magnificensia barroca." *Artes de México* no. 25 (July–August 1994): 52–64.

McCaa, Robert. "*Calidad, Clase,* and Marriage in Colonial Mexico: The Case of Parral, 1788–1790." *Hispanic American Historial Review* 64, no. 3 (1984): 477–501.

McClintock, Anne. *Imperial Leather: Race, Gender and Sexuality in the Colonial Contest.* New York: Routledge, 1995.

Melzer, Sara E., and Katheryn Norberg, eds. *From the Royal to the Republican Body: Incorporating the Political in Seventeenth- and Eighteenth-Century France.* Berkeley and Los Angeles: University of California Press, 1998.

Meyer, Michael C. *The Course of Mexican History.* Cambridge: Cambridge University Press, 1999.

Mills, Kenneth, and William B. Taylor. *Colonial Spanish America: A Documentary History*. Wilmington, Del.: Scholarly Resources, 1998.

Mirzoeff, Nicholas. *An Introduction to Visual Culture*. London and New York: Routledge, 1999.

———, ed. *The Visual Culture Reader*. London and New York: Routledge, 1998.

Moore-Gilbert, Bart. *Postcolonial Theory: Context, Practices and Politics*. London: Verso, 1997.

Mörner, Magnus. *Race Mixture in the History of Latin America*. Boston: Little, Brown and Company, 1967.

Mues Orts, Paula. "Imágenes corporales: Arte virreinal de los siglos XVII y XVIII en Nueva España." In *El cuerpo aludido: Anatomías y construcciones México, siglos XVI-XX*, 47–69. Mexico: Instituto Nacional de Bellas Artes, 1998.

Olavarría y Ferrari, Enrique de. *Reseña histórica del teatro en México, 1538-1911*. Vol. 3. 3rd ed. Mexico: Editorial Porrúa, 1961.

Pagden, Anthony. "Fabricating Identity in Spanish America." *History Today* 42 (May 1992): 44–49.

———. "Identity Formation in Spanish America." In *Colonial Identity in the Atlantic World, 1500-1800*. Edited by Nicholas Canny and Anthony Pagden, 51–93. Princeton: Princeton University Press, 1987.

———. *Lords of All the World: Ideologies of Empire in Spain, Britain and France, c. 1500-1800*. New Haven: Yale University Press, 1995.

———. *Spanish Imperialism and the Political Imagination*. New Haven: Yale University Press, 1990.

Pagliaro, Harold E., ed. *Racism in the Eighteenth Century*. Cleveland and London: The Press of Case Western Reserve University, 1973.

Perry, Elizabeth Q. *"Escudos de Monjas*/Shields of Nuns: The Creole Convent and Images of Mexican Identity in Miniature." Ph.D. diss., Brown University, 1999.

Poole, Deborah. *Vision, Race, and Modernity: A Visual Economy of the Andean Image World*. Princeton: Princeton University Press, 1997.

Popkin, Richard H. "The Philosophical Basis of Eighteenth-Century Racism." In *Racism in the Eighteenth Century*, edited by Harold E. Pagliaro, 245–262. Cleveland and London: The Press of Case Western Reserve University, 1973.

Prakash, Gyan, ed. *After Colonialism: Imperial Histories and Postcolonial Displacements*. Princeton: Princeton University Press, 1995.

Rama, Angel. *The Lettered City*. Translated and edited by John Charles Chasteen. Durham: Duke University Press, 1996.

Rodrígues O., Jaime E., ed. *Mexico in the Age of Democratic Revolutions, 1750-1850*. Boulder and London: Lynne Rienner Publishers, 1994.

Romero de Terreros, Manuel. *La Plaza de Mayor de México en el Siglo XVIII*. Mexico City: Imprenta Universitaria, 1946.

Said, Edward. *Culture and Imperialism*. New York: Alfred A. Knopf, 1993.

———. *Orientalism*. New York: Random House, 1978.

Sarrailh, Jean. *La España ilustrada de la segunda mitad del siglo XVIII*. Mexico City: Fondo de Cultura Económica, 1957.

Schávelzon, Daniel, ed. *La polémica del arte nacional en México, 1850–1910*. Mexico City: Fondo de Cultura Económica, 1988.

Schwartz, Stuart B. "Colonial Identities and the *Sociedad de Castas*." *American Review* 4, no. 1 (1995): 185–197.

Seed, Patricia. "Social Dimensions of Race: Mexico City, 1753." *Hispanic American Historical Review* 62 (1982): 569–606.

Shohat, Ella, and Rober Stam. "Narrativizing Visual Culture: Towards a Polycentric Aesthetic." In *The Visual Culture Reader*, edited by Nicholas Mirzoeff, 27–52. New York: Routledge, 1998.

Smith, Paul Julian. *The Body Hispanic: Gender and Sexuality in Spanish and Spanish American Literature*. Oxford: Clarendon Press, 1989.

de Solano, Franciso. *Las voces de la ciudad: México a través de sus impresos (1539–1821)*. Madrid: Consejo Superior de Investigaciones Científicas, 1994.

Stern, Steve J. *The Secret History of Gender*. Chapel Hill: University of North Carolina Press, 1995.

Stolcke, Verena. *Marriage, Class and Color in Nineteenth-Century Cuba: A Study of Racial Attitudes and Sexual Values in a Slave Society*. London and New York: Cambridge University Press, 1974.

Stoler, Ann Laura. *Race and The Education of Desire: Foucault's "History of Sexuality" and the Colonial Order of Things*. Durham: Duke University Press, 1995.

Taylor, William B. *Drinking, Homicide and Rebellion in Colonial Mexican Villages*. Stanford: Stanford University Press, 1979.

———. *Magistrates of the Sacred: Priests and Parishioners in Eighteenth-Century Mexico*. Stanford: Stanford University Press, 1996.

Tovar de Teresa, Guillermo. "Arquitectura efímera y fiestas reales." *Artes de México* no. 1, 3rd ed. (1993): 34–47.

Twinam, Ann. *Public Lives, Private Secrets: Gender, Honor, Sexuality and Illegitimacy in Colonial Spanish America*. Stanford: Stanford University Press, 1999.

Valdés, Dennis Nodin. "The Decline of the *Sociedad de Castas* in Mexico City." Ph.D. diss., University of Michigan, 1978.

Vargaslugo, Elisa. "Austeridad del alma." *Artes de México* no. 25 (July–August 1994): 45–51.

Viqueira Albán, Juan Pedro. *Propriety and Permissiveness in Bourbon Mexico*. Translated by Sonya Lipsett-Rivera and Sergio Rivera Ayala. Wilmington, Del.: Scholarly Resources, 1999.

Vogeley, Nancy. "José Joaquín Fernández de Lizardi (1776–1827)." In *Latin American Writers*, edited by Carlos A. Solé and Maria Isabel Abreu, 1: 119–128. New York: Charles Scribner's Sons, 1989.

von Kügelgen, Helga. "'Así "repercute" la gloria del mundo' Aproximación a la reconstrucción de los arcos de triunfo de Don Carlos de Sigüenza y Góngora y Sor Juana Inés de la Cruz." In *XVII Coloquio Internacional de Historia del*

 Arte: Arte, historia e identidad en América: Visiones comparativas, 3:707–727.
 Mexico City: Universidad Nacional Autónoma de México, 1994.

Widdifield, Stacie G. *The Embodiment of the National in Late Nineteeth-Century Mexican Painting*. Tucson: University of Arizona Press, 1996.

Wiesner, Merry. *Women and Gender in Early Modern Europe*. Cambridge: Cambridge University Press, 1997.

Wold, Ruth. *El diario de México, primer cotidiano de Nueva España*. Madrid: Editorial Gredos, 1970.

Index

Academy of San Carlos. *See* Royal
 Academy of San Carlos
de Ajofrín, P. fray Francisco, 36
Alameda, 115–116. *See also* Mexico City:
 and urban renovations
de Alba-Koch, Beatriz, 170n. 95
alcalde mayor, and cuarteles, 111
allegorical time, 148–149
allegory: and Aztec-Mexica imagery, 44–46;
 use in *El periquillo sarniento*, 140–141
Alzate y Ramírez, José, 143–144
ambivalence. *See* post-colonial theory
de Apelo, Mauricia Josepha: and calidad,
 37; Inquisition case of, 25–26
Arce y Miranda, Andrés, and *casta*
 paintings, 49–50
aseo, 109, 117
Aztec-Mexica: artifacts, 141; imagery used
 in eighteenth century, 44–46; imagery
 used in nineteenth century, 136, 141. *See
 also* de León y Gama, Antonio

Baniciforte, Viceroy, and equestrian statue,
 123–124
baths, sweat, 117
Bhabha, Homi, 17–19. *See also* post-colonial
 theory
Bivian, Christobal Ramon, ecclesiastic
 court case of, 1–6
Black Africans: and blood pollution, 12–13;
 and lineage in *casta* paintings, 66–68;
 and marriage laws, 13, 118; in New
 Spain, 13, 34, 36; and shifting marriage
 patterns, 38–39; and the *sociedad de*

castas, 36–37; and sumptuary laws,
 118–119
blood purity, 10–13, 16, 159n. 20;
 certification of, 118; and lineage, 12, 37;
 and lineage in *casta* paintings, 66–68;
 and miscegenation, 13–14; and passing,
 14; pollution of, 12–14, 36
body, the: and academic art, 138–139; in
 body politic, 8–9; Bourbon regulation
 of, 8, 43, 116–118; and calidad, 6–9; in
 casta paintings, 132–134; colonial, 2–7,
 18, 107, 152; in *El periquillo sarniento*,
 128–132, 140–141; of the Indian, 141,
 147–148; of the mestizo, 141, 147–148;
 and the nation state, 7, 147–149;
 nineteenth- and eighteenth-century
 notions of, 148–149; and
 physiognomics, 9; of the plebeian, 125;
 as a social body, 2–6, 5–9; trope of, 7–9,
 108; visualization of, 43, 148
Bourbon dynasty, 32–33, 34; *See also*
 Mexico City: and urban renovations
Bucareli, Viceroy, 115, 117
Burke, Marcus, 50, 133; and naïve
 classicism, 68–69

Cabrera, Miguel, 23, 104, 133; *casta*
 paintings by, 27–30, 27 fig. 2.3, 29 fig.
 2.4, 35, 69–83, 69–83 figs. 3.16–3.26,
 158n. 7; mid-century style of, 69, 83;
 and naïve classicism, 69; portraiture by,
 23, 23 fig. 2.2, 31 fig. 2.6
caciques, 12
calidad: and bloodlines, 14; and *casta*

paintings, 28, 102–105; as construct, xvi, 5–6, 9, 14–15; as discourse, 6–9, 15–20; and Doña Margarita de Castañeda, 5–6, 14–16, 19–21, 25–26; and Mauricia Josefa de Apelo, 25–26; and physiognomics, 9, 14, 37–38, 42; and public spaces, 28; and raza, 6; and the social body, 5–9. *See also casta* painting

Cámara, 33–34

Cañeque, Alejandro, 7–8

carnaval, regulation of, 120–121

casta(s): as lineage, 66–68; and passing, 6, 43. *See also casta* painting; plebeians; *sociedad de castas*

casta painting: and academic art, 54; and *calidad*, 28, 102–105; and colonial discourse, 132–135; and criollo sentiment, 49; and economic ordering, 101; and gender, 157n. 43; as genre, 49; and hybridity, 52–54; as lineage groupings, 66–68; and the marketplace, 101; and nineteenth-century painting, 145, 149; and notions of race, 51; and physiognomics, 101–103; and portraiture, 26–27, 54; previous study of, 50–52; and the *sociedad de castas*, 52, 66–68; and space, 101; as visual practice, 32, 53, 132–135; viewership of, 50; viewing structures: gaze and surveillance, 53, 83, 104–105, 132–135. *See also casta* painting, production of; Fisher, Abby Sue; García Saiz, María Concepción; Katzew, Ilona; Rodríguez Juárez, Juan; Cabrera, Miguel; de Islas, Andrés

casta painting, production of: 48–49, 52–53, 162n. 44; in the mid-eighteenth century, 68–69; in the late eighteenth century, 100–103; in the nineteenth century, 53, 136–139

de Castañeda, Doña Margarita: and *calidad*, 56, 14–16, 37; and colonial discourse, 19–21, 25–26; and ecclesiastic court case, xvi, 1–6, 20–21; and the social body, 14–16

Castera, Ignacio (master architect), 115

castizo(s): in *casta* painting lineage, 66–67; marriage patterns of, 40, 40 table 2.4; in sociedad de castas, 36–37

cédula de gracias al sacar, 33–34

de la Cerda y Aragón, Viceroy, 44

Chappe d'Auteroche, Monsignor, 109

citizenship: and *castas*, 137; and allegorical time, 148

Coliseo, 121–122

colonial discourse, 15. *See also* body, the: colonial; post-colonial theory

colonialism: and colonial identity, 135; and New Spain, 4, 7, 16; study of, 15–16. *See also* Cañeque, Alejandro

convents, regulation and reform of, 46, 49

Cope, R. Douglas, 42

costumbrista painting, 145

Council of the Indies, 33–34

criollo(s): antagonism of, toward Spaniards, 33, 46; and *casta* paintings, 49, 52; cultural identity of, 46–48; and economics of New Spain, 41; and *monja coronada*, 46–48; patriotism of, 46; social and civil prerogatives of, 10. *See also limpieza de sangre*

Croix, Viceroy, 112; and *populachos*, 116; and *pulque*, 116; and urban renewal, 112, 115–116

cuadros de casta. See casta painting

cuadros nacionales, 146

cuarteles, 110–112

cultural geography, 145

dance schools, 117

don, doña, 4, 155n. 9

ecclesiastical court. *See* de Castañeda, Doña Margarita

El periquillo sarniento, 125–132, 139–141; and *calidad*, 127–128; and the *hombre de bien*, 128–132; and physiognomics, 128–132; as social critique, 129–130, 140–141; and trope of the body, 130–131, 140–141; and use of allegory, 140–141

Enlightenment, 8–9, 11–12
escudos de monjas, xv, 46–48, 104
español(es). *See* Spaniard(s)

Fabregat, José Joaquín, 124, 134
Fabres, Felipe, 30
de Fagoaga, Juan Pascual, 111
Feijoo, Benito, 9; and notions of race, 11–12
Fernández de Lizardi, José Joaquín,
 125–126. *See also El periquillo de
 sarniento*
Fisher, Abby Sue, 51–52
Foucault, Michel, 15

gachupín, 3, 154n. 5
de Gálvez, José (inspector general in New
 Spain), 33
García Sáiz, María Concepción, 48, 50–51
gaze: use of, in *casta* paintings, 83–84,
 104–105; as construct, 18–19. *See also*
 physiognomics; surveillance
gente vulgar. *See* plebeians
Gregoria, *la macho*. *See* Piedra, Gregoria,
 Inquisition case of

Haidt, Rebecca, 8–9
Hapsburg dynasty, 32
hombre de bien, 9; in *El periquillo
 sarniento*, 128–132, 140
hombria de bien, 131–132
hybridity. *See* post-colonial theory

Inquisition court. *See* de Apelo, Mauricia
 Josefa; Piedra, Gregoria, Inquisition
 case of
de Islas, Andrés, 84; *casta* paintings by,
 84–102, 84–102 figs. 3.26–3.42; late
 eighteenth-century style of, 100–103;
 and Miguel Cabrera, 83–84, 100–101, 133
The Itching Parrot. *See El periquillo de
 sarniento*

Kagan, Richard, 110
Katzew, Ilona, 51–52
Kuznesof, Elizabeth, 9–10

de León y Gama, Antonio, 142–144, 149
libro de castas, *libro de españoles*, xvi, 1–2,
 16, 20, 32,
limpieza, and cleanliness, 109
limpieza de sangre, 2, 10; and elite
 prerogatives, 10. *See also* blood purity
Lopez, Andrés, 138
Lorenzana y Butrón, Antonio, 49

marriage: laws, 118; patterns of, 39–41, 39
 table 2.3, 41 table 2.4; used for passing,
 40–41
mestizo(s): in *casta* painting lineage, 66–67;
 marriage patterns of, 40, 40 table 2.4; in
 nineteenth-century painting, 147–148; in
 population of Mexico City, 38–39; in
 sociedad de castas, 36–37
Mexican iconography. *See* Sigüenza y
 Góngora, Carlos
Mexico City: and Alameda renovations,
 115–116; eighteenth-century
 descriptions of, 108–109; mapping of,
 114; *parián* in, 35, 107, 117–118; and
 Plaza Mayor, 35, 106–107, 123;
 population of, 38–41, 38 table 2.1, 39
 table 2.2; population shifts in, 43; and
 sanitation, 113; signage system of, 112;
 street illumination in, 111–112, 164n. 22;
 traza in, 34, 110; and urban order, 34,
 107, 110–111; and urban renovations,
 111–118, 122–123
mimicry. *See* post-colonial theory
miscegenation, 13, 14, 28; and
 physiognomics, 9. *See also* blood purity:
 pollution of
monja coronada, xv, 47–48, 104
Monroy, Petronilo, 148
mulatto(s): in *casta* painting lineage, 66–67;
 eighteenth-century views of, 13–14;
 marriage patterns of, 40, 40 table 2,4; in
 population of Mexico City, 38–39; in the
 sociedad de castas, 36–37. *See also* blood
 purity: pollution of

national identity, and citizenship, 144. *See*

passing, 43; in population of Mexico City, 39; social and civil prerogatives of, 36; in *sociedad de castas*, 36–37. *See also* blood purity; *limpieza de sangre*

street lighting. *See* Mexico City: street illumination in

sumptuary laws, 5, 13

surveillance: as colonial practice, 14, 18–20; in *El periquillo sarniento*, 130–131; and Mexico City renovations, 111–112; as strategy in *casta* painting, 83, 101–102, 104–105. *See also* gaze

theater, 141; reforms of, 121–122

time, allegorical, 148

Twinam, Ann, 10, 33–34

urban spaces: narrating of, 108–109; ordering of, 107–108; planning of, 108. *See also cuarteles*; Mexico City

Valazquez, Don Antonio, 123

Valdés, Dennis Nodin, 38–40

Viera, Juan de, 35, 108–109, 126

Villarroel, Hipólito, 109, 112

Viqueira Albán, Juan Pedro, 121

women: and gender issues, 157n. 43; in legal system, 4

Widdifield, Stacie G., 147–148

Lightning Source UK Ltd.
Milton Keynes UK
UKOW02f1257161216

290069UK00001B/18/P